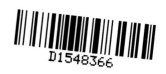

HISTORIC PHOTOS OF
LOUISVILLE

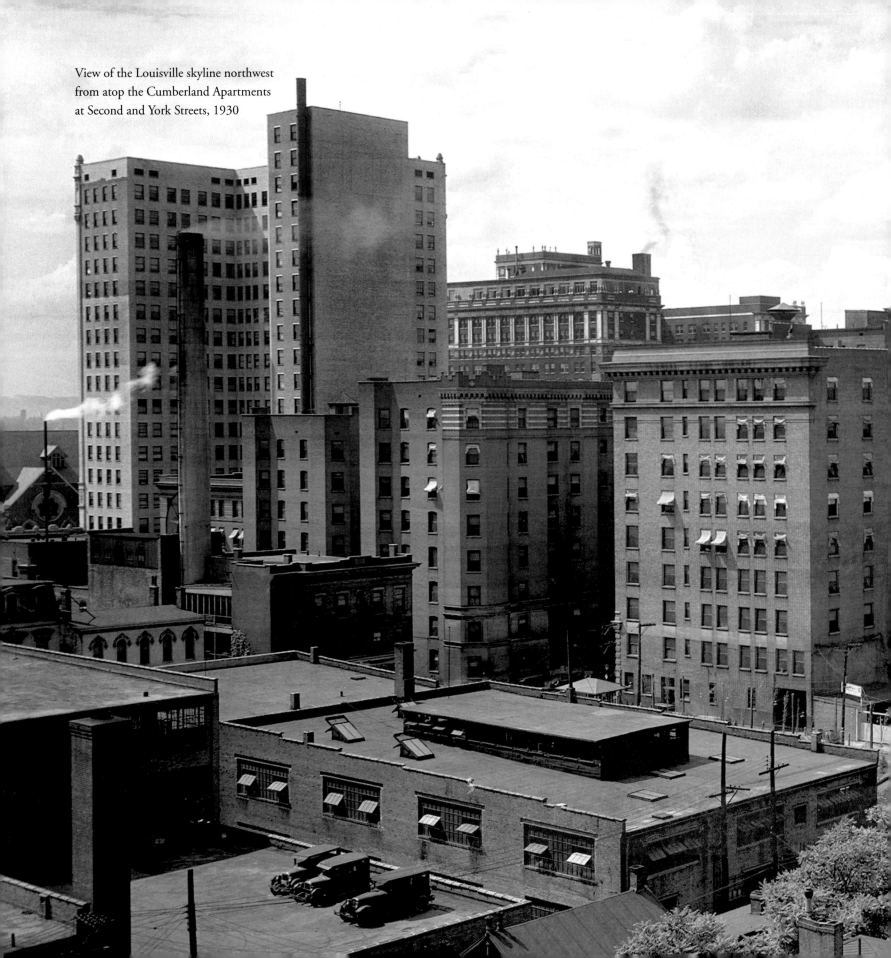

View of the Louisville skyline northwest from atop the Cumberland Apartments at Second and York Streets, 1930

HISTORIC PHOTOS OF
LOUISVILLE

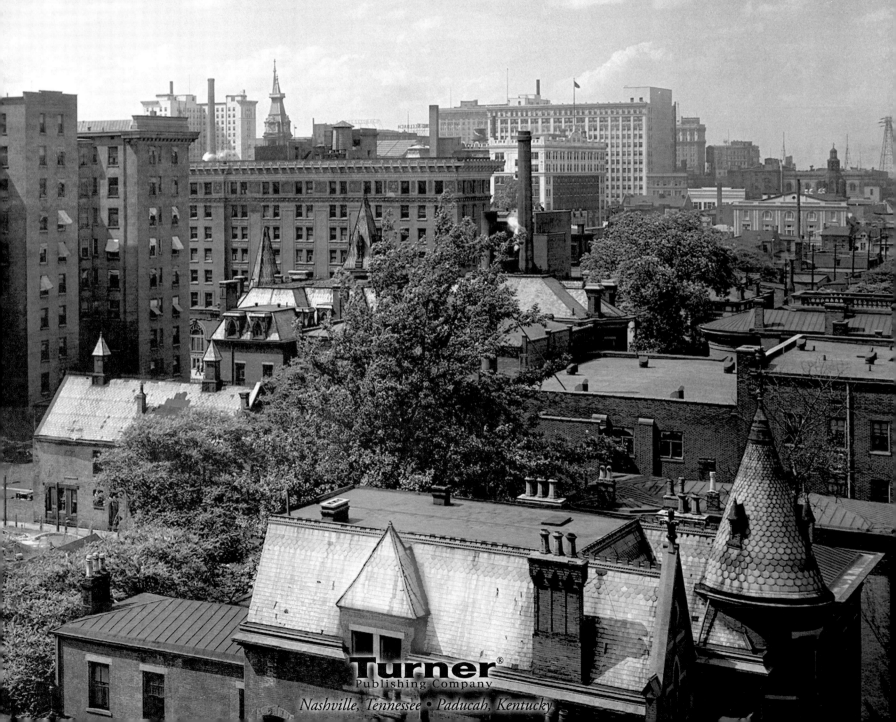

Turner®
Publishing Company

Nashville, Tennessee • Paducah, Kentucky

Turner Publishing Company
200 4th Avenue North • Suite 950 412 Broadway • P.O. Box 3101
Nashville, Tennessee 37219 Paducah, Kentucky 42002-3101
(615) 255-2665 (270) 443-0121

www.turnerpublishing.com

Library of Congress Control Number: 2006905292

ISBN: 1-59652-277-1

Printed in the United States of America

0 9 8 7 6 5 4 3 2 1

CONTENTS

Louisville Gas & Electric Company generating station and the intersection of Second and Main Streets in 1930 from the George Rogers Clark Memorial Bridge

ACKNOWLEDGMENTS

This volume, *Historic Photos of Louisville,* is the result of the cooperation and efforts of several individuals, organizations, institutions, and corporations. It is with gr eat thanks that we acknowledge the valuable contributions of the following for their generous support.

Stock Yards Bank & Trust

U.S. Bank

Norton Healthcare

Wyatt, Tarrant & Combs

The majority of the photographs in this volume were selected from the 1.5 million items housed at the Special Collections Department at the Ekstrom Library, University of Louisville. We would like to recognize the assistance and support of the Archives staff: Delinda Buie, Bill Carner, Ann Collins, James Manasco, George McWhorter, Suzy Palmer, and Amy Purcell. Student Assistant Chrissie Leake also provided valuable help with the scanning of the photographs.

Finally, we would like to offer thanks to Donna Neary for her advice and for proofreading the manuscript.

PREFACE

Since the beginning of American photography in the 1840s, billions of images have been produced. The survival of these images, however, has largely been left to chance, with little official recognition given to the rich visual history represented in this prodigious, though for the most part haphazard, production. Until the last quarter of the twentieth century, archivists, including many in Kentucky, did not consider photographs to be items worth collecting. In addition, the natural enemies of photographs—floods, fires, dirt, insects, and neglect—took a tremendous toll.

Louisville narrowly escaped the total destruction of the first one-hundred years of its photographic history during the great Ohio River flood of 1937. Remaining at or above flood stage for several days, the river put floodwater into the basements and first floors of 60 percent of the city. Unfortunately, all of the city's photographic studios, many with collections going back to the middle of the nineteenth century, were located within a few blocks of the riverfront. The Caufield & Shook Studio, Louisville's largest, lost nearly thirty thousand negatives stored in the basement of its building at 638 S. Fourth Street. Of the thirty-six photographic studios active in Louisville in 1938, twenty-three were nearer the river than Caufield & Shook.

Many studio collections were a complete loss, but 1937 made clear the threat posed by a river which had flooded the downtown at least once a decade for more than a century. It caused two of the studios, Caufield & Shook and the Royal Photo Company, to exercise great diligence in protecting what remained of their negatives. Those negatives today constitute two of the biggest segments of the holdings of the University of Louisville's Photographic Archives.

Founded in 1968 to collect and preserve the visual history of the city, the Photographic Archives' collections have grown to approximately 1.5 million photographs, making it one of the most important collections in the U.S. Its collections have a national and international reputation and have drawn scholars representing many fields of research. It attempts to meet the research needs of a wide range of academic disciplines as well as their reproduction needs. Photographs from the collections frequently appear in books, journals, and documentary films in addition to student theses and dissertations.

The power of photographic images is that they are less subjective than words in their treatment of history. Although the

photographer can make decisions regarding subject matter and how to capture and present it, photographs do not provide the breadth of interpretation that text does. Instead, they offer an original, untainted perspective that allows the viewer to observe and interpret.

The goal in publishing this work is to provide broader access to a set of extraordinary photographs that seek to inspire, provide perspective, and evoke insight that might assist people who are responsible for determining Louisville's future. In addition, the book seeks to preserve the past with adequate respect and reverence.

The photographs selected have been reproduced in dramatic black-and-white tones to provide depth to the images. With the exception of touching up imperfections caused by the damage of time, no other changes have been made. The focus and clarity of many images is limited to the technology and the ability of the photographer at the time they were taken.

The early twentieth-century assumption that photographs were insignificant ephemera, unworthy of inclusion in collections of historical research materials, has been proven false by institutions such as the University of Louisville Photographic Archives and others of its kind. The value of these images of an earlier era will continue to be recognized, and institutions like the Photographic Archives will continue to play an important role in preserving them and making them available to scholars and the public.

—*James C. "Andy" Anderson, Author*

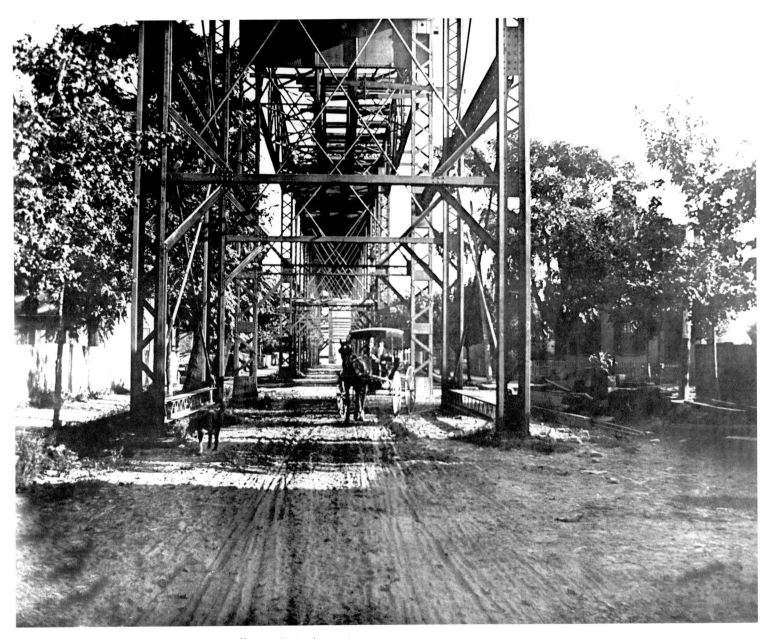

Horse and buggy under the Louisville and Jeffersonville Bridge, 1891

Pre-Civil War to the Centennial

1860–1899

The Falls of the Ohio at Louisville is the only natural impediment to river navigation between Pittsburgh, Pennsylvania, and Cairo, Illinois. Prior to 1830, goods and passengers were portaged around the falls, requiring all river travelers to stop at Louisville. With the opening of a canal around the falls in 1830, river traffic thrived and so did the city. Businesses related to the transport of goods—forwarding agents, commission merchants, wholesalers, insurers, and warehouses—dominated Louisville's economy.

Although strategically important to the Union, Louisville was never seriously threatened by hostilities during the Civil War, and its economy was relatively undamaged. In the decades following the war, the city concentrated on expanding its economy and markets, transporting goods by river and by rail and serving as a major supplier to the Southern states. Manufacturing began to replace the earlier mercantile and agricultural economy. The city had made rail connections into the Southern states with the founding of the Louisville & Nashville railroad in the 1850s. Routes north became possible with the building of the first bridge across the Ohio in 1870. A new city hall built in 1873 featured both agricultural products and railroads in its exterior decorations. The city's growing industrial prowess was displayed in the annual Industrial Exposition held from 1872 to 1882. The first Kentucky Derby was held in 1875.

The more impressive Southern Exposition, from 1883 to 1887, did even more to portray Louisville as a progressive manufacturing center. The event was opened by President Chester A. Arthur and was the first such exposition to be lit by electric lights. Forty-six hundred of Edison's new incandescent bulbs lighted the halls at night while arc lights illuminated the grounds.

The city experienced a building boom in the second half of the century. The new Galt House Hotel opened on East Main Street in 1869. The Tyler Block, an impressive commercial "Palace," opened in 1874. The year 1878 saw the completion of the Carter Dry Goods Company, now the Louisville Science Center, in the 700 block of West Main Street.

Recreation included major league baseball. Gentlemen's teams had played the sport since at least the 1850s, but Louisville became a major league city when the meetings founding the National League were held in the city and the Louisville Grays became a charter member of the League in 1876. John A. "Bud" Hillerich, son of the company's founder, made the Hillerich and Bradsby Company's first "Louisville Slugger" bat in 1884.

The pumping station and standpipe tower of the Louisville Water
Company, River Road and Zorn Avenue, completed in 1860. Circa 1860s

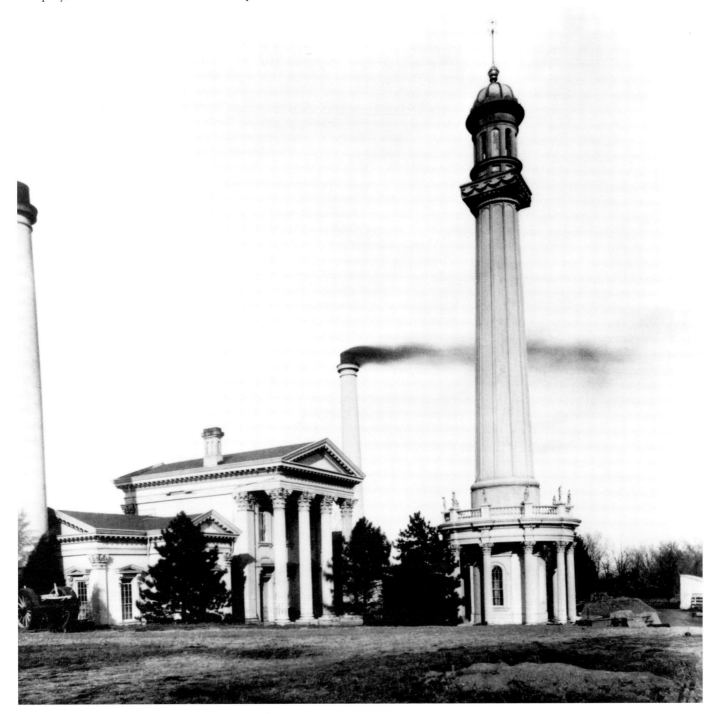

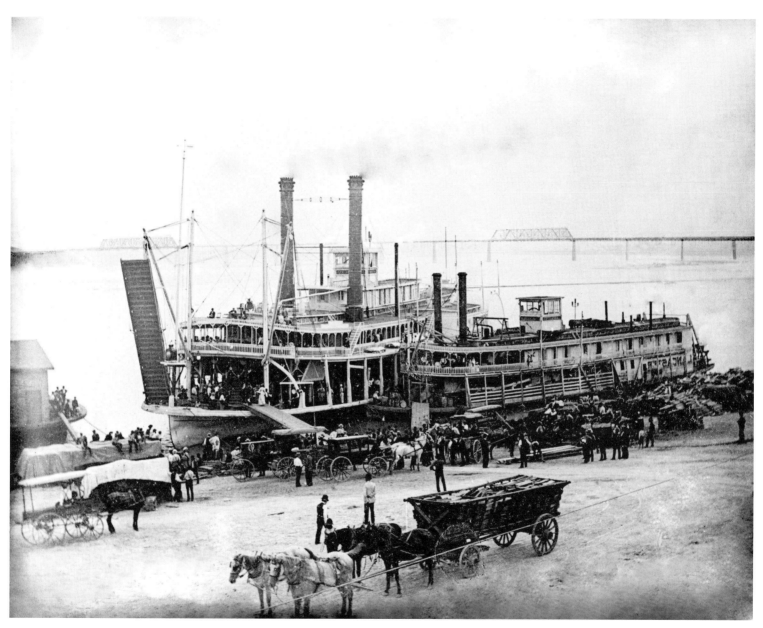

Wagons unload freight from steamboats on the Louisville wharf in the late 1870s. In the background can be seen the Ohio River Bridge, Louisville's first bridge across the Ohio, completed in 1870.

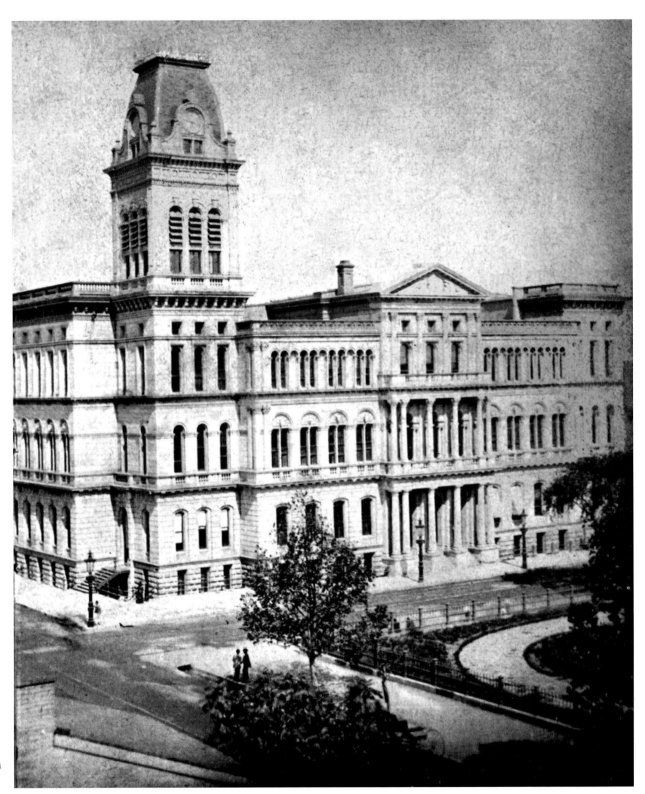

Louisville's City Hall
is seen in this stereo
view taken shortly
after its completion in
1873.

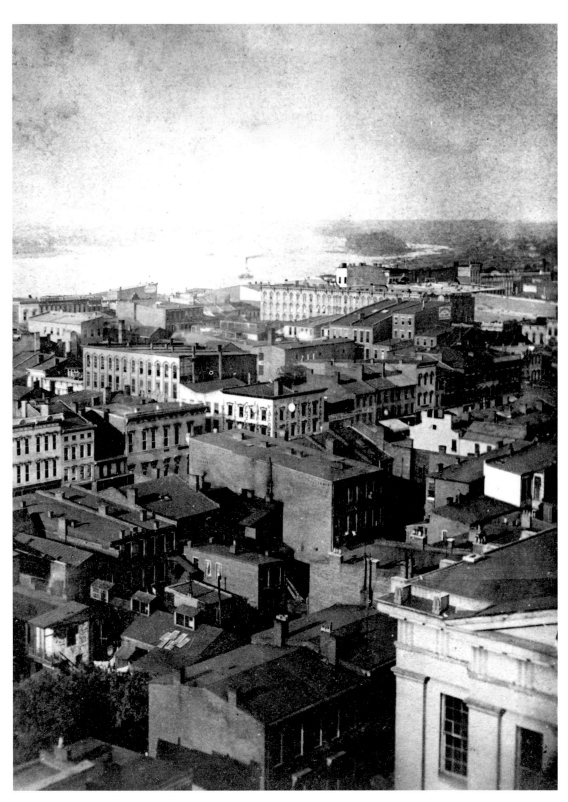

View northeast from the tower of Louisville's City Hall in the 1870s. The corner of the Jefferson County Courthouse can be seen at lower right. Third, Fourth and Fifth Streets in the background are crowded with hotels and commercial buildings.

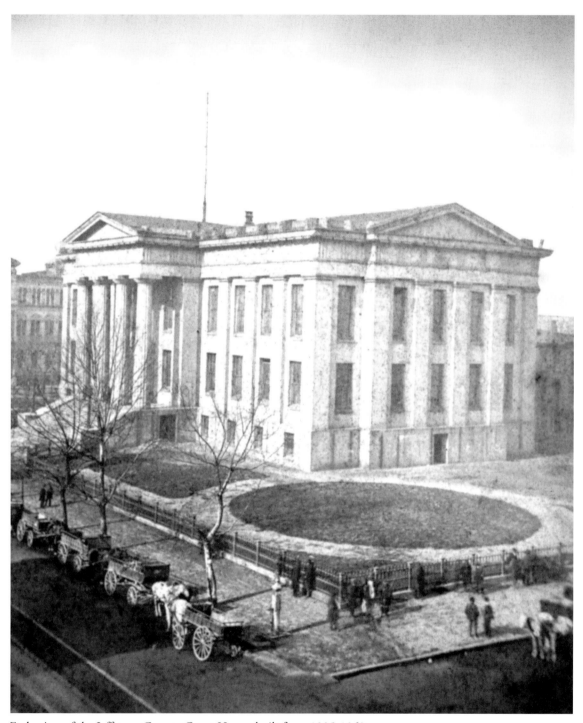

Early view of the Jefferson County Court House, built from 1835-1860.

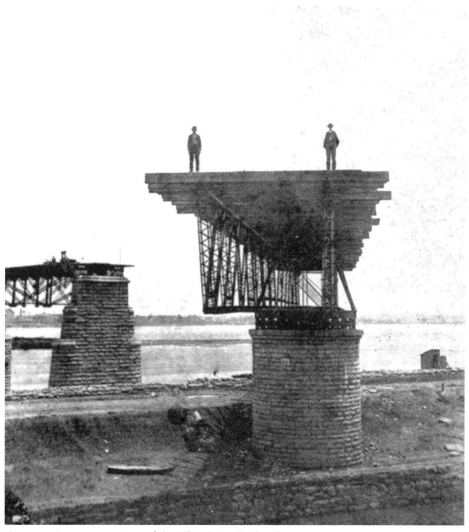

Construction progress view of the Ohio River Bridge (later called the Fourteenth Street Bridge and the Pennsylvania Railroad Bridge.) This view shows a swing span near the Indiana side.

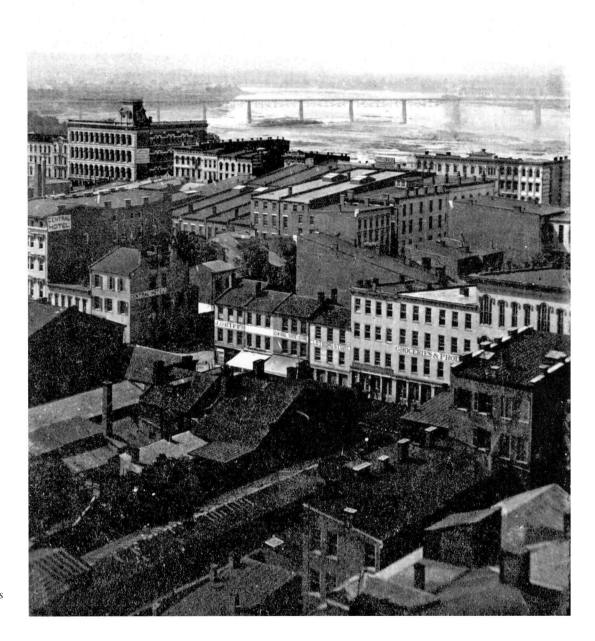

View northwest from the tower of Louisville's City Hall in the 1870s. The Ohio River and the Ohio Falls Bridge are in the background.

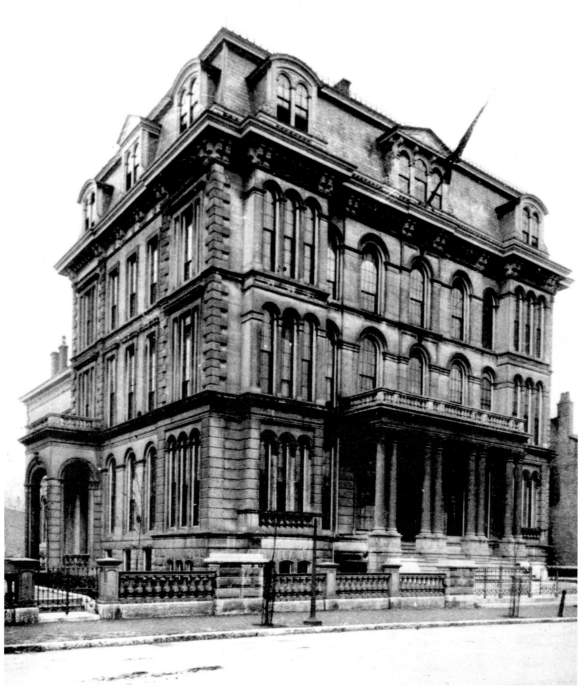

Female High School, on the west side of First Street north of Chestnut shortly after its completion in 1873. Parts of the original building are now surrounded by the newer Ahrens Educational Resource Center.

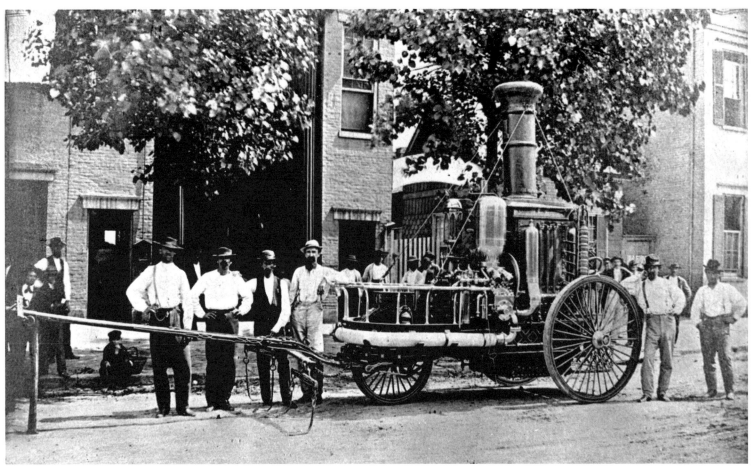

Firemen of City of Louisville Engine Co. No. 1, on Jefferson Street between Preston and Jackson in 1874.
All Louisville fire companies were volunteers until June 1, 1858.

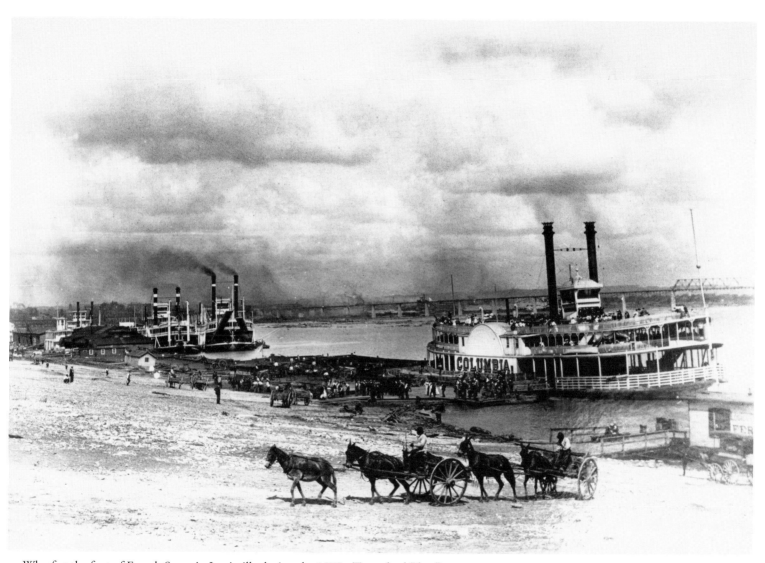

Wharf at the foot of Fourth Street in Louisville during the 1870s. Two-wheel "dray" wagons were used to haul goods to and from the steamboats.

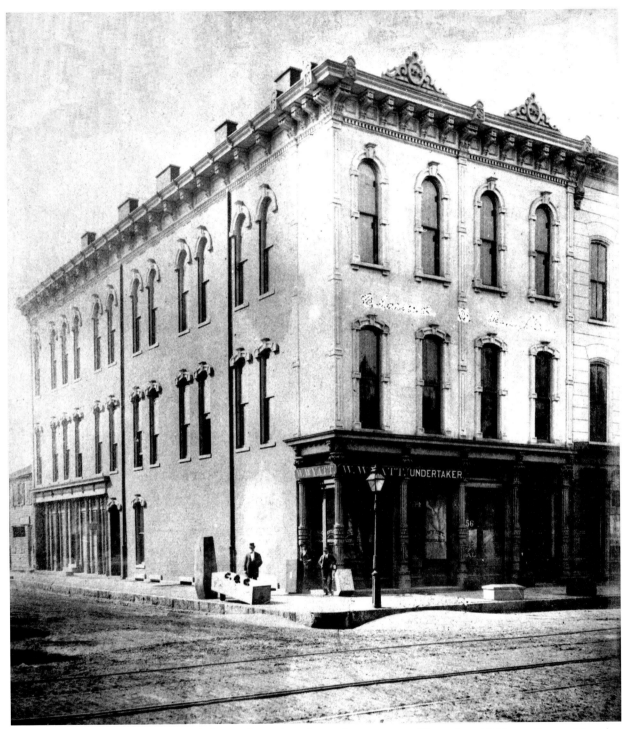

Washington Wyatt's undertaking establishment, located on the southwest corner of Seventh and Jefferson Streets. Note the caskets displayed on the sidewalks. Circa 1875.

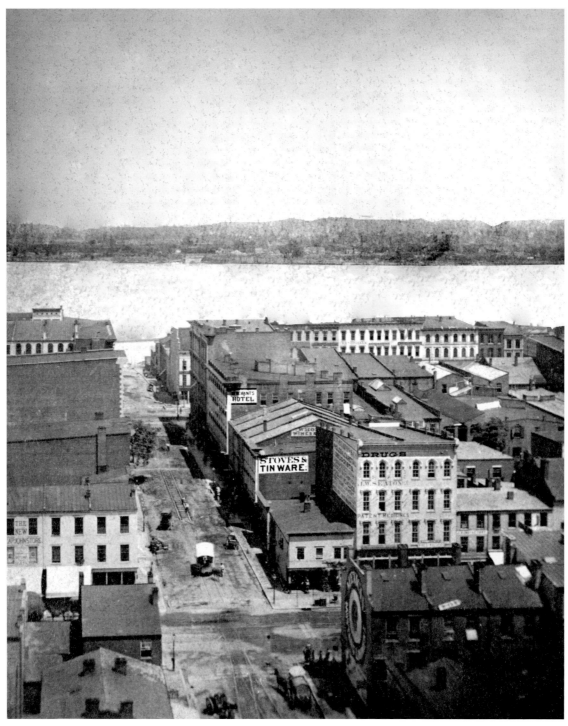

View north from the City Hall Tower in 1870s. Both commercial wagons and personal buggies can be seen on Sixth Street.

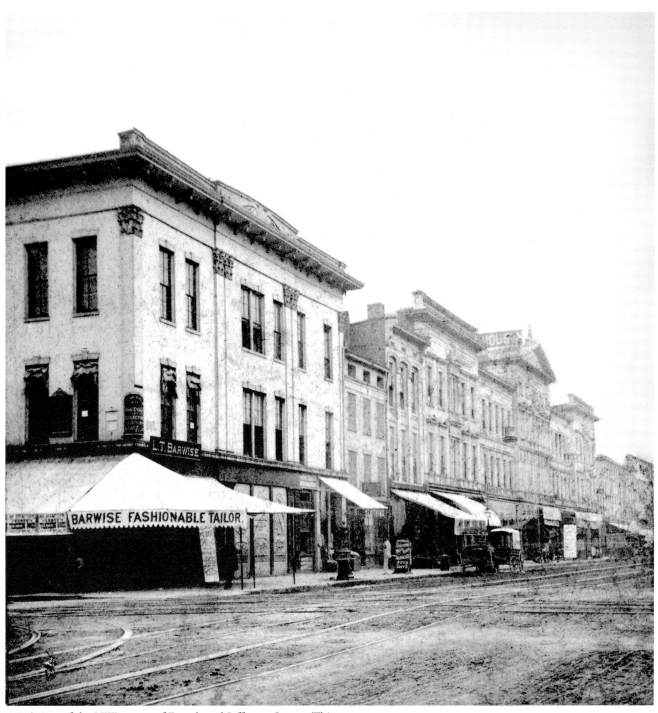

1876 view of the NW corner of Fourth and Jefferson Streets. This scene shows Luther Barwise's gentlmen's tailor shop.

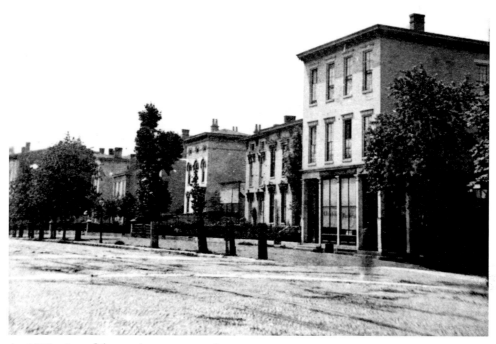

An 1870s view of the northwest corner of
Broadway at Third Street showing the drug
and chemist's shop run by C. Lewis Diehl, a
lecturer at the Louisville Medical College.

A Louisville policeman in the uniform of the 1890s posed for photographer George Martin.

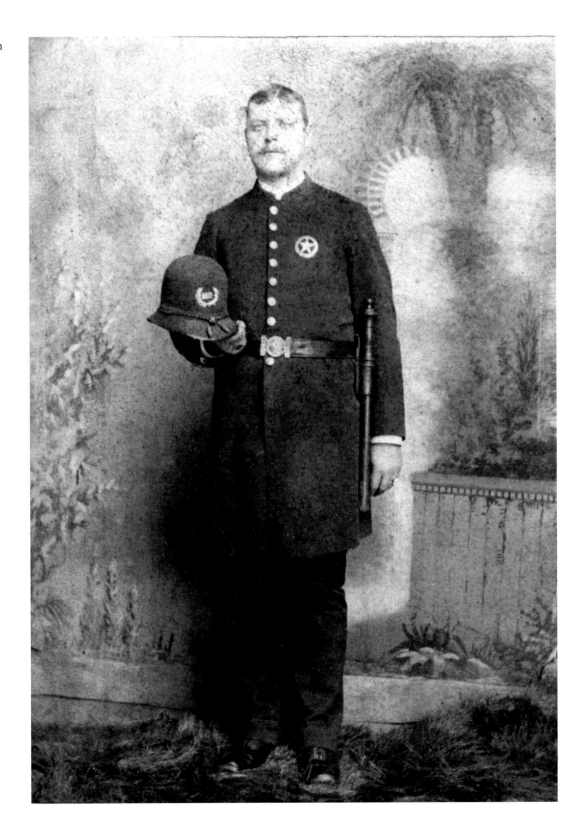

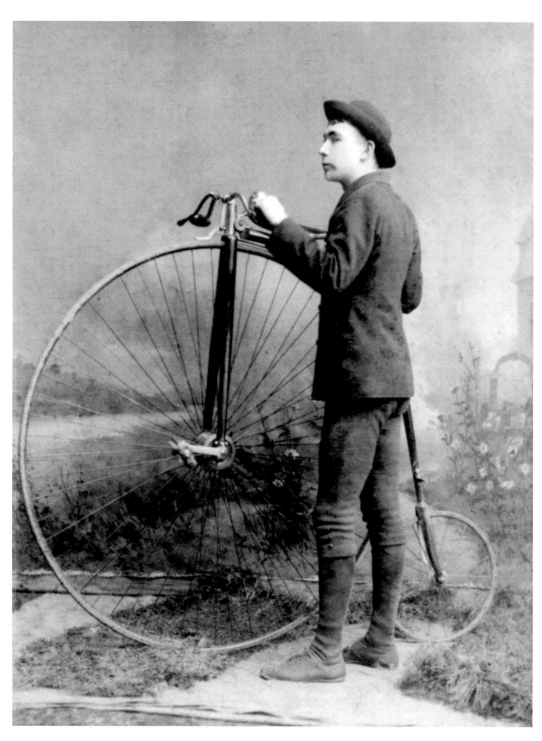

A cyclist posed with the high-wheeled "penny farthing" bicycles popular in the 1880s.

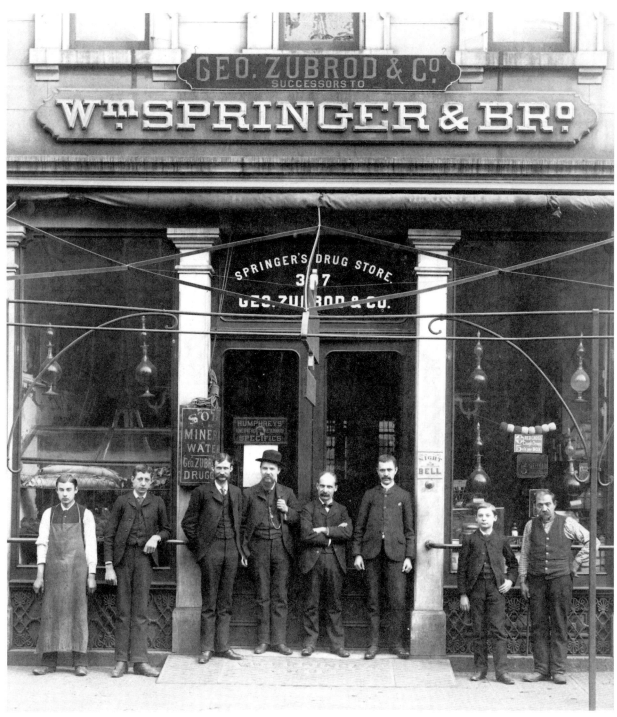

George Zubrod operated this drug store at 307 West Market after 1883 when he purchased it from William Springer. Zubrod and other German chemists who immigrated to Louisville, were instrumental in founding a school of pharmacy here. Circa 1883.

Looking east along Broadway from Shelby Street during the flood of 1884.
The tower at the gate of Cave Hill Cemetery is visible in the background.

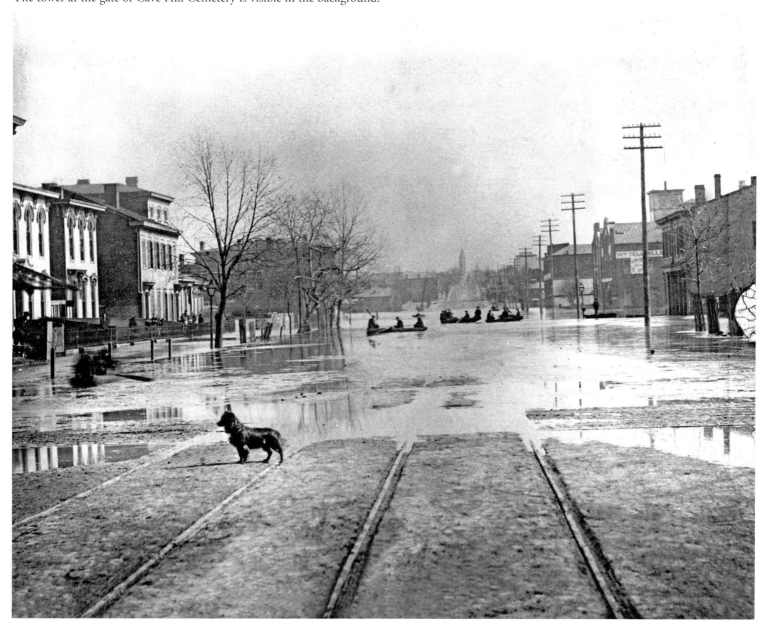

Trolley car in front of the Southern Exposition Building. The Southern
Exposition, on land now occupied by Central Park, opened in 1883
and was lit with Edison's new electric bulbs. Circa 1885.

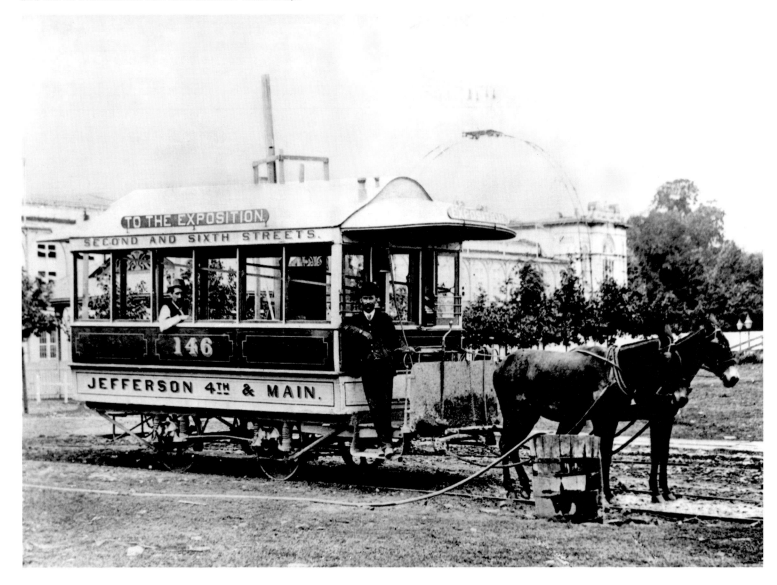

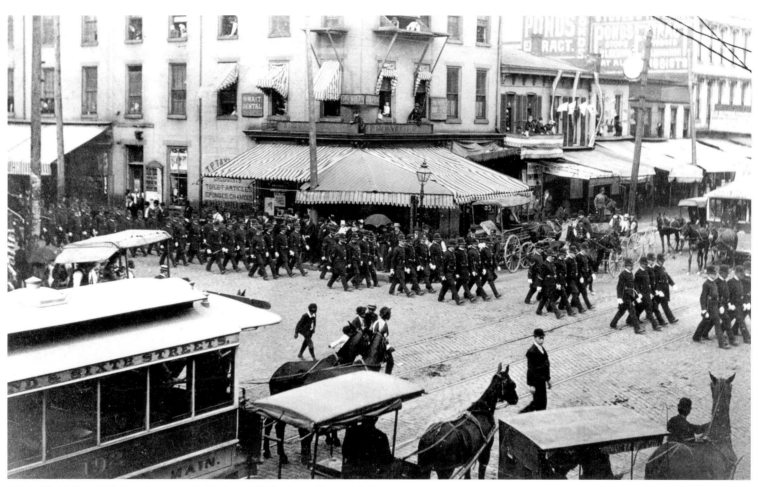

Louisville Police participate in a parade in about 1892, shown here at the intersection of Third and Jefferson Streets.

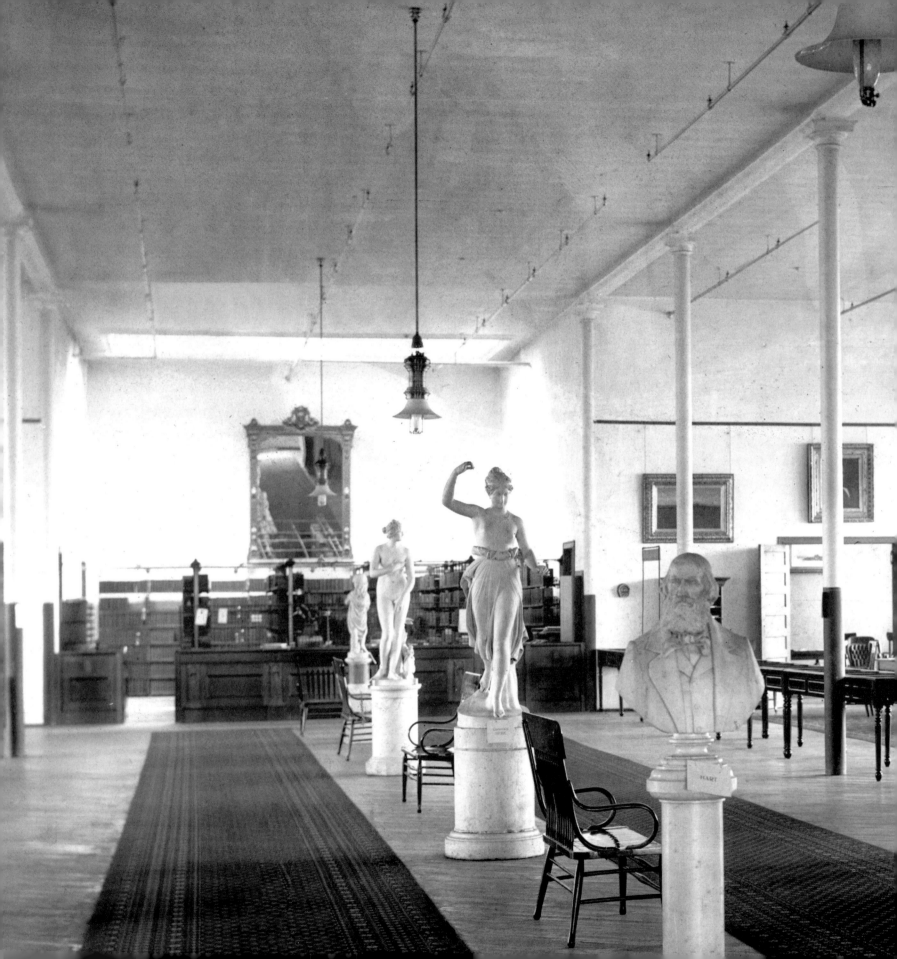

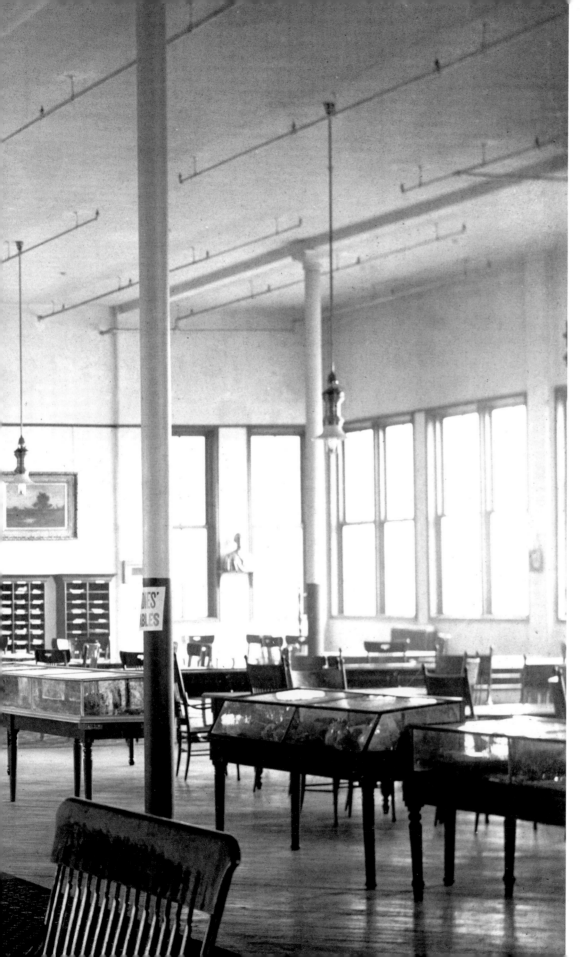

Museum and exhibition hall at Louisville Polytechnic Society, circa late 1880s.

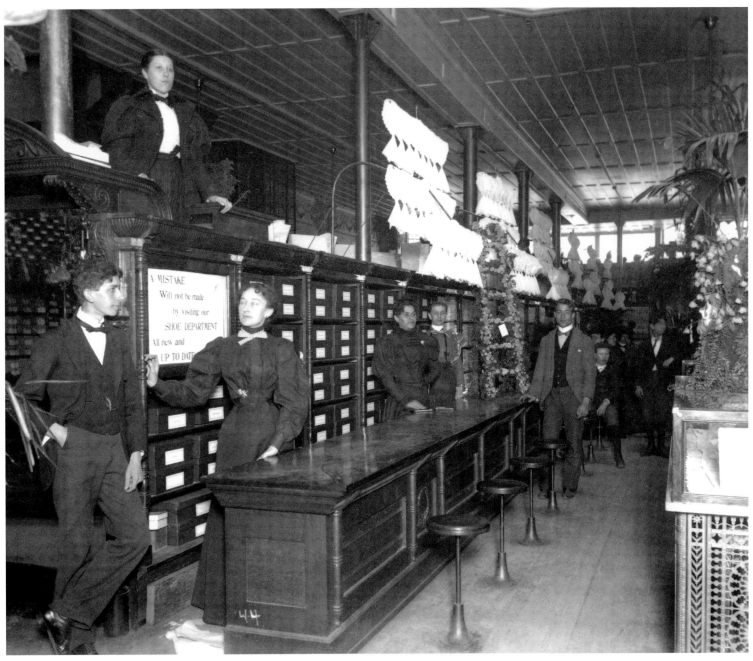

Interior view of what is believed to be J. Bacon's Sons Department Store on Market, between Third and Fourth Streets, circa 1890s.

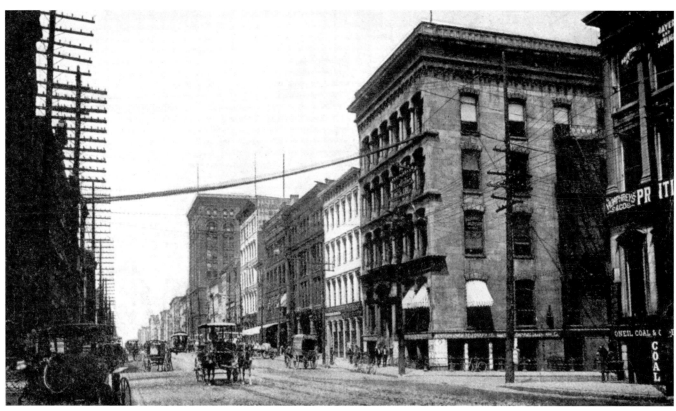

This old post card view shows Main Street looking west from
Third Street in about 1890.

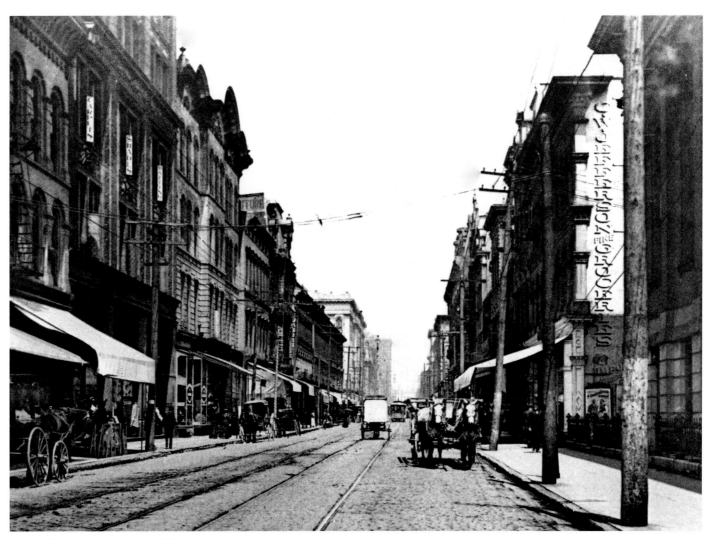

View of Fourth Street north of Walnut
in the 1890s.

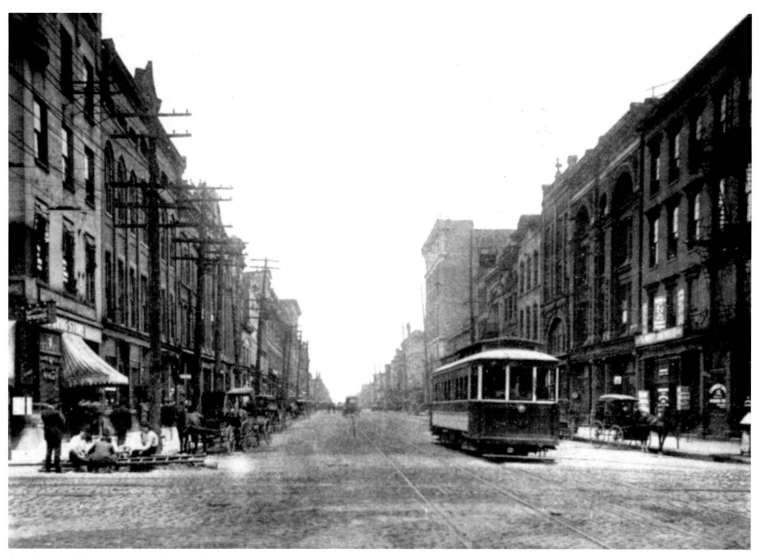

An electric trolley moves west along Jefferson Street at
Fifth Street, in the 1890s.

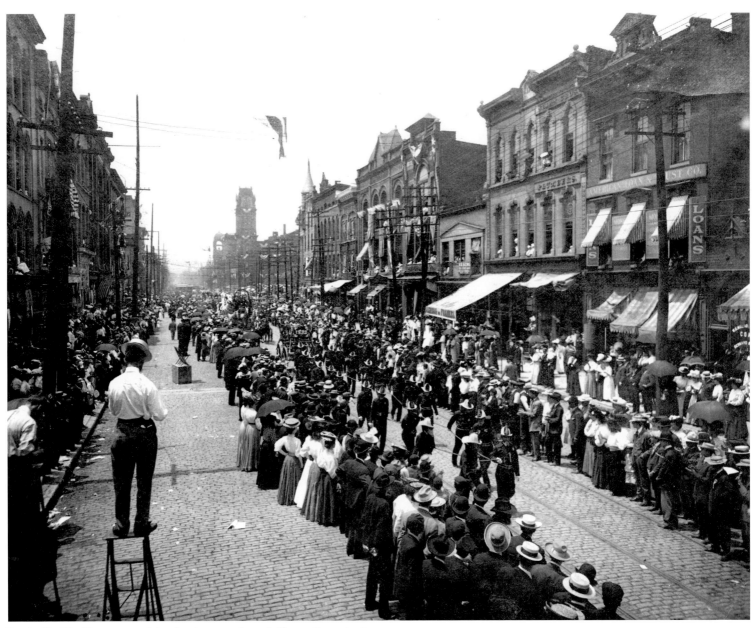

Louisville City Firemen participating in a parade on Jefferson Street in the 1890s. Louisville City Hall in is the background.

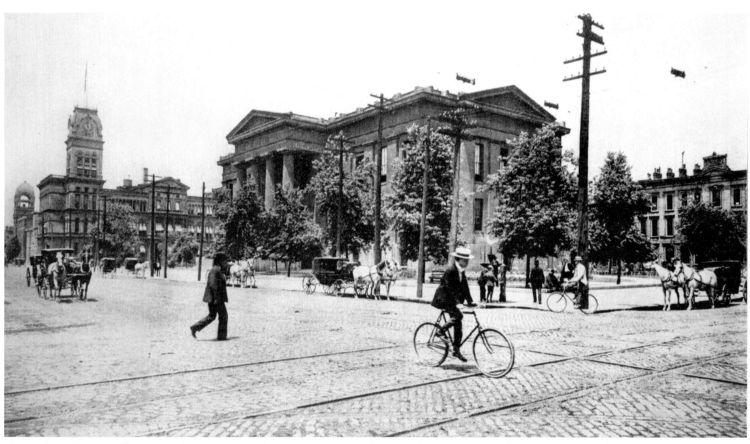

Horses, bicycles and walking seem the primary modes of transportation for those doing business at the Court House and at City Hall (background). The "Safety Bicycle" seen here had only recently replaced the more dangerous high-wheeler and led to a tremendous increase in the use of bicycles by commuters who couldn't afford horses and wished to avoid the expense of trolleys. Circa 1890s.

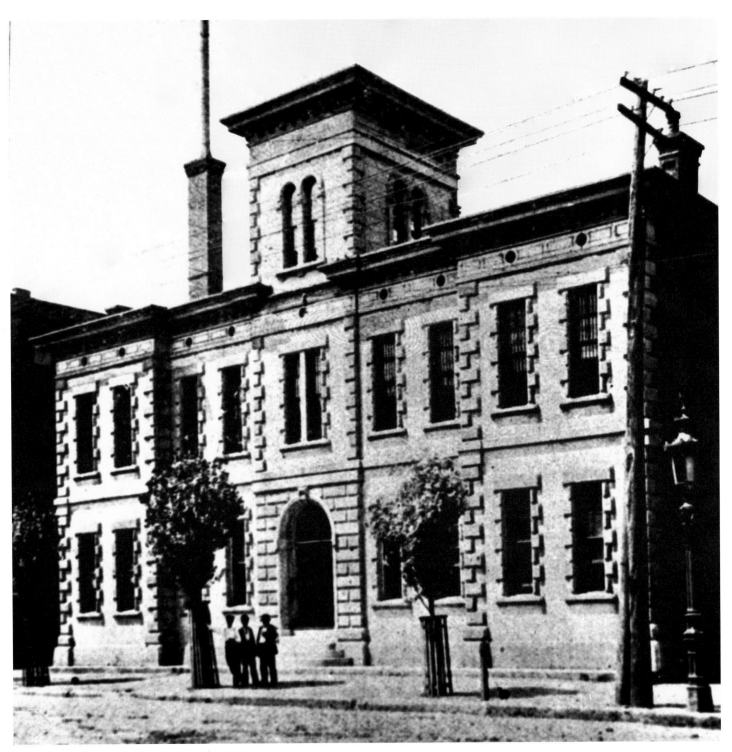

The Jefferson County Jail as it appeared in 1895.

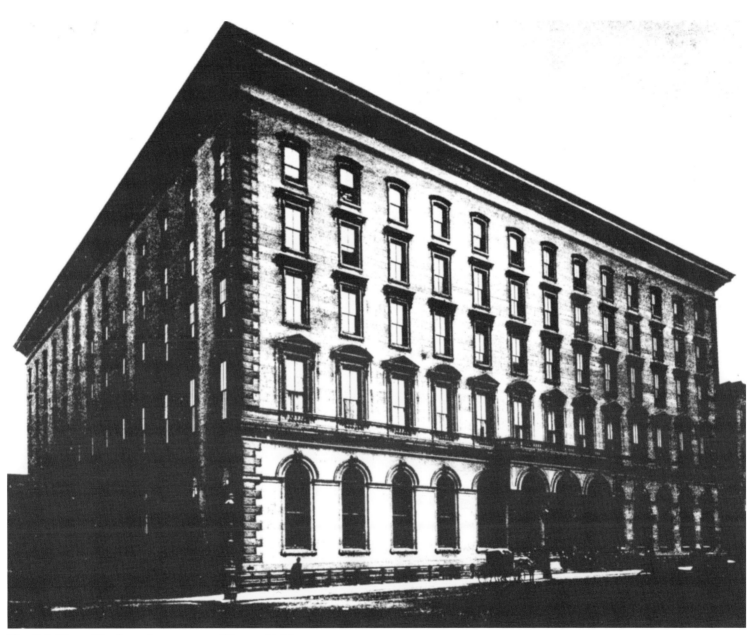

The Galt House Hotel, northeast corner of First and Main, was designed by architect Henry Whitestone and completed in 1869. Circa 1897.

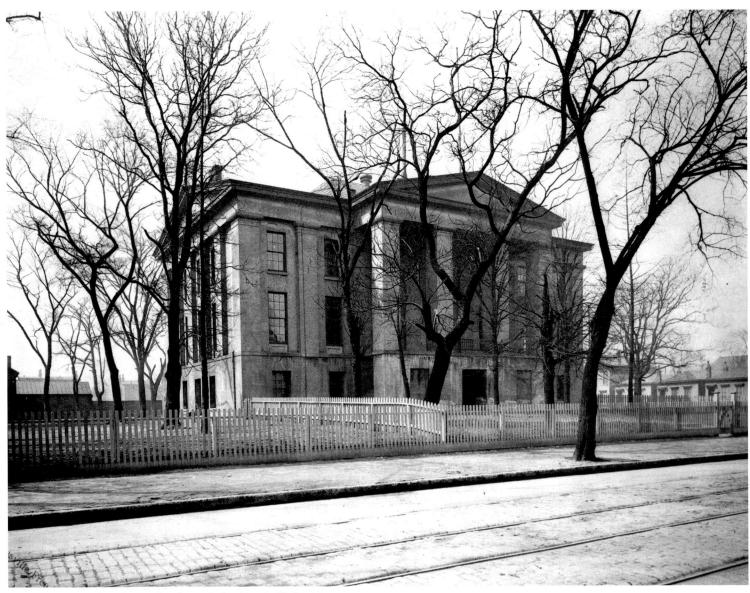

Male High School, as depicted in "Art Work of Louisville", 1897.

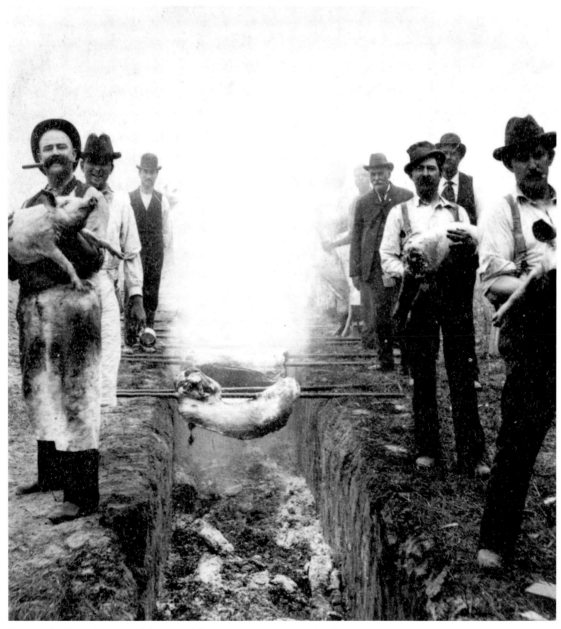

During the Grand Army of the Republic encampment in Louisville in 1895, these pigs were roasted in "The Great Barbeque."

Stage coaches took passengers to areas not served by the Railroads
until motorized carriers took over this service. Circa 1890s.

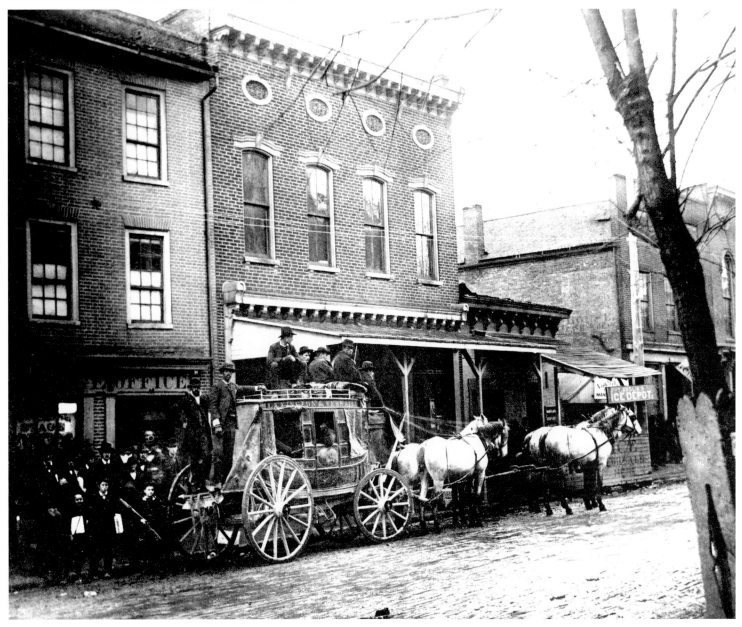

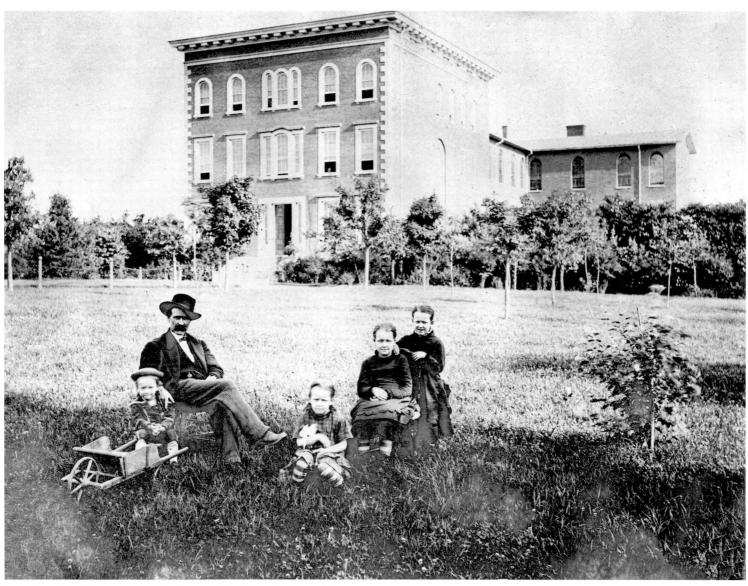

Superintendent's home, Louisville House of Refuge, circa 1890. The House of Refuge was located on south Third Street on what is now the University of Louisville's Belknap Campus.

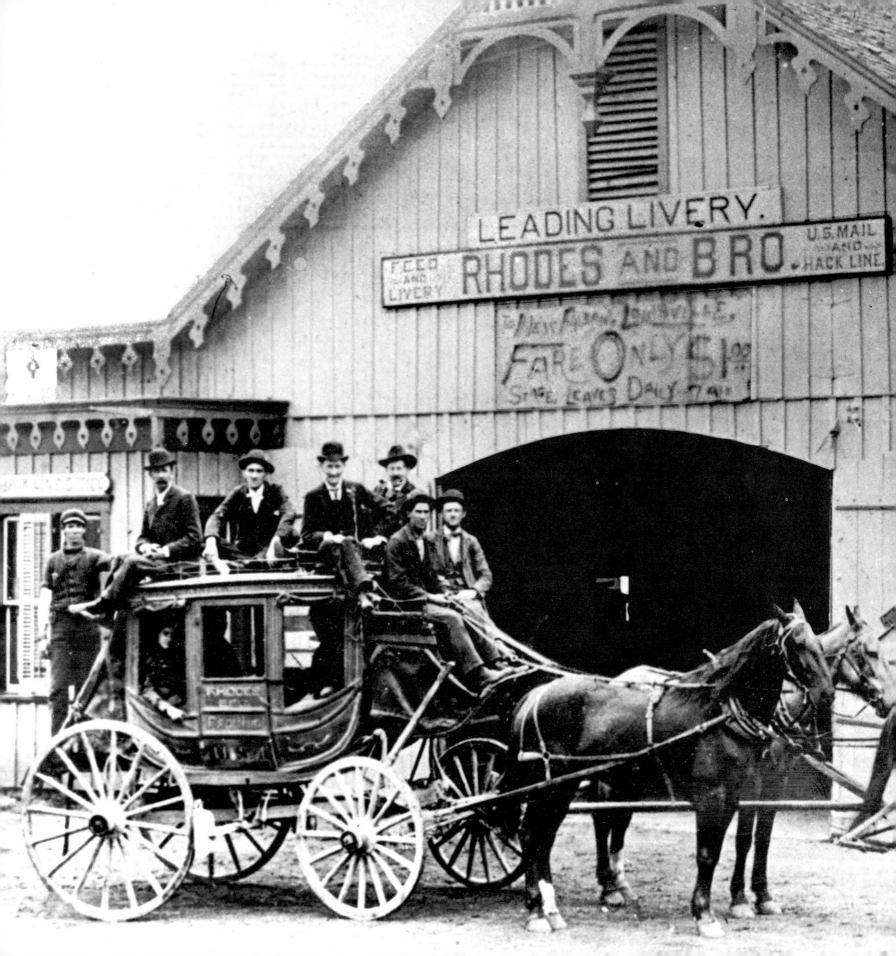

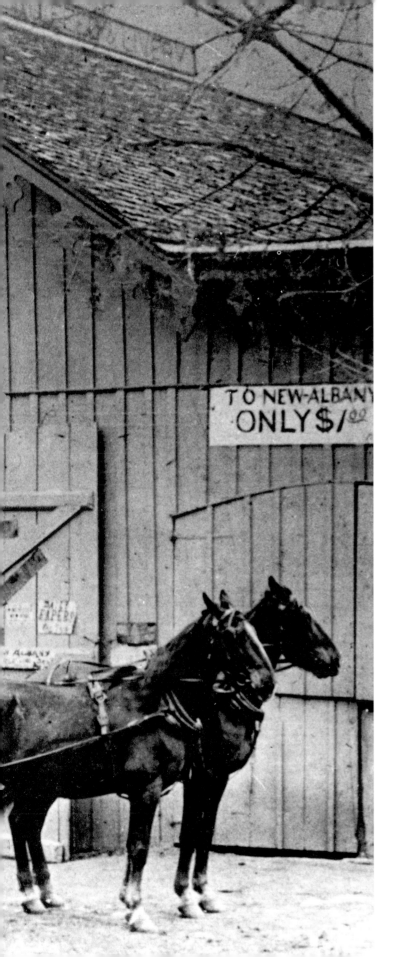

Passengers could travel to New Albany, Indiana on this stage coach for only $1.00 in the 1890s.

An 1892 view of the old Post Office and Custom House at the northeast corner of Fourth and Chestnut Streets. This building was razed in 1942, having been replaced in 1931 by a new Post Office on Broadway. Fourth Street is in the foreground.

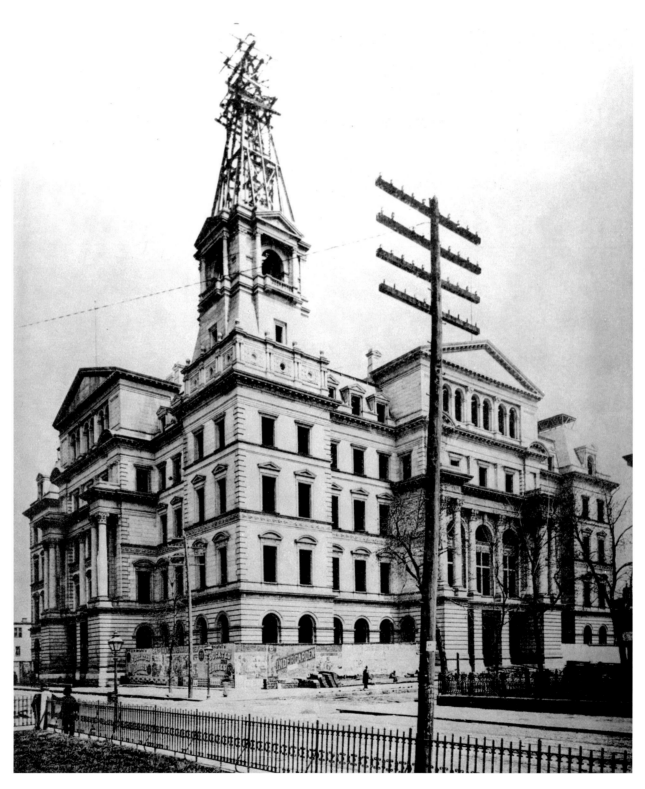

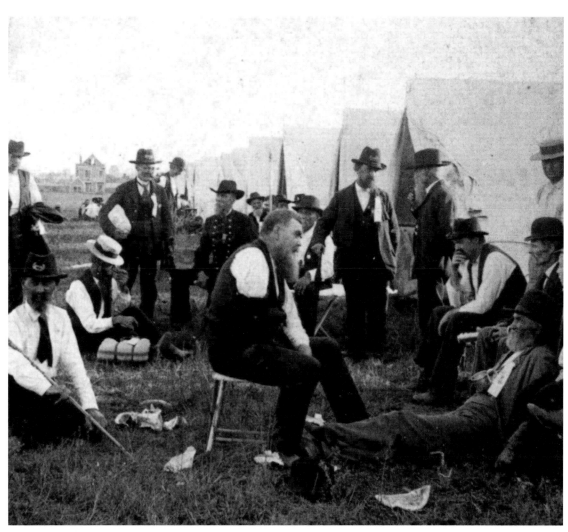

This souvenir view of the Louisville Encampment
of the Grand Army of the Republic in 1895 is titled
"Reminiscence: The Story of the Empty Sleeve."

The type of electric trolley car first used in Louisville,
photographed here in the 1890s.

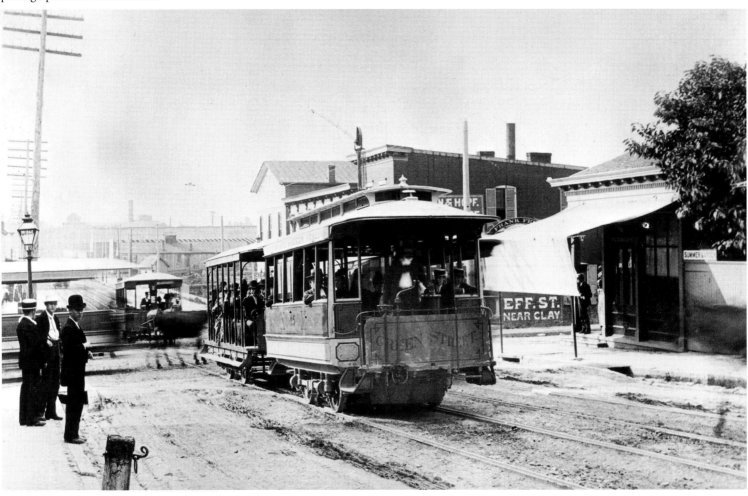

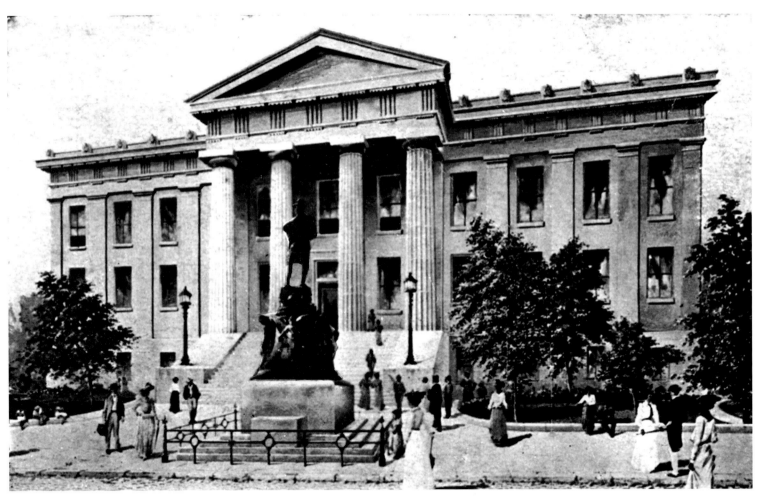

The Jefferson County Court House, on Jefferson Street
between Fifth and Sixth, in the 1890s.

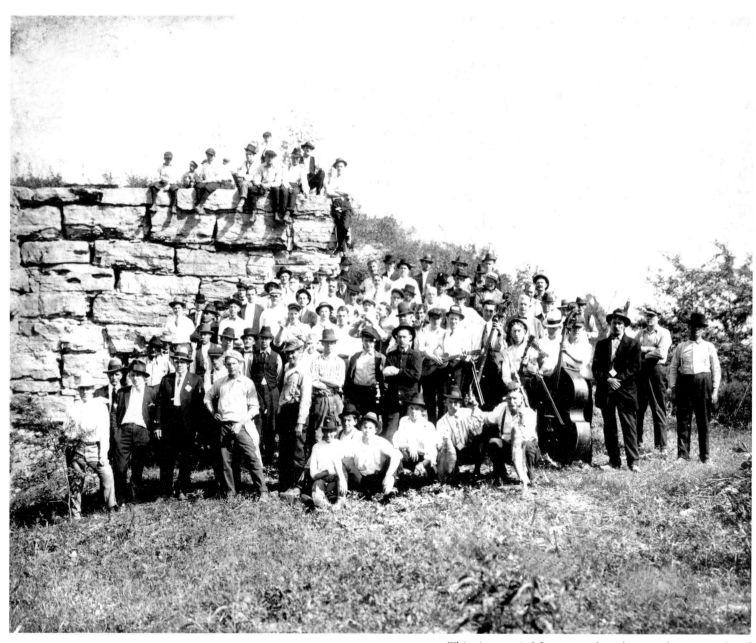

This view, copied from an earlier photograph, seems to be of a company outing in the country, complete with band.

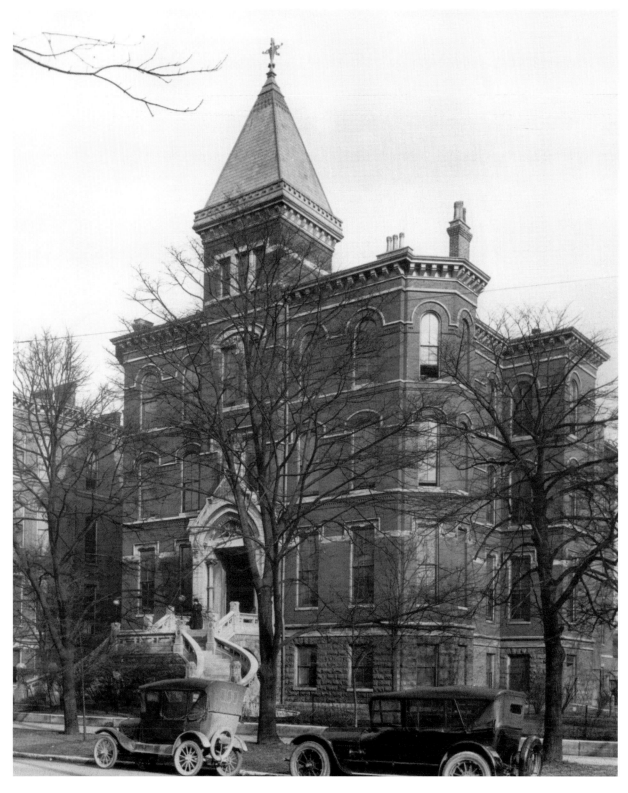

Norton Hospital began as a simple wing at Third and Oak Streets in the 1890s.

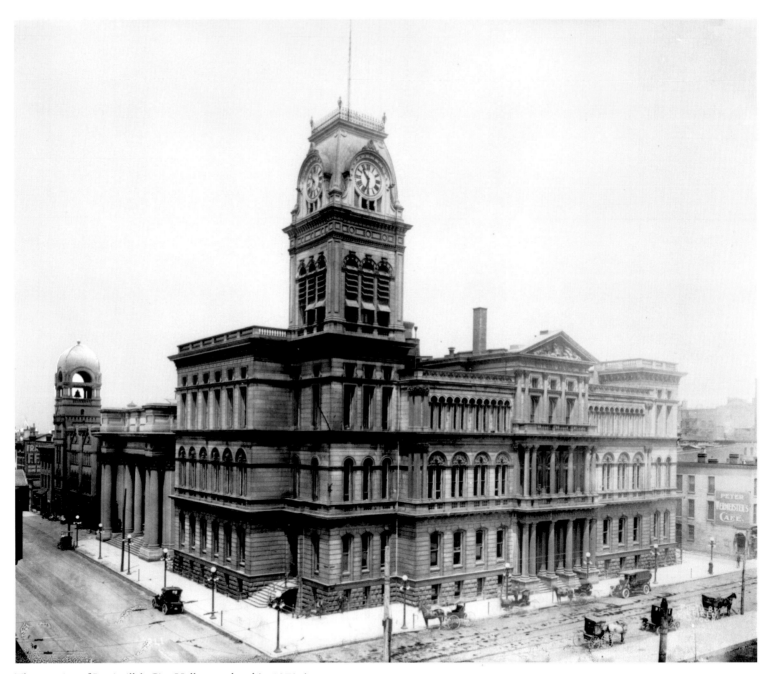

The exterior of Louisville's City Hall, completed in 1873, is decorated with bands of tobacco leaves and the carved heads of hogs, horses and cattle. Circa 1906.

The Beginning of a New Century to The End of World War I

1900–1919

At the beginning of the twentieth century, Louisville's population of 200,000 meant that it was larger than Atlanta, its largest southern rival, and was among the nation's twenty largest cities. It was also increasingly an industrial and manufacturing city, a fact trumpeted by its newspapers and city fathers.

The look of the city began to change, with commercial and office buildings replacing residences in the central city and denser residential areas springing up in what had been suburban retreats. Architectural firms such as D. X. Murphy (Jefferson County Jail, City Hospital), Mason Maury (Kaufman-Strauss Building, Kenyon Building), Brinton B. Davis (Jefferson County Armory, Kentucky Home Life Building), and Joseph & Joseph (Rialto Theater, Elks Club Republic Building) accounted for much of the change downtown. The development of the new Olmsted parks led to the construction of many fine homes surrounding Shawnee and Cherokee parks.

In 1902, Mayor Charles F. Grainger and prominent citizens met to plan a proposal to send to Andrew Carnegie, who had offered to build library buildings in cities that would agree to maintain and run them. Carnegie's reaction to Louisville's proposal was so favorable that money was received to construct both a main library and seven branches throughout the city.

The war in Europe necessitated construction of a major training facility, Camp Zachary Taylor, just southeast of the city along Poplar Level Road. The camp, which was constructed from June through August 1917, contained two thousand buildings spread over two thousand acres. At its peak in the summer of 1918, sixty-four thousand troops were stationed there. When it was designated a field artillery replacement depot in June 1918, it became the largest artillery training camp in the U.S. Its artillery school was transferred to Camp Henry Knox (Fort Knox) when the camp was closed in 1920.

Louisville's impressive street car system, begun with mule cars in the 1840s, was electrified at the turn of the century. This allowed the extension of Louisville's system of trolleys, leading to dramatic growth of suburban communities south and east of the city prior to 1920. Clifton, Crescent Hill, and Saint Matthews to the east and from Iroquois Park southward, all benefited. Trolleys also connected the city to southern Indiana, with lines crossing the Kentucky and Indiana Terminal Bridge to New Albany, and the Fourteenth Street Bridge and Big Four Bridges to Clarksville and Jeffersonville.

Automobiles were an increasing presence in the city, but railroads, trolleys, and ferries were still thriving at the start of the 1920s.

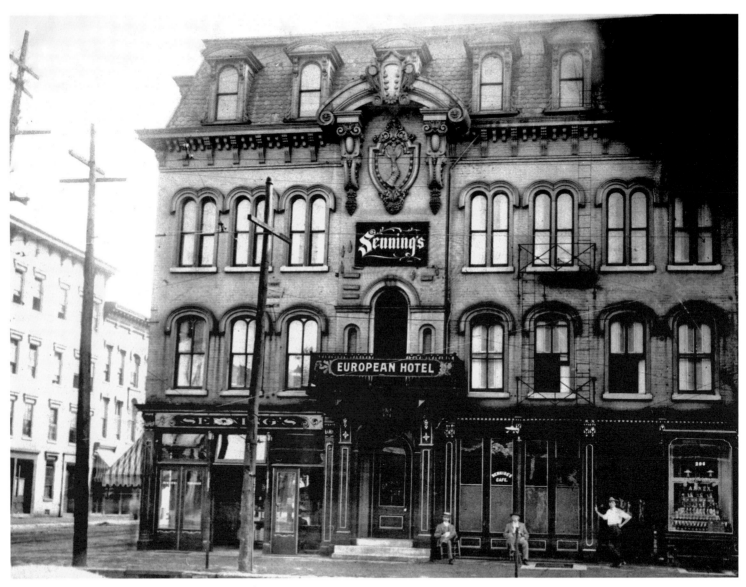

Sennings European Hotel and Restaurant opened in 1883. Circa 1900.

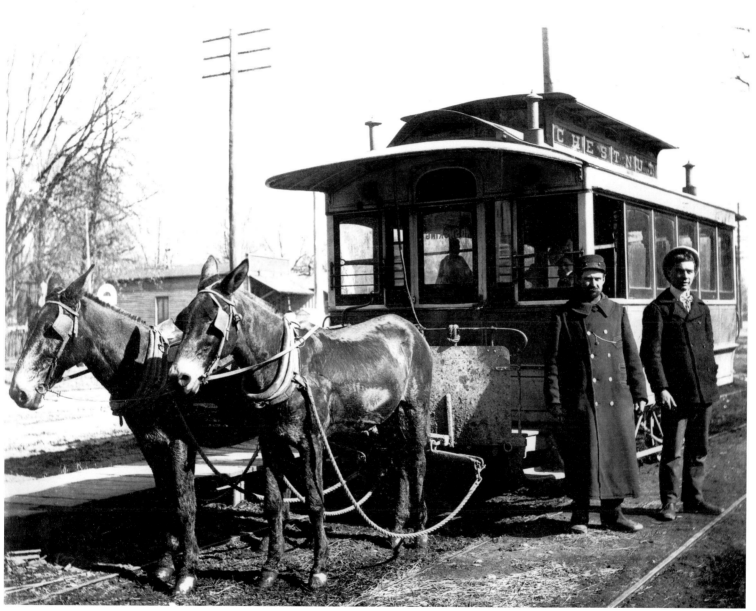

The last mule-drawn trolley car in service in Louisville, on the Chestnut Street line, photographed in 1901. Mule car service had begun in Louisville in 1844.

James (Jimmie) Winkfield won the Kentucky Derby aboard His Eminence in 1901 and Alan-a-Dale in 1902. He later raced in Europe for the Czar of Russia, fled the Russian Revolution with the Czar's horses and settled in Paris. He was forced to flee the Nazi invasion of France, returning again to America. He died in France in 1974, but made a final appearance at Churchill Downs in 1960 to celebrate his victories there. Circa 1902.

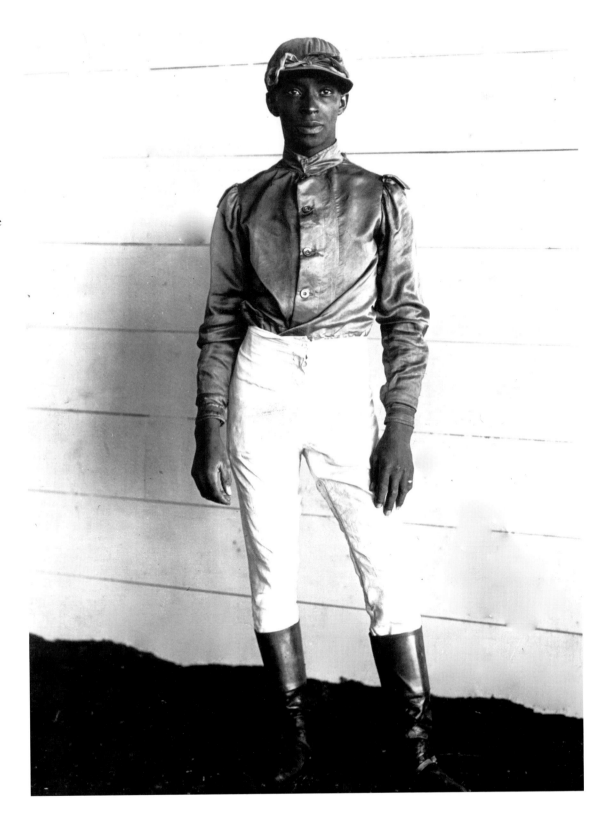

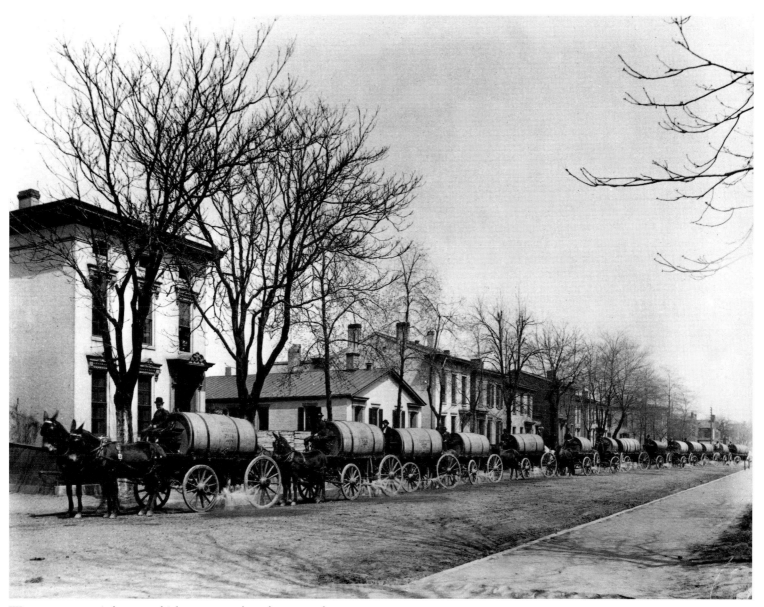

Water wagons carried water, which was sprayed on the unpaved
streets in the summers to keep down dust. Circa 1901.

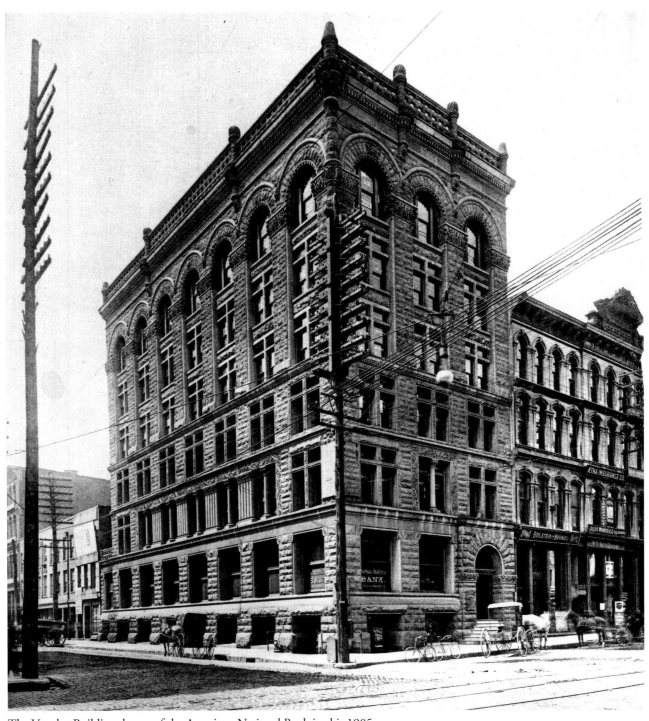

The Vaughn Building, home of the American National Bank in this 1905
view, was on the south west corner of Third and Main Streets.

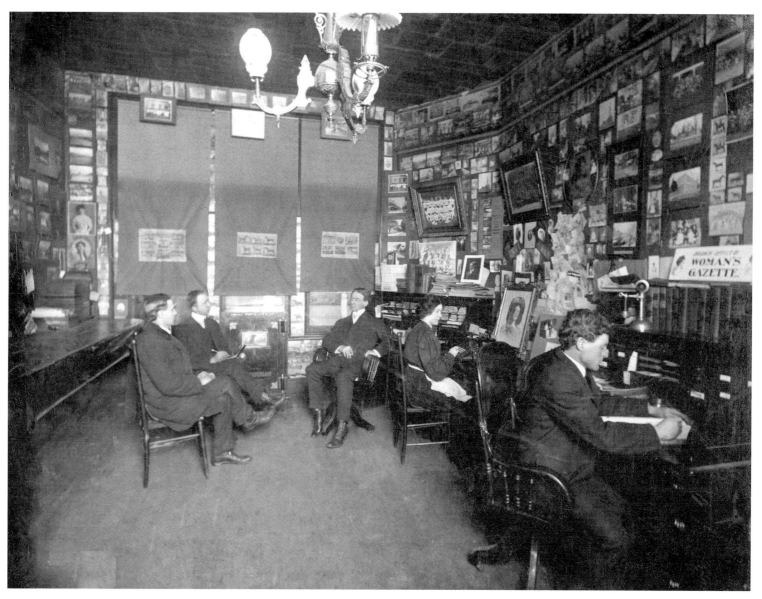

A business meeting in the offices of the Royal Photo View Company in 1905.

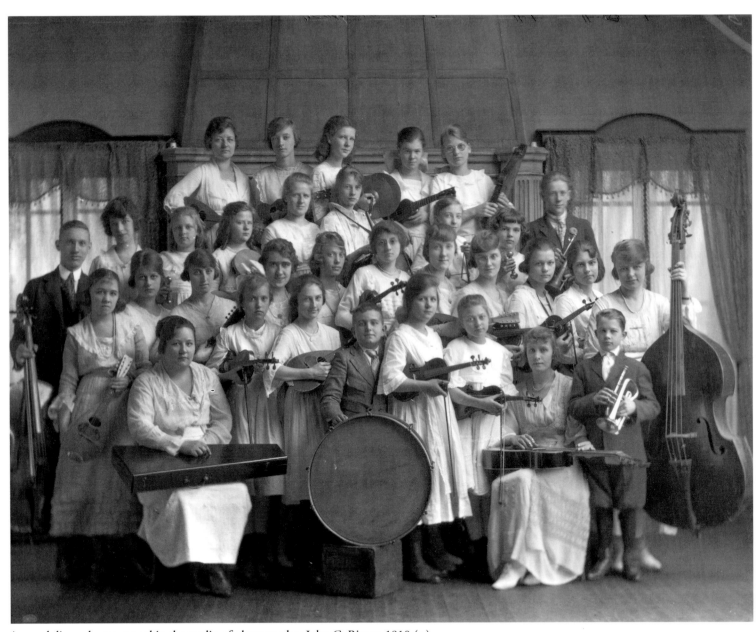

A mandolin orchestra, posed in the studio of photographer John C. Rieger. 1910 (c.)

A balcony of the Willard Hotel, 516-520 West Jefferson Street, was the site of an 1896 campaign speech by presidential candidate William Jennings Bryan. 1905.

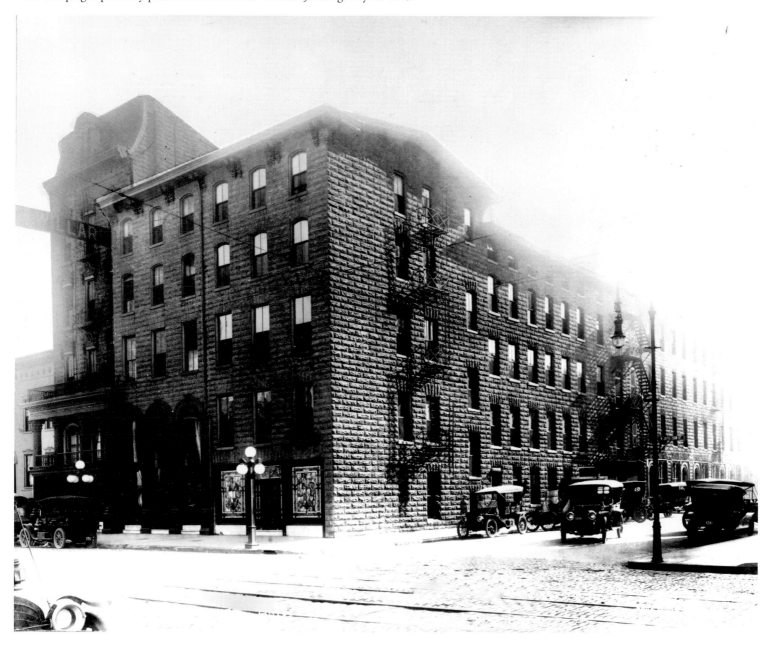

A camera club enjoys an outing in Seneca Park in 1910.

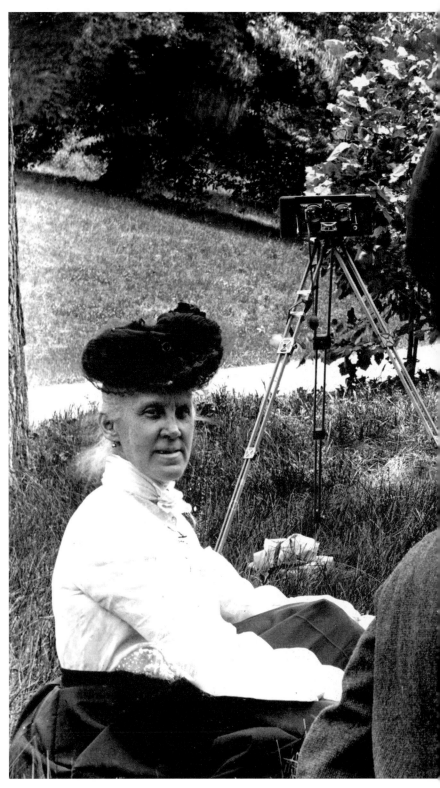

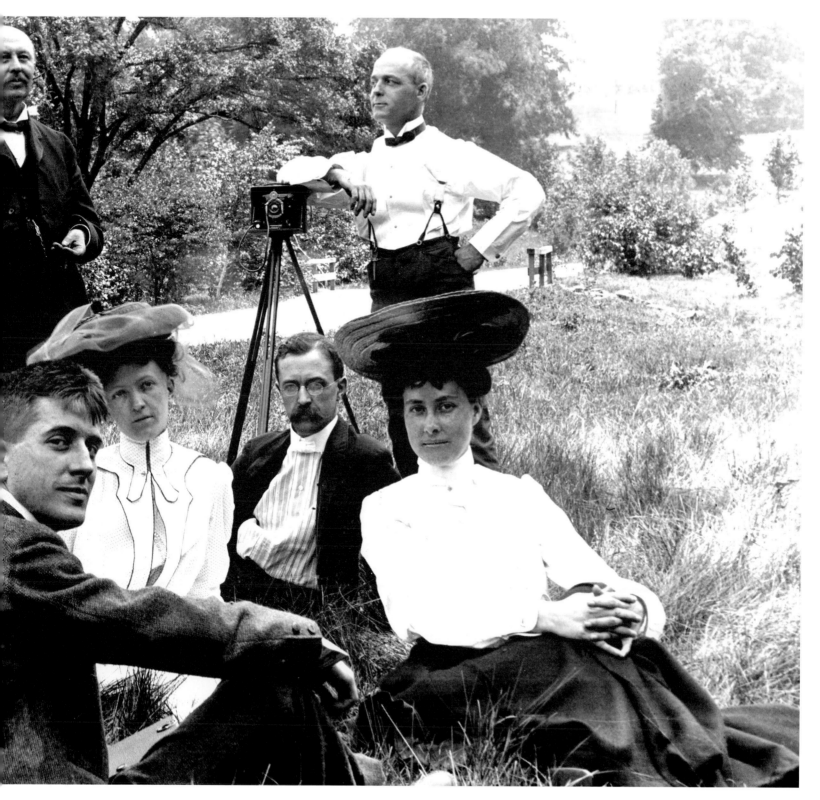

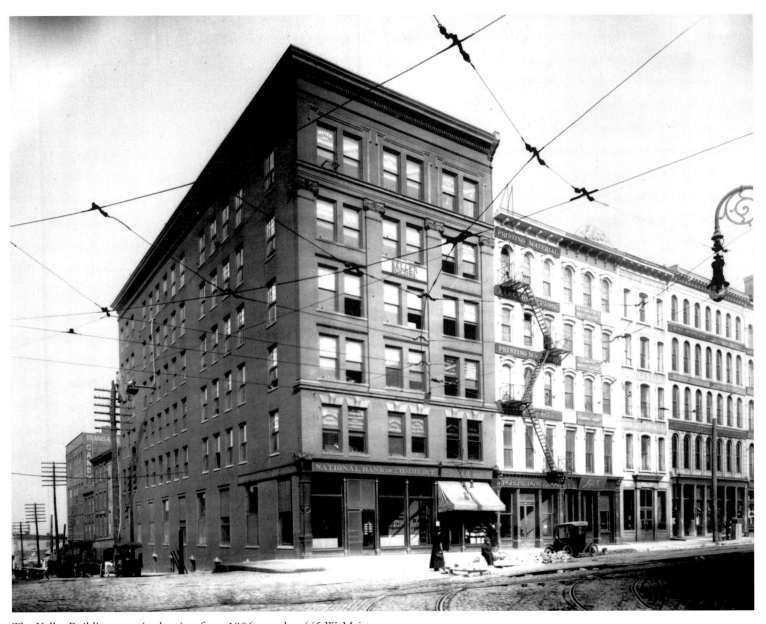

The Keller Building, seen in the view from 1906, stood at 445 W. Main.

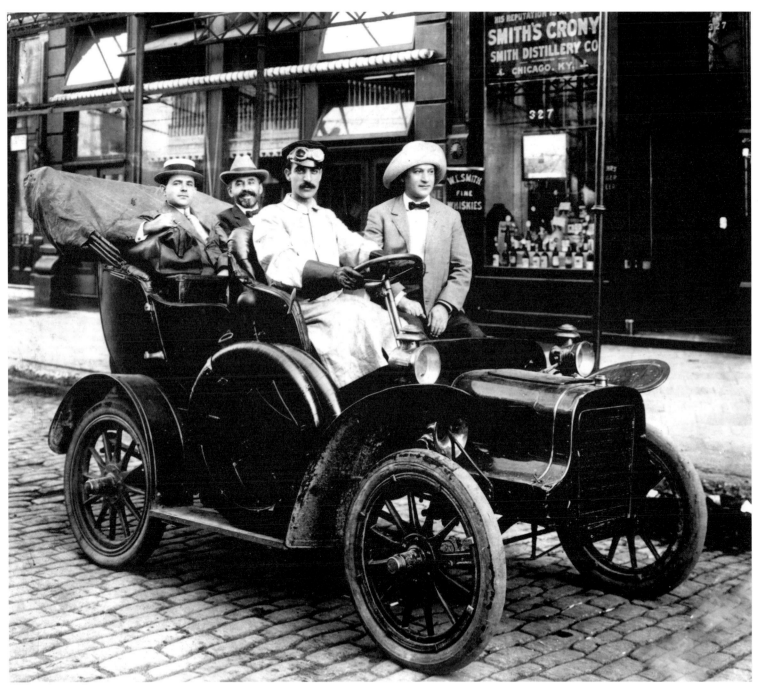

Louis Bramson, owner of the Royal Photo Studio, sets out with friends for an automobile outing in 1906. Mr. Branson is the man in the front seat with bow tie and hat.

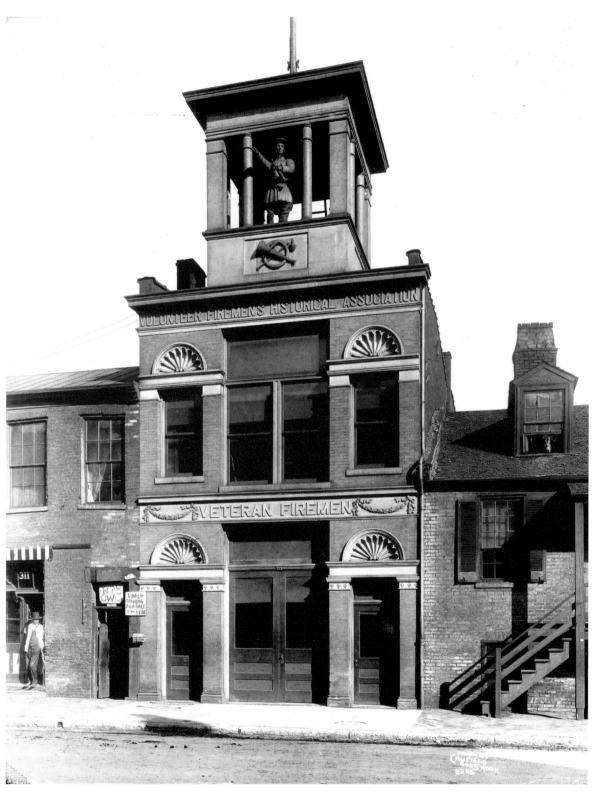

The Volunteer Firemen's
Historical Association, seen
here in about 1907, was at
313 S. First Street.

58

Jefferson County Court House, circa 1907.

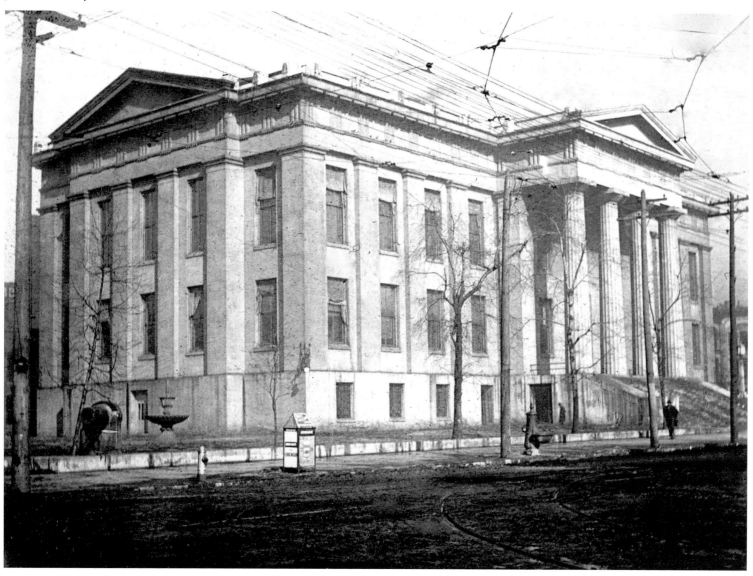

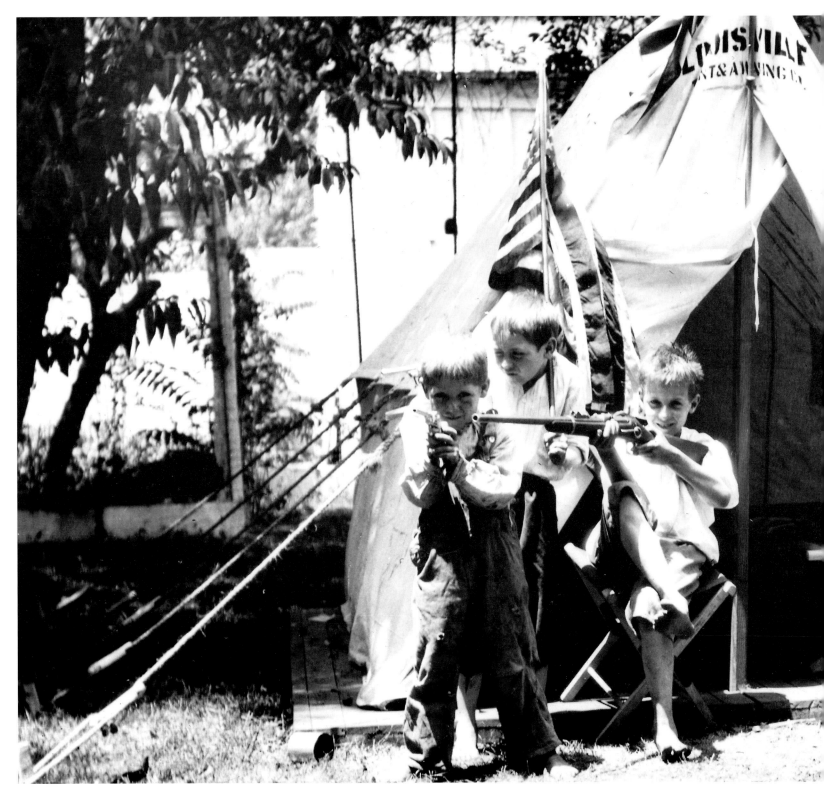

Jacob Bennett, Charles Henry Bennett, Nutall Fisher, Thatcher Hoertz and Sanford Strother played soldiers in their camp in the Strother back yard at 1125 South Brook Street. Circa 1910.

Frederick Douglas Debate Team
at the Western Branch Library.
Circa 1910.

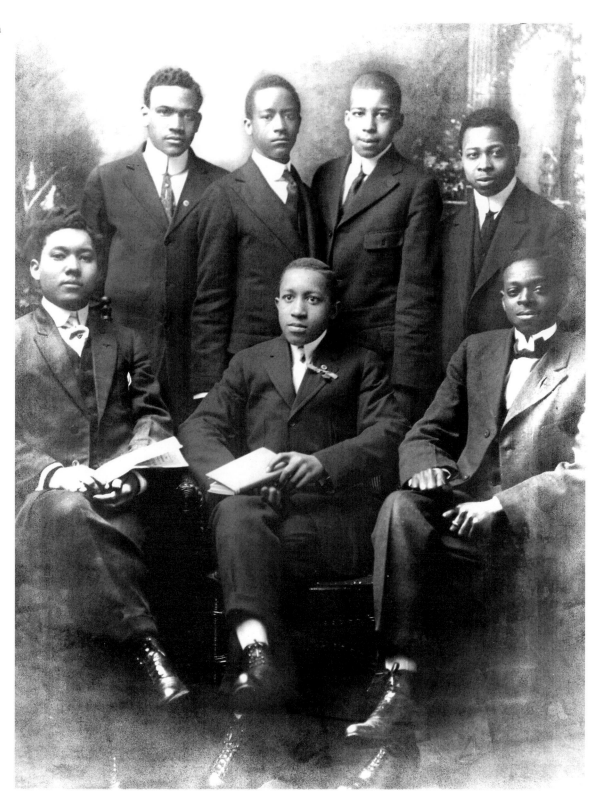

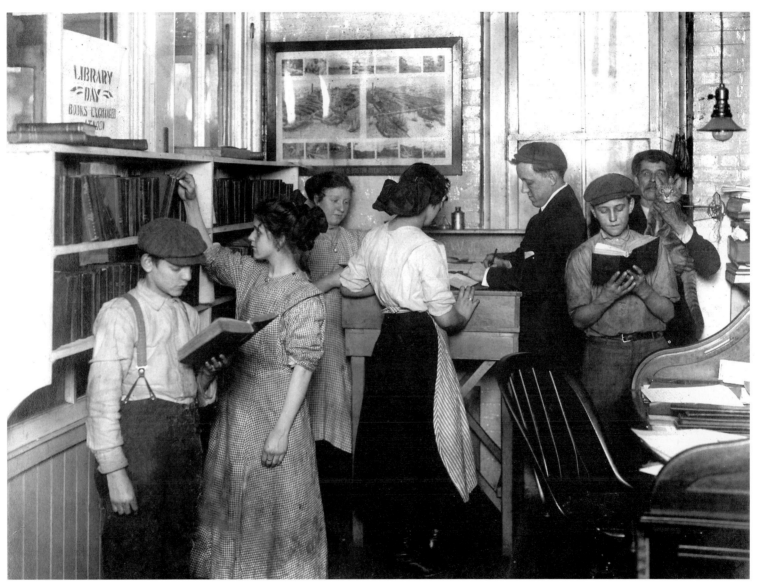

Workers borrowing books from the lending library
at the Louisville Cotton Mills. Circa 1915.

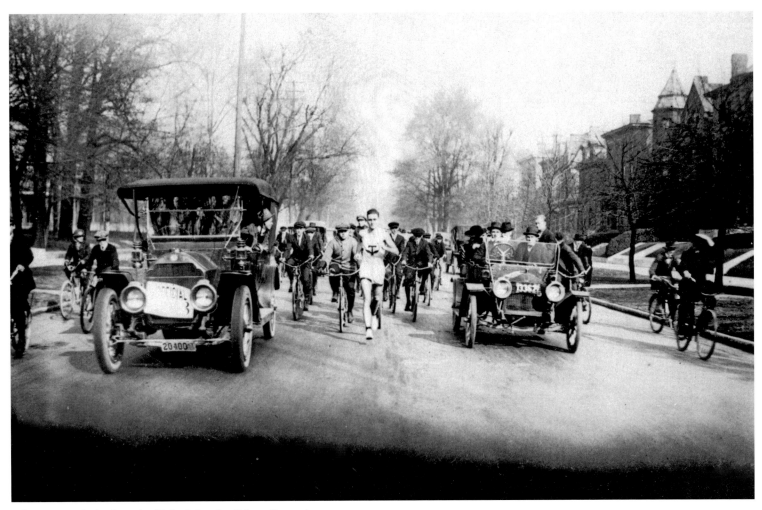

Ed Dravenstedt, leading the "Baby Marathon" from Iroquois
Park to downtown on Thanksgiving morning in 1914. Mr.
Dravenstedt's father is third from left in the car at the right.

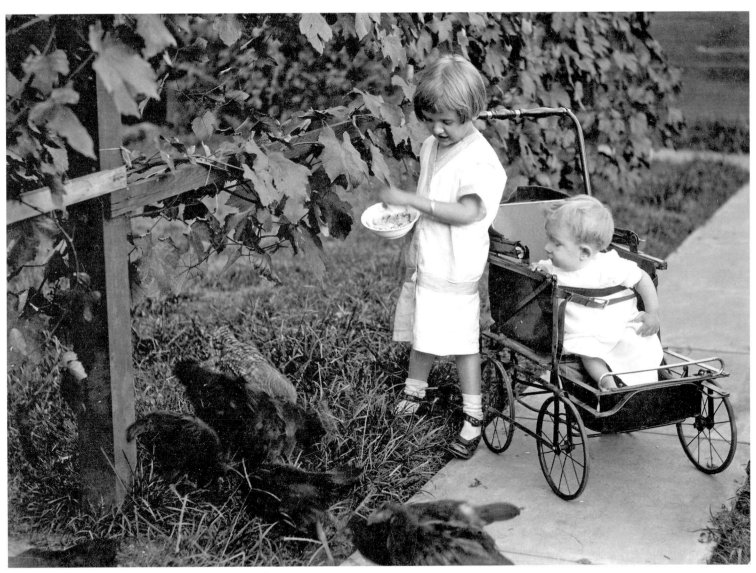

Virginia and John C. Rieger (children of photographer
John C. Rieger) feeding the chickens in the back yard of
their home at 1920 Duker Avenue. 1914.

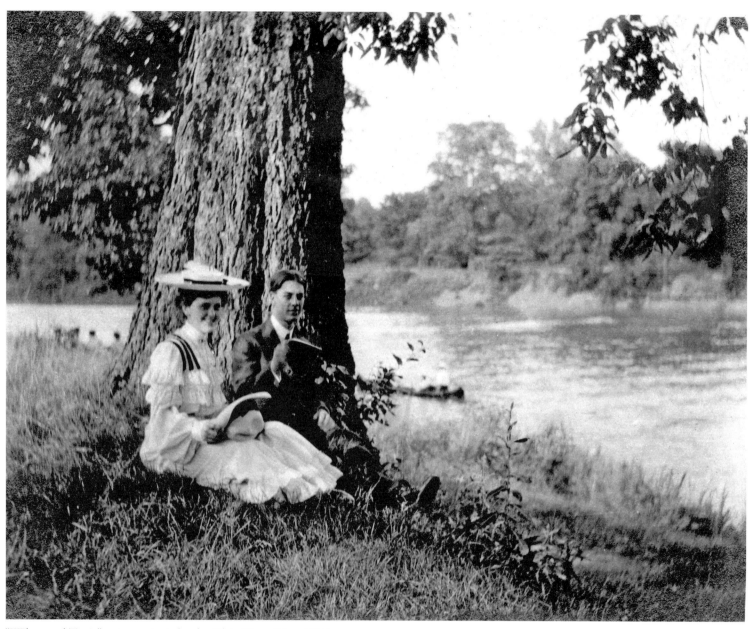

"Wilma and Tersie" enjoy a picnic by the Ohio River. Circa 1917.

The Carter Dry Goods Company Building, in the
700 block of West Main Street, is now the home of
the Louisville Science Center. 1919.

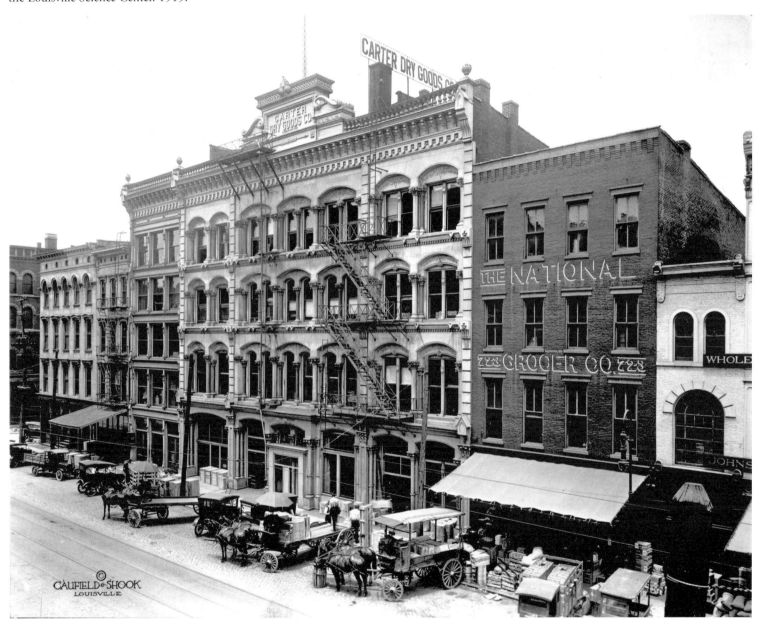

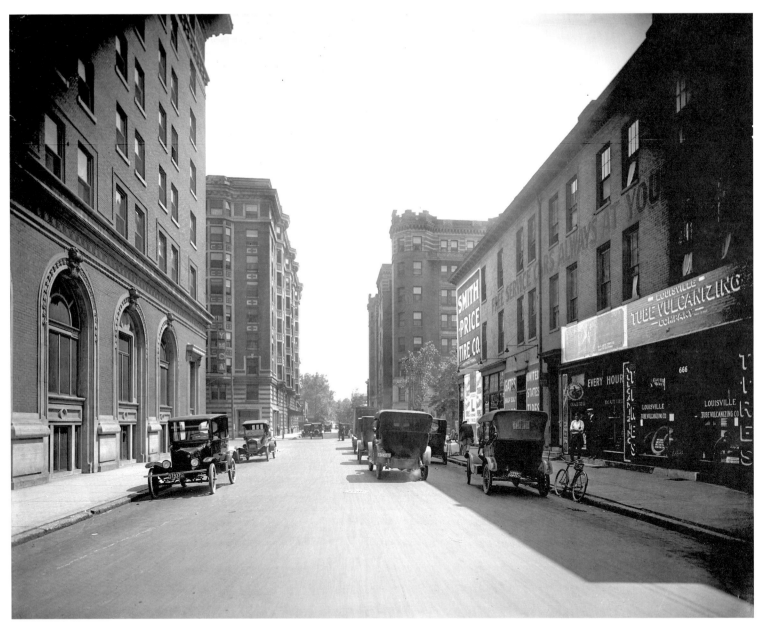

Third Street, looking south from just north of Broadway in 1919. The YMCA is at left and the two large buildings on the opposite side of Broadway are the Weissinger Gaulbert Apartments.

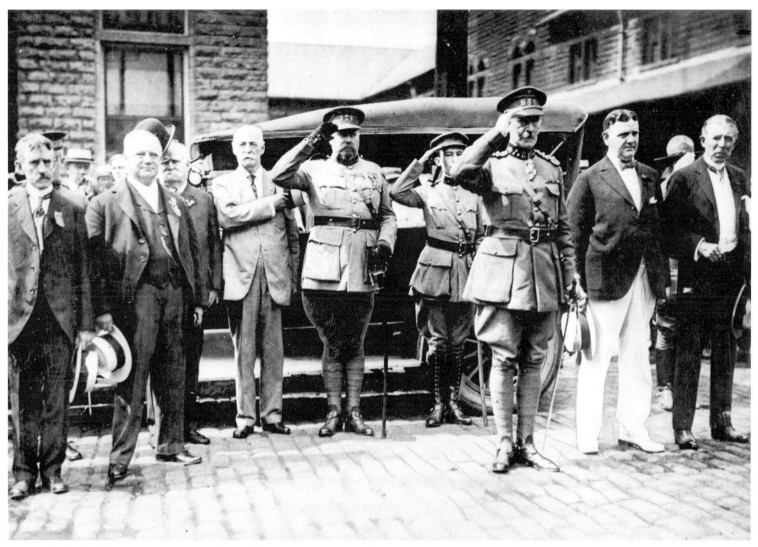

A wagonload of celebrants mounts up in front of the Citizen Union Bank in preparation for the Armistice day parade on November, 11, 1918 at the end of World War I.

This unidentified family lived in Louisville's Parkland neighborhood in 1919.

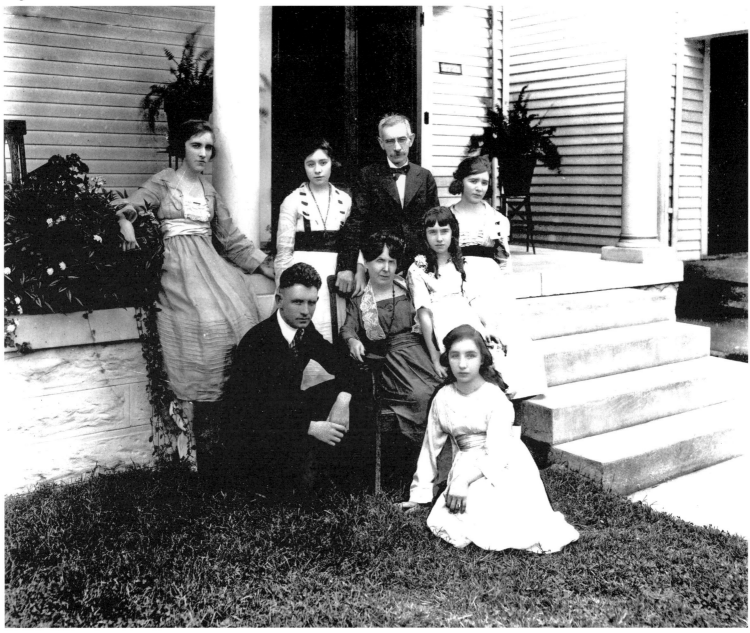

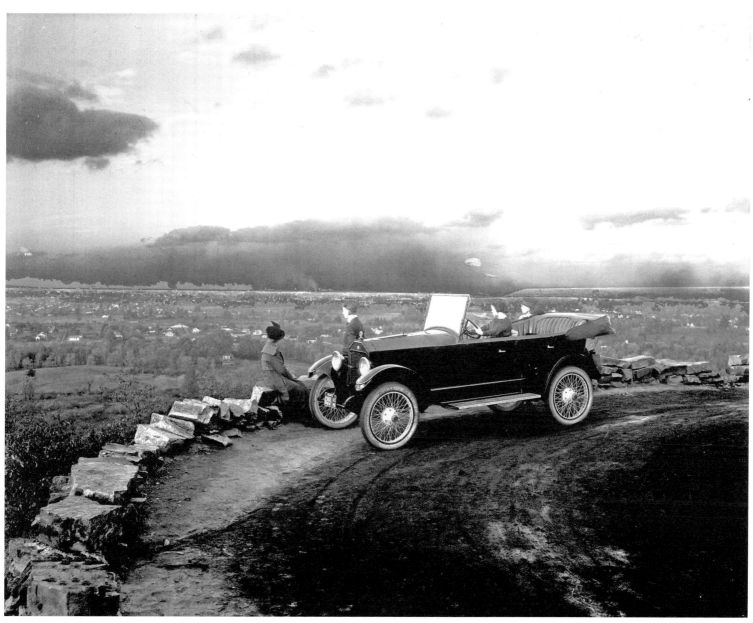

The Dixie Flyer, an automobile built in Louisville, is seen at the Iroquois Park
lookout in this 1919 view.

Looking East on Market Street between 4th and 5th Streets. 1921.

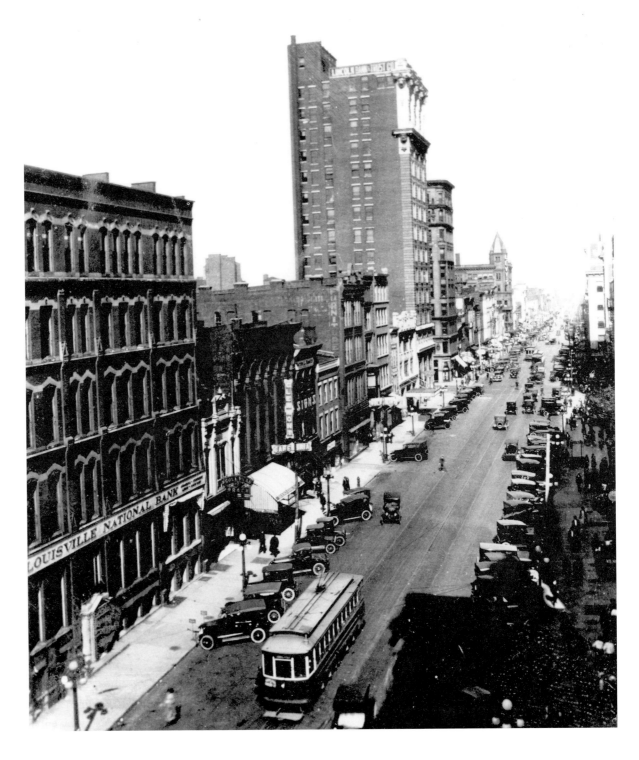

A City Between World Wars

1920–1939

Although Louisville continued to grow in population, the rate of increase began to decline. This could in part be attributed to the growth of suburban areas. Efficient trolley and interurban service to these areas made it possible to work downtown but live in semi-rural communities. Once again annexation was exercised by the city, this time to add some eleven square miles to its boundaries.

Industrial growth slowed during these decades, leading to many efforts to improve the city's economy and to a good deal of "boosterism" to promote the city and its central location within the continental United States. The Board of Trade launched a "Million Dollar Factory Fund" to raise private funding for loans to promising manufacturers. One of the more notable successes was a small cleaning-powder manufacturer lured from Virginia, which eventually became the Reynolds Metals Company.

Louisville's first airport was built in 1919, when flying enthusiast Abram H. Bowman leased fifty acres east of the city and built a wooden hangar. In 1929, Louisville's first bridge across the Ohio built exclusively for automobiles was completed between Second and Main Streets in Louisville and Illinois Avenue in Jeffersonville, Indiana. That same year saw other major changes in the Ohio River at Louisville. The Louisville Gas & Electric Company completed a hydroelectric dam across the falls, and in October President Herbert Hoover visited the city to celebrate the completion of a rebuilt canal around the falls.

Louisville had been a city of breweries since the influx of German immigrants in the middle of the nineteenth century, and was the center for the distilling of bourbon whiskey. Prohibition forced the closing of twelve breweries and more than thirty distilleries, with a total loss of 6,000 to 8,000 jobs, a significant blow to the city's economy.

The city was to suffer another catastrophe in January and February 1939, when one of the greatest floods in United States history put more than 60 percent of the city under water. After a state of emergency was declared, 230,000 people were evacuated to higher ground. Homes and businesses were destroyed and 90 people died. Nearly twenty inches of rainfall in January, the most ever, kept the river above flood stage for twenty-three days.

This crowd at Twelfth and Main enjoys a keg of beer just prior to the start of prohibition in January, 1920.

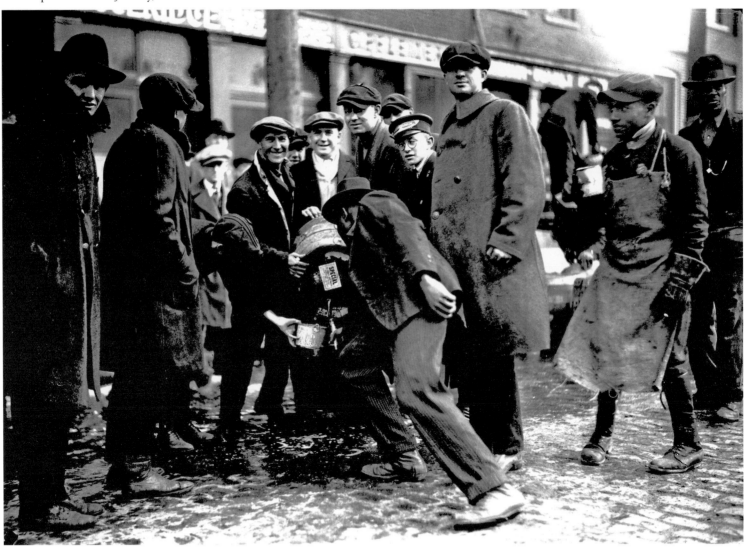

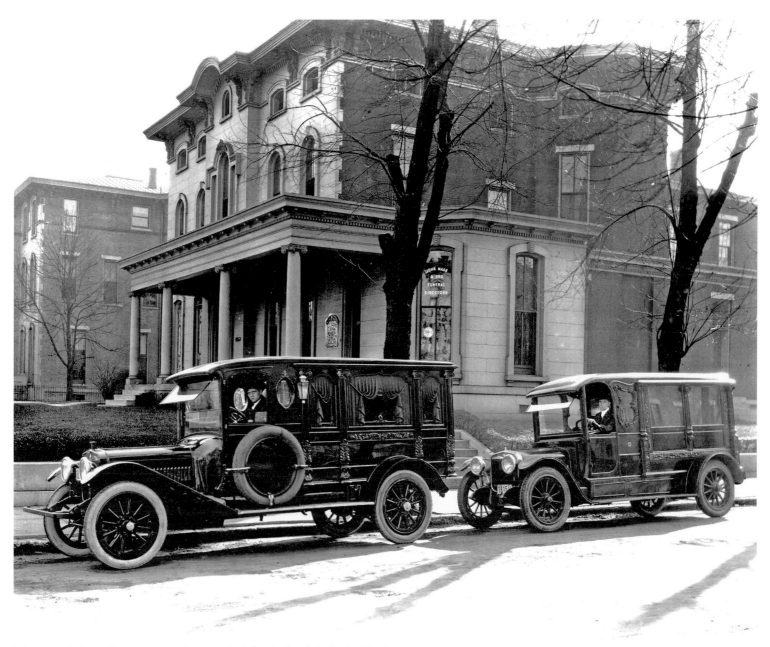

These new Winton hearses were photographed for the local dealer beside the
John Haas and Bro. Funeral Home, 300-302 E. Broadway, in 1920.

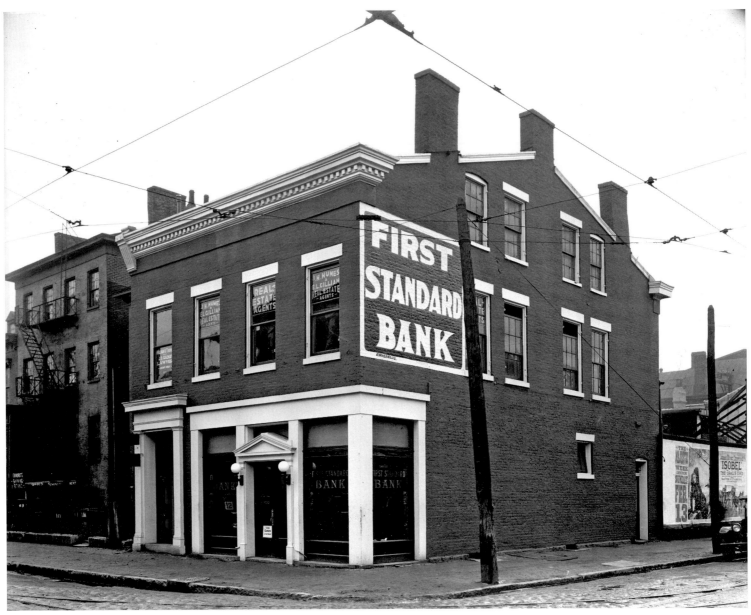

The First Standard Bank, at Seventh and Walnut, was an African American-owned business in the 1920s. 1921.

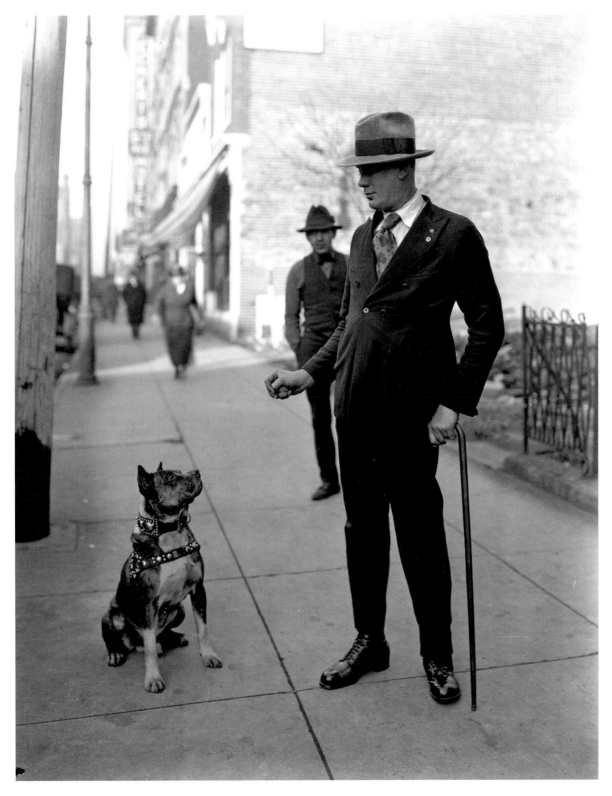

This blind newsstand owner was photographed for the *Louisville Times* in 1920.

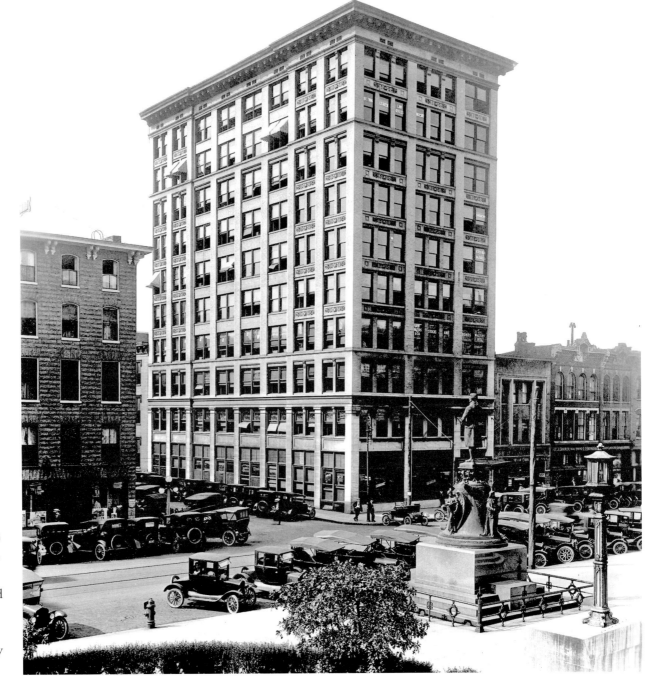

This bronze figure of Thomas Jefferson by Sir Moses Jacob Ezekiel (1844-1917) was presented to the people of Kentucky by Isaac and Bernard Bernheim, in 1901. It stands in front of the Jefferson County Courthouse. 1921.

These gentlemen enjoy a home-brewed beer and a
sunny back yard in 1921.

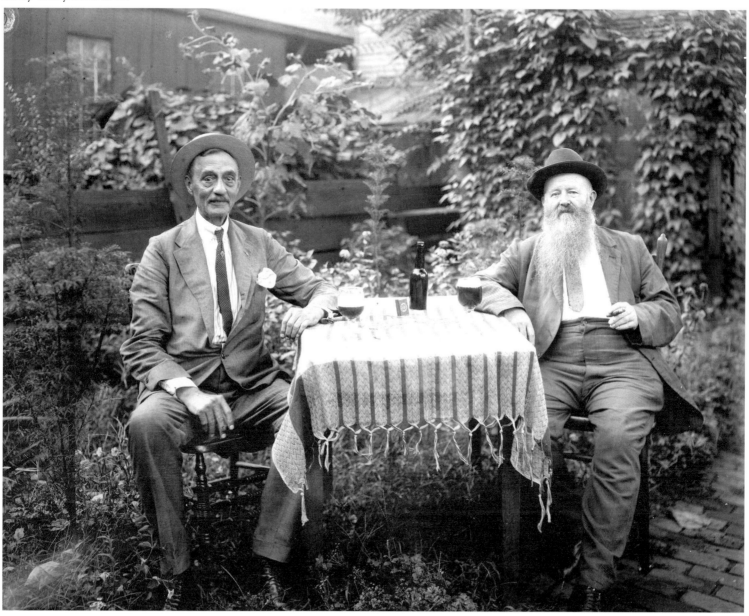

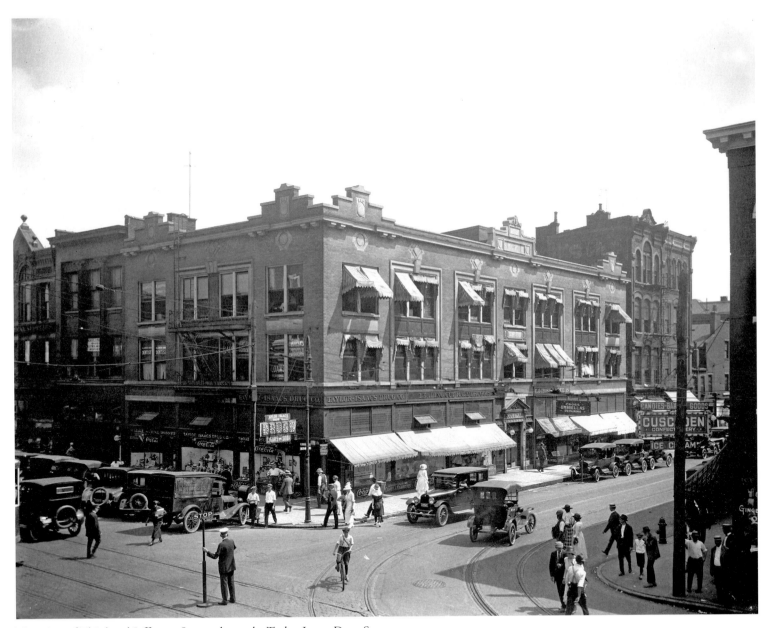

This view of Third and Jefferson Streets shows the Taylor-Isaacs Drug Store and Cuscaden's Confectionary. Cuscaden's was famous for the invention of brick ice cream. 1921.

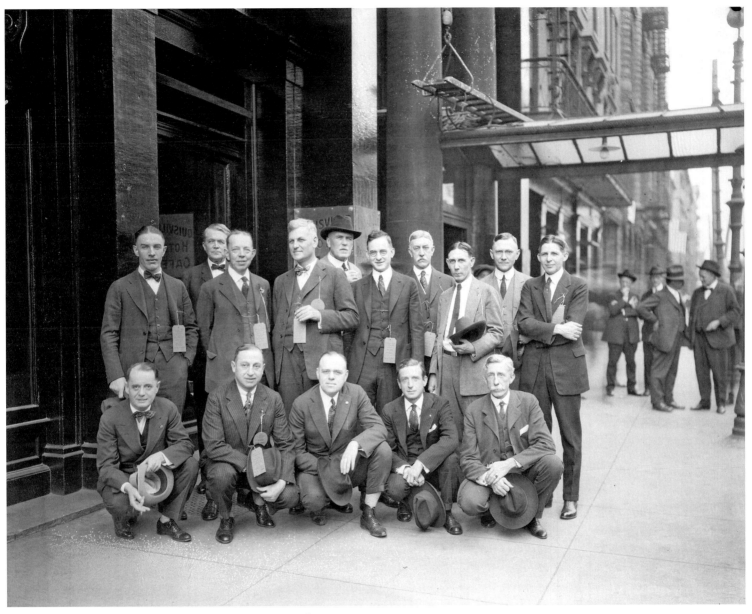

This photograph was taken for the *Evening Post* newspaper during
a "Main Street Celebration" in April, 1921.

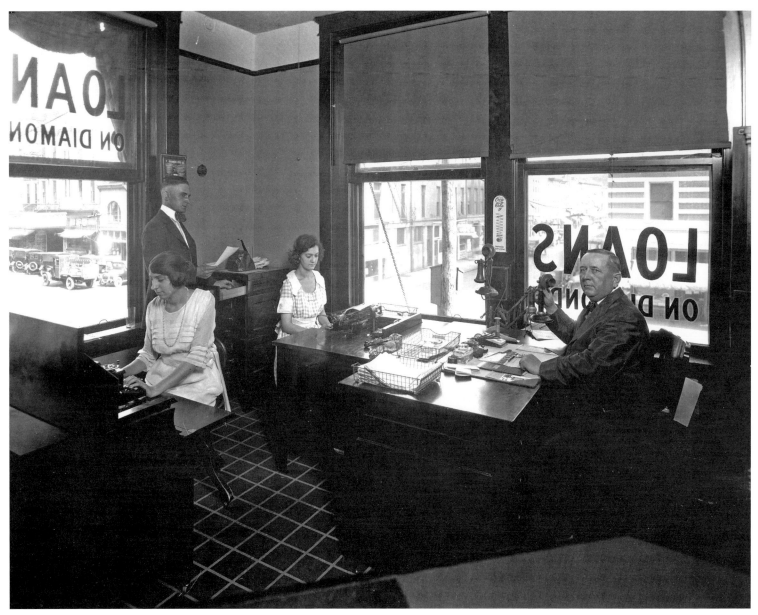

Office workers at People's Provident Association (insurance,) Third and
Jefferson, in 1921.

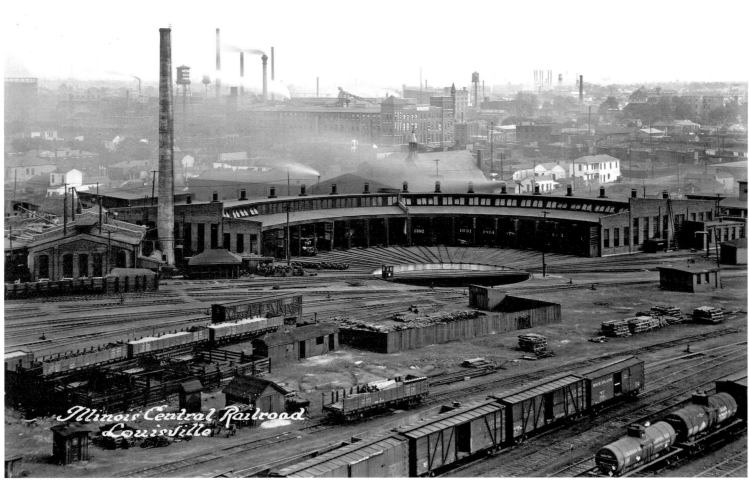

The Illinois Central Railroad roundhouse, near Thirteenth and Oak Streets in 1921.

This replica of a pioneer log cabin was exhibited at the
Kentucky State Fair in 1923.

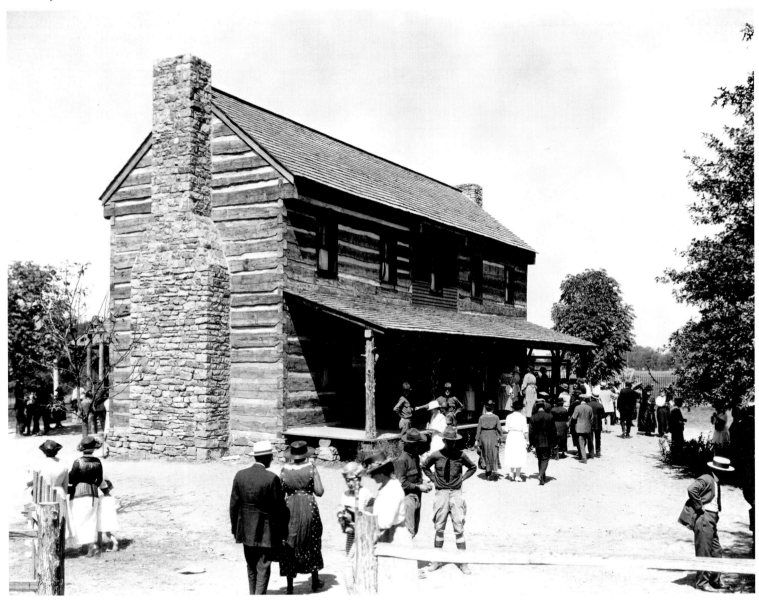

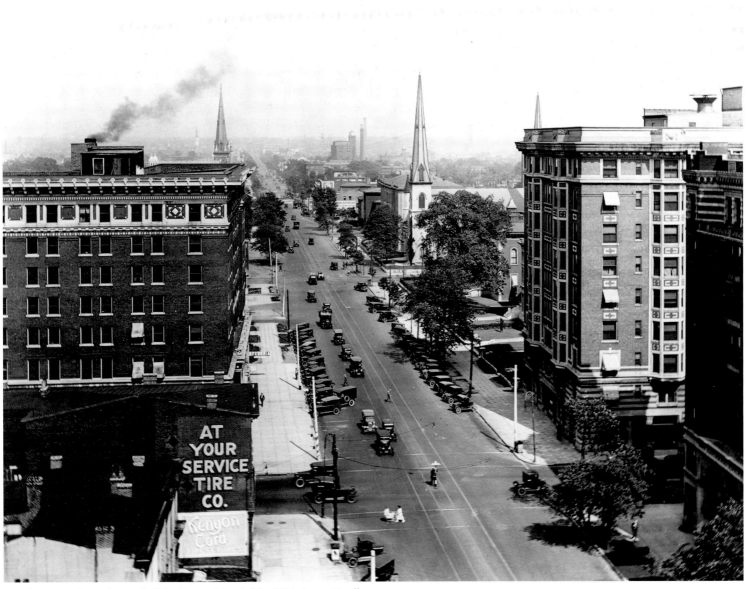

Broadway east from the roof of the Brown Hotel. The Weissinger-Gaulbert Apartments, Third and Broadway, are at right. Farther east, at Second Street, is the spire of the Second Presbyterian Church. 1923.

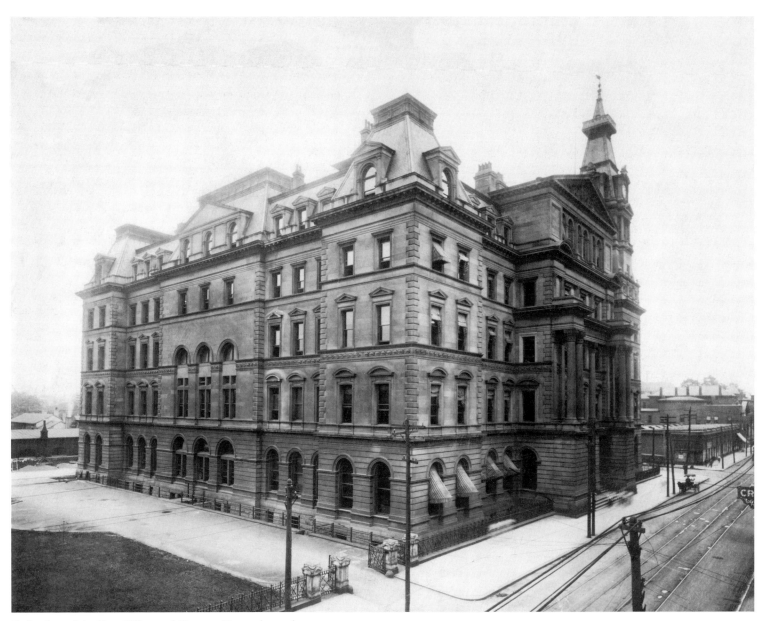

Early view of the Post Office and Custom House, located on
Fourth Street between Chestnut (background) and Guthrie
Streets. Circa 1925.

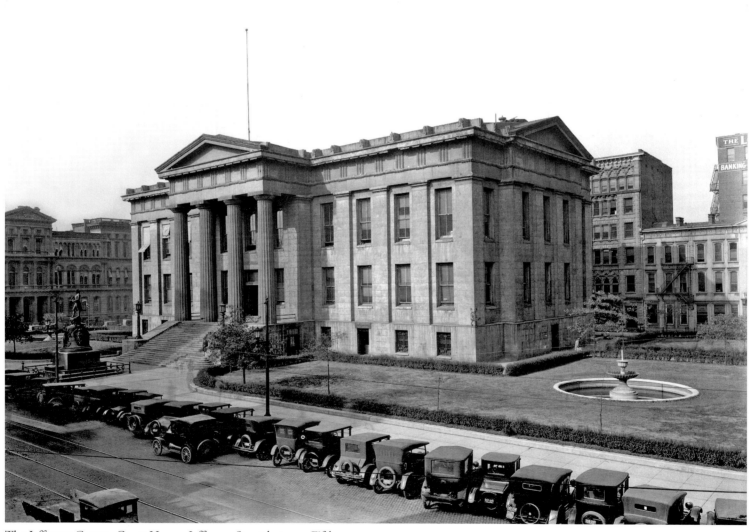

The Jefferson County Court House, Jefferson Street between Fifth
and Sixth. Louisville's City Hall is at left. 1925.

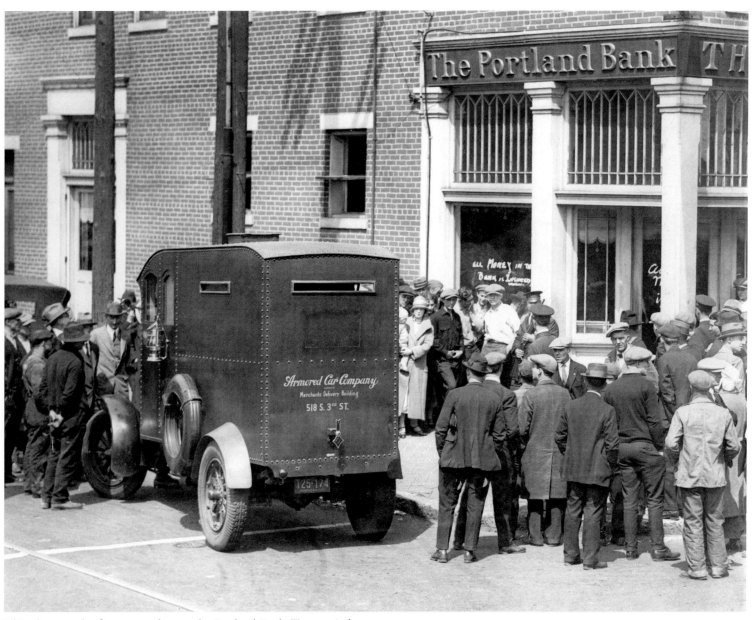

This photograph of an armored car at the Portland Bank, Twenty-sixth
and Bank Streets, was made for the *Courier-Journal* in 1925.

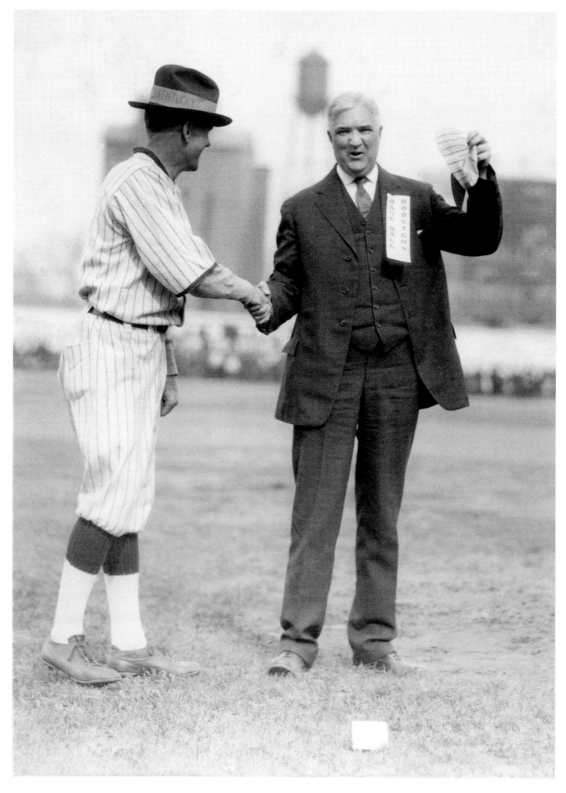

Nick Cullop, Louisville Colonels pitcher and future major leaguer, greets Mayor Huston Quinn on opening day in 1925 at Parkway Field.

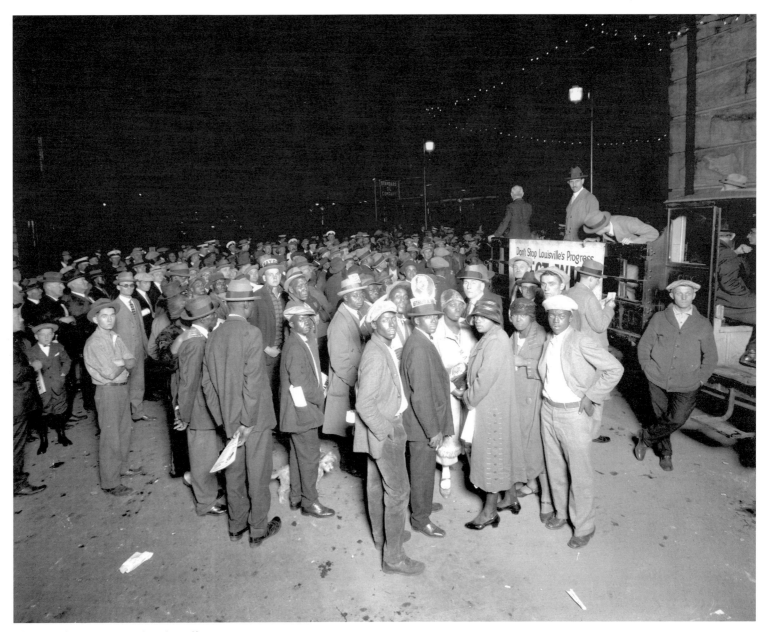

This October, 1925 crowd at the Jefferson
County Armory, awaits a speech by mayoral
candidate Arthur A. Will.

First Street, looking south from Kentucky Street in 1926.
The houses seen at the right are now the site of the Victor H.
Engelhard Elementary School.

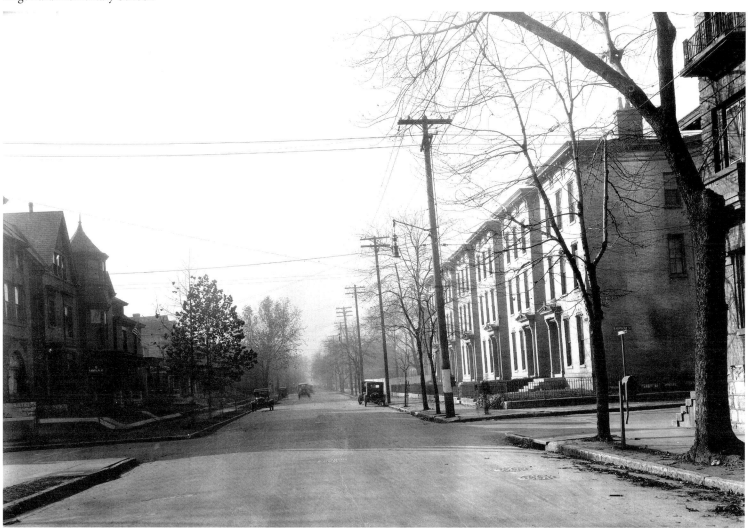

Grand Stairway, Rialto Theater, 616 S. Fourth Street. Modeled on the Capitol Theater in New York City, the Rialto, built in 1921, was promoted as Louisville's "Million Dollar Theater." 1921.

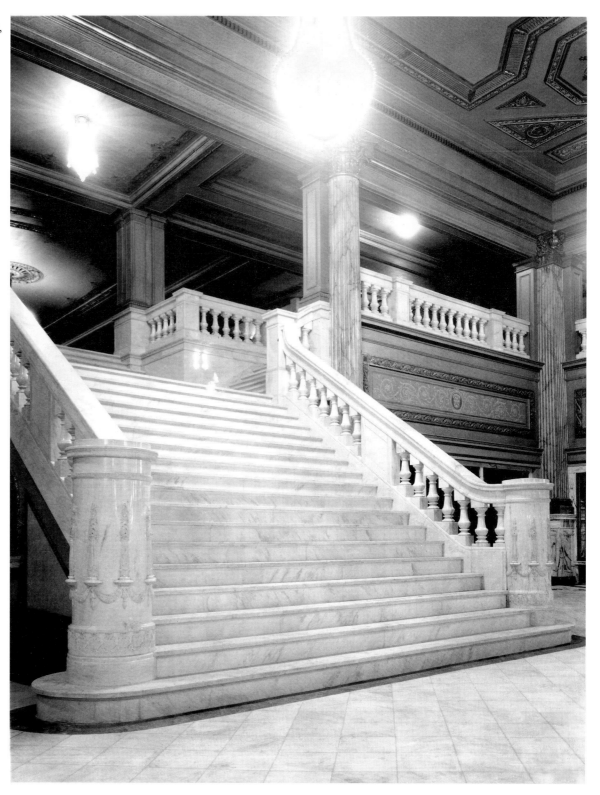

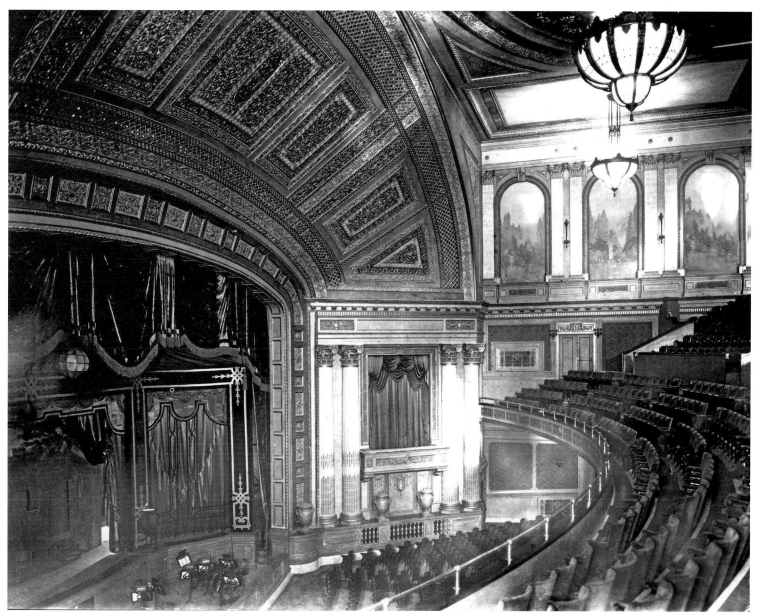

The auditorium of Louisville's Rialto Theater, 616 S. Fourth Street, showing the stage and screen. Interior decorations of the Rialto, built in 1921, included terra cotta tiles from the Rookwood Pottery in Cincinnati. The auditorium could seat 3,500 people. The theater was torn down in 1969.

Table settings and glassware crowd the window of Fourth Street's F. W. Woolworth five-and-ten-cent store in 1926.

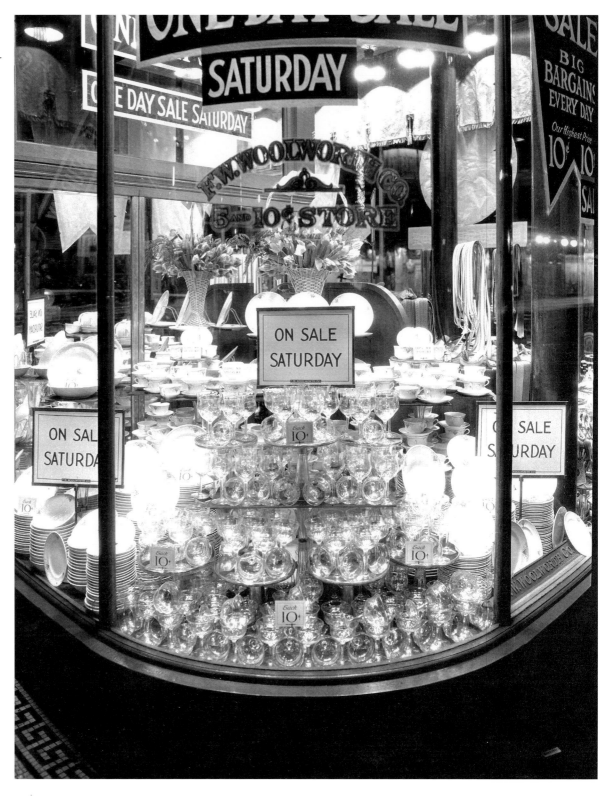

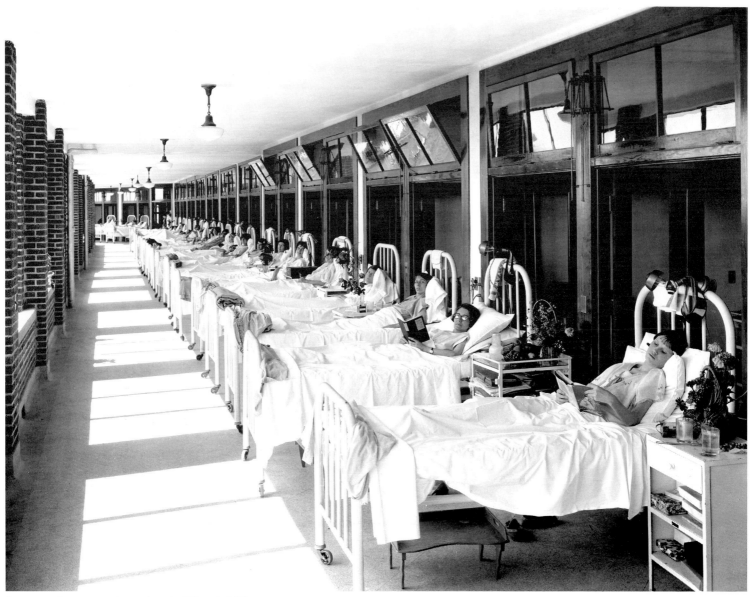

Sun room in a women's ward at the Waverly Hills (tuberculosis) Sanitarium, located south of the present Pleasure Ridge Park. 1926.

Short's Tire Service's road crew seems ready to
serve, even if facing the wrong way. 1926.

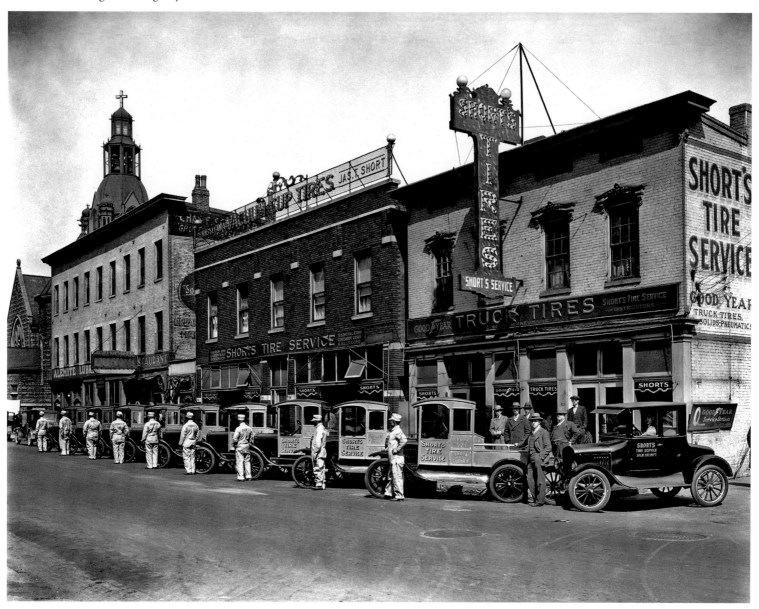

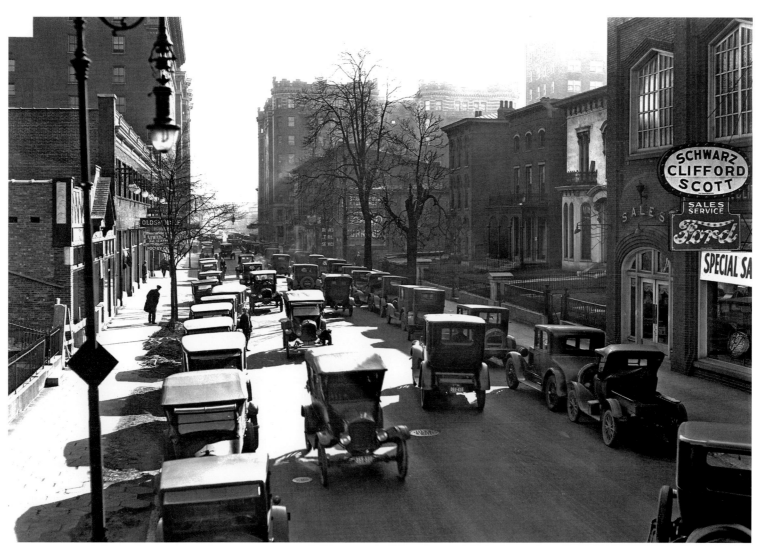

Third Street, looking south from Chestnut, seems as busy in this
1926 view it is today. The Weissinger-Gaulbert Apartments can be
seen in the background at Third and Broadway.

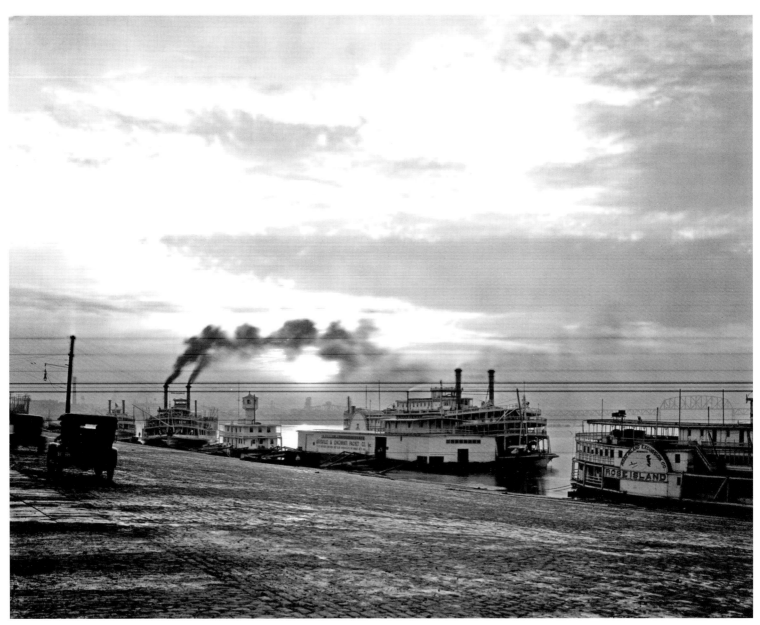

The Louisville wharf is crowded with steamboats in this 1927 view. The excursion steamer "Rose Island," which carried day-trippers to the upriver amusement park of the same name, is at right.

Ford salesman R. G. Potter, left, shows off one of his models to a prospective couple. 1927.

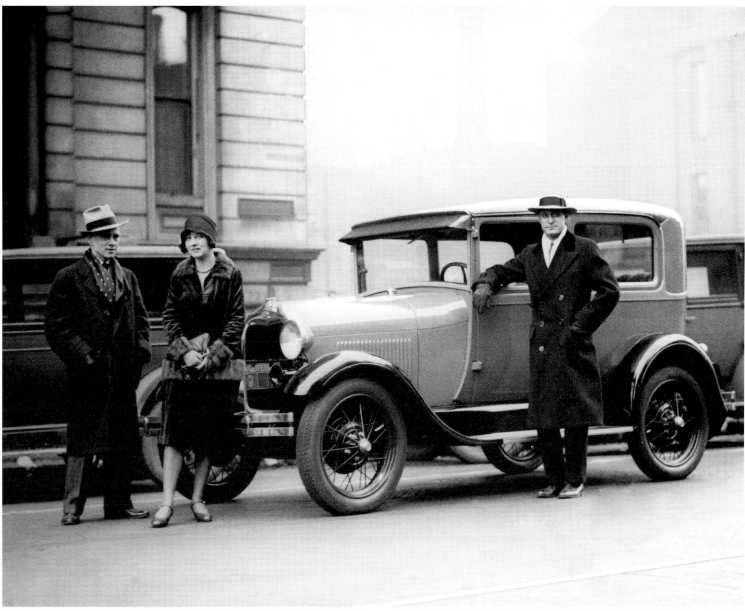

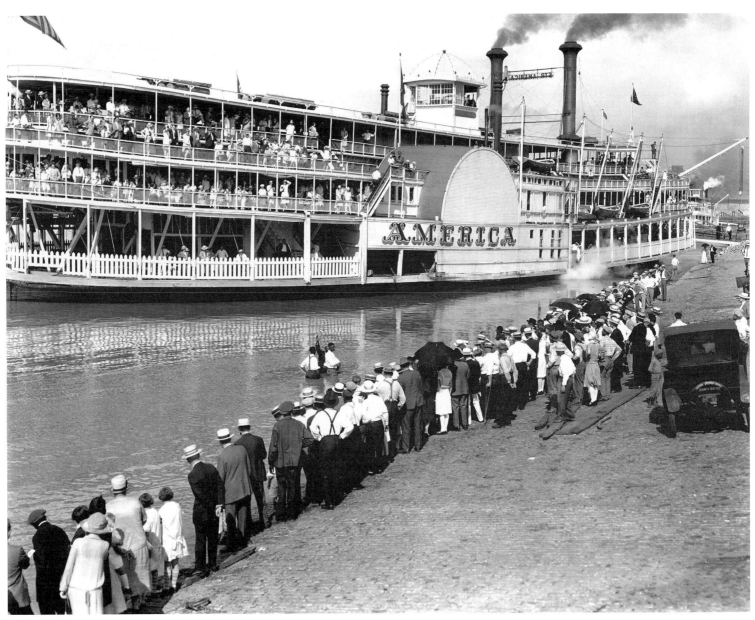

A baptism in the Ohio River takes place as the steamer
America leaves the Louisville wharf in this 1927 view.

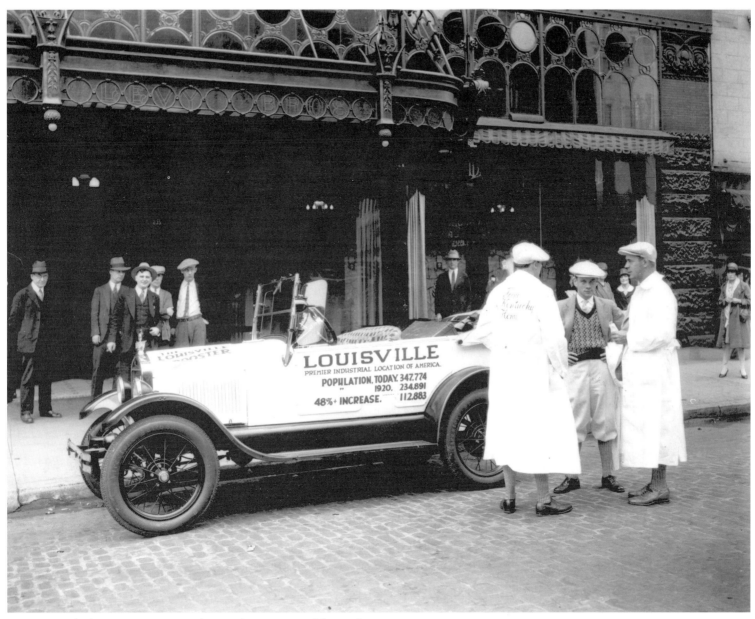

In 1927, Ford salesman R. G. Potter, along with E.J. Lucas of the Ford Motor Company and Louisvillian Pinkney Reeves Allen drove this car over 3,000 miles as "Louisville Boosters", promoting the city as a trade and business center. The crew and car are seen here in front of Levy Brothers Dry Goods, now the Old Spaghetti Factory.

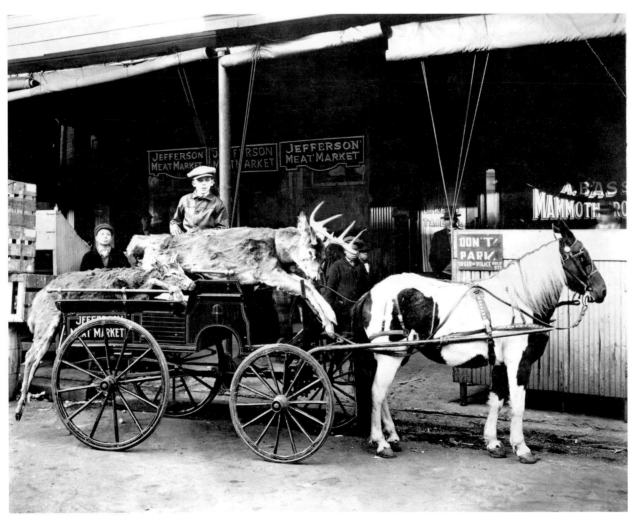

Wild-killed deer are delivered to the Jefferson Meat Market in a pony-driven wagon in 1927. The meat market was located in the Haymarket distrcit.

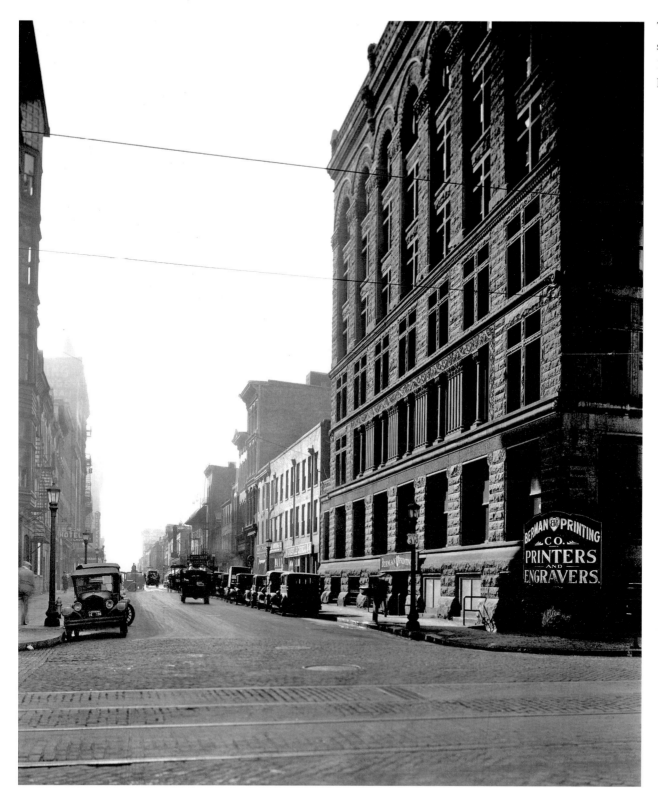

Third Street, looking south from Main, in 1927. The Vaughn Building is at right.

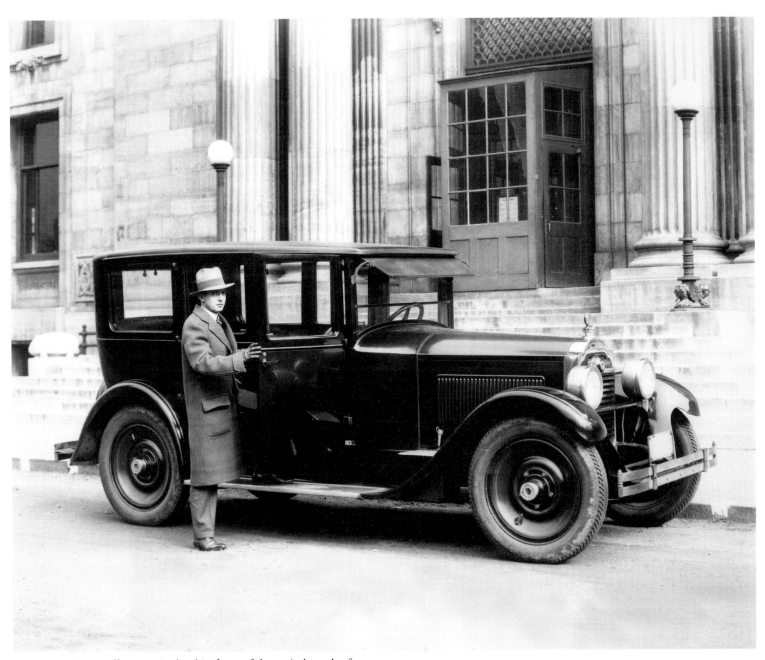

A salesman shows off a 1927 Packard in front of the main branch of the Louisville Free Public Library, frequently used as background for automobile advertisements.

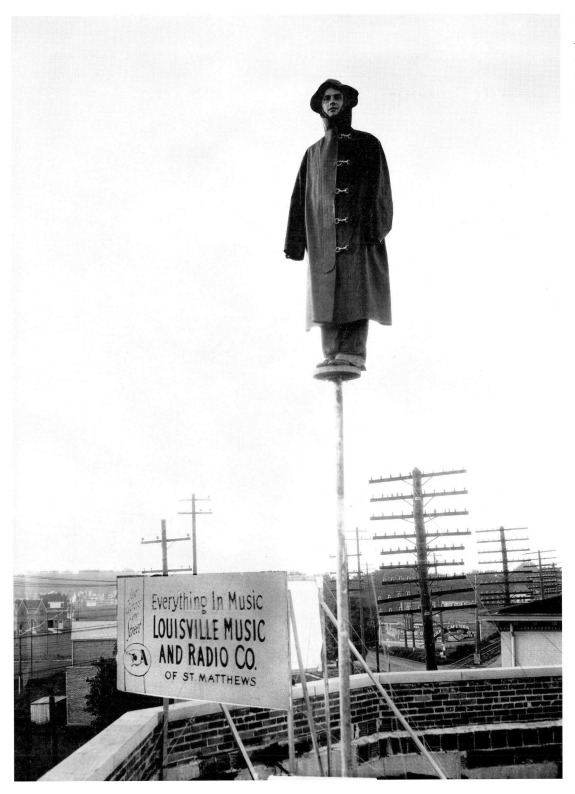

Popular flagpole stander Jimmie Jones stood atop a pole at Schuler Motor Co. in St. Matthews for 57 hours and 40 minutes as part of a publicity stunt. 1928.

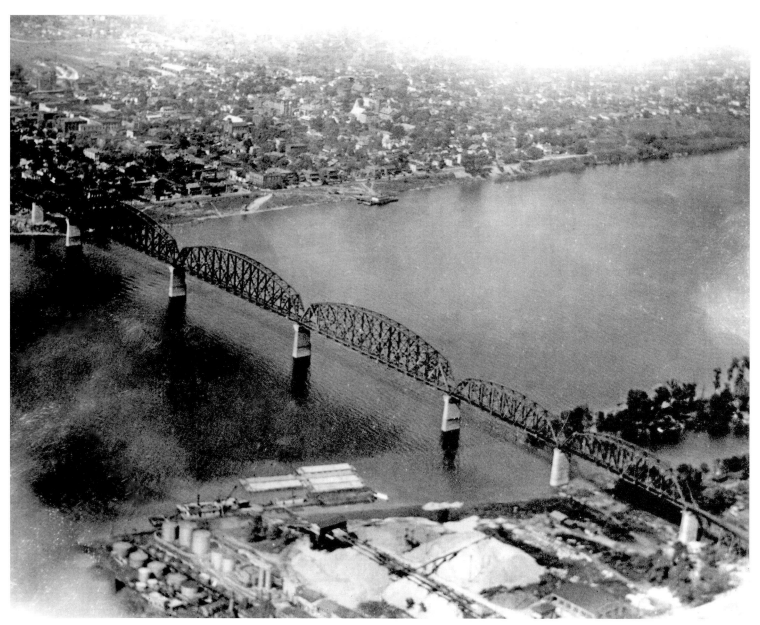

This 1929 view shows the Big Four Bridge between Louisville and Jeffersonville, completed in 1895. Plans call for converting the bridge into a pedestrian walkway connecting Waterfront Park to the Indiana shore.

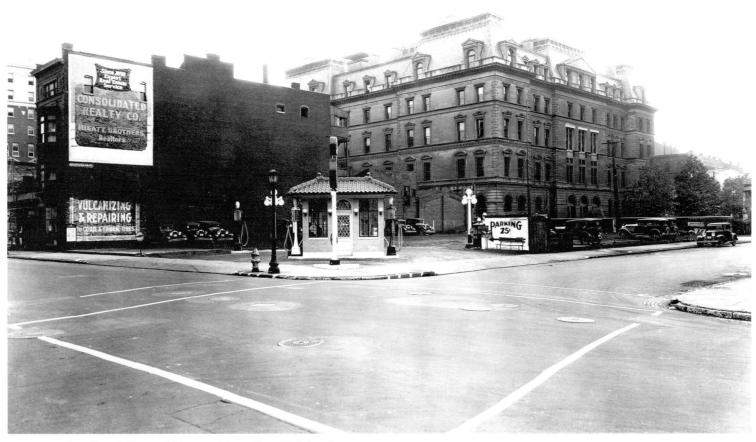

Rear view of the Post Office and Customs House from Third and
Guthrie Streets in 1929.

Aetna Oil service station at Third and Oak Streets in 1929.

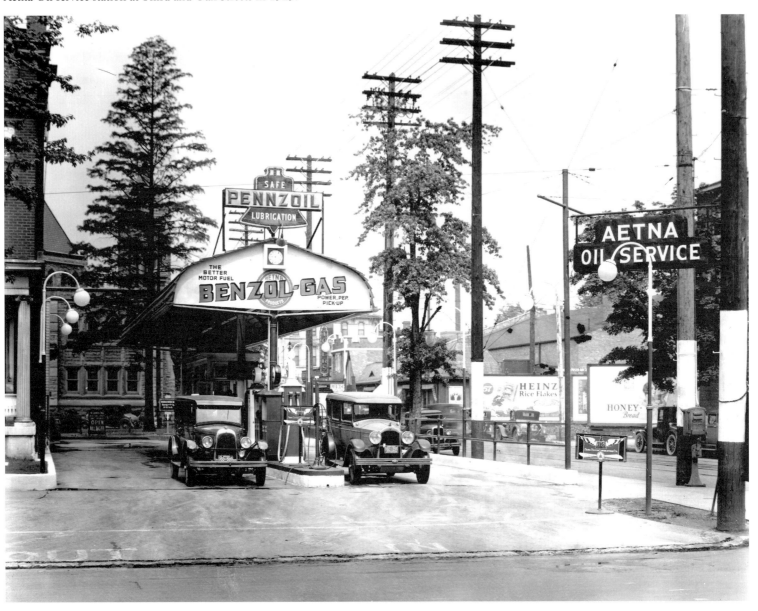

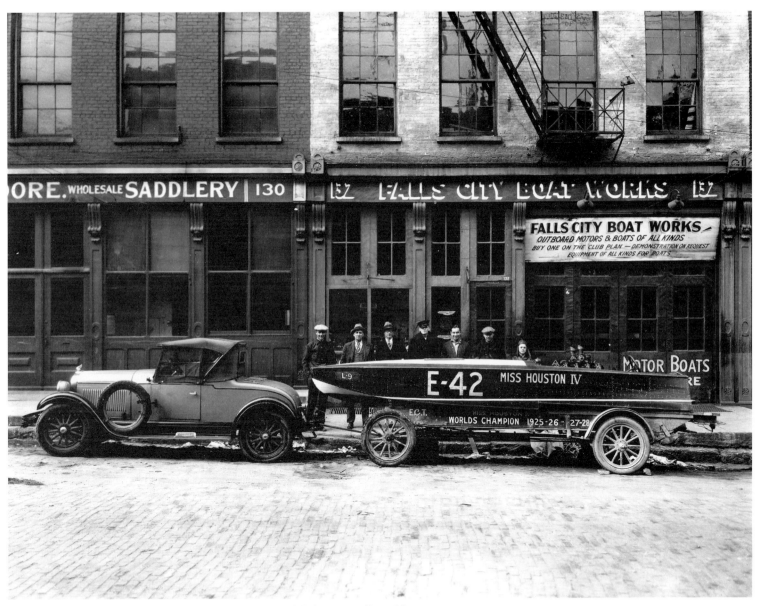

In 1930, the speed boat "Miss Houston IV" was renamed "The Louisville Kid."
It then won the National Regatta in Madison, Indiana. 1929.

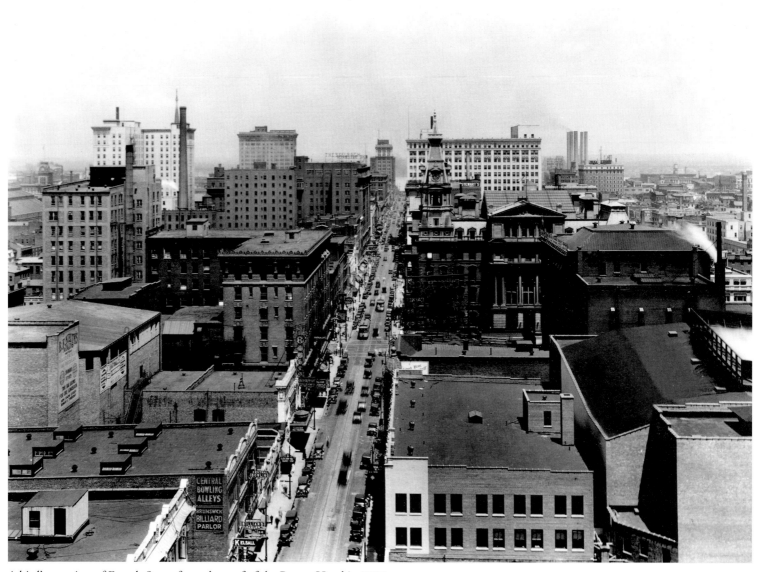

A bird's-eye view of Fourth Street from the roof of the Brown Hotel in 1929.

Beautician class at Ahrens Trade School in 1932.

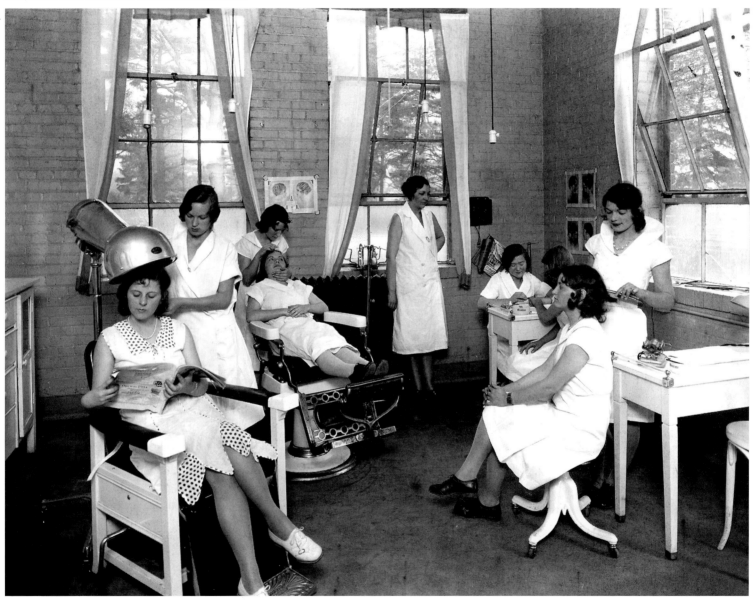

These old "Has Been" cars raced on the trotting track
of the old Kentucky State Fair Grounds in 1931.

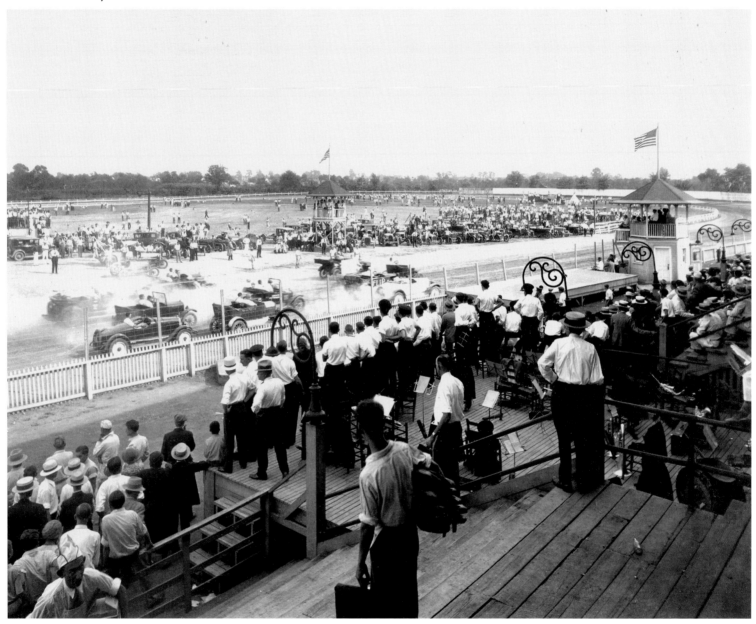

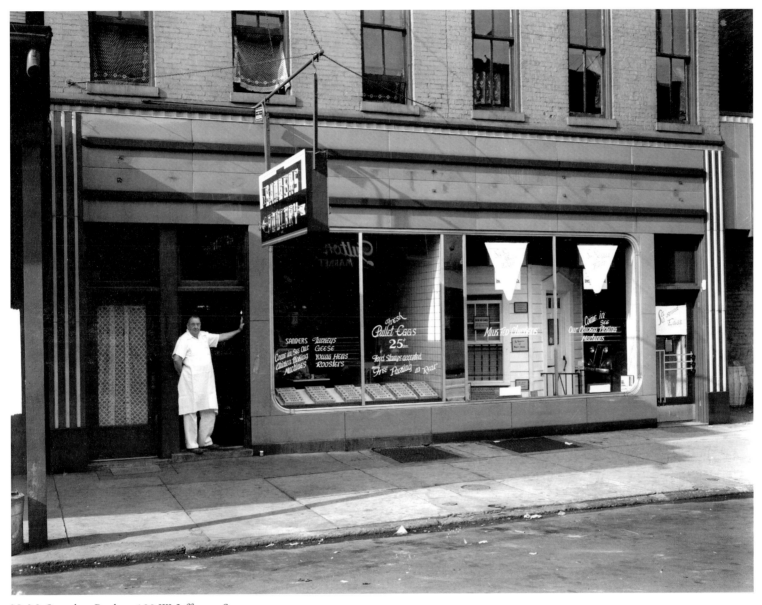

N. M. Saunders Poultry, 120 W. Jefferson Street, on
the edge of the Haymarket district. 1930's.

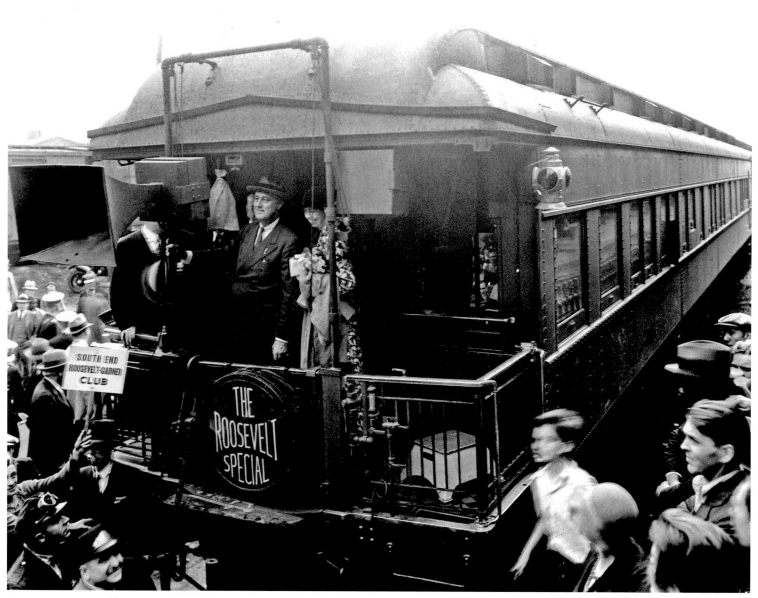

A campaigning Franklin D. Roosevelt spoke from the back of
a special train at the Louisville & Nashville Railroad's Union
Station in 1932.

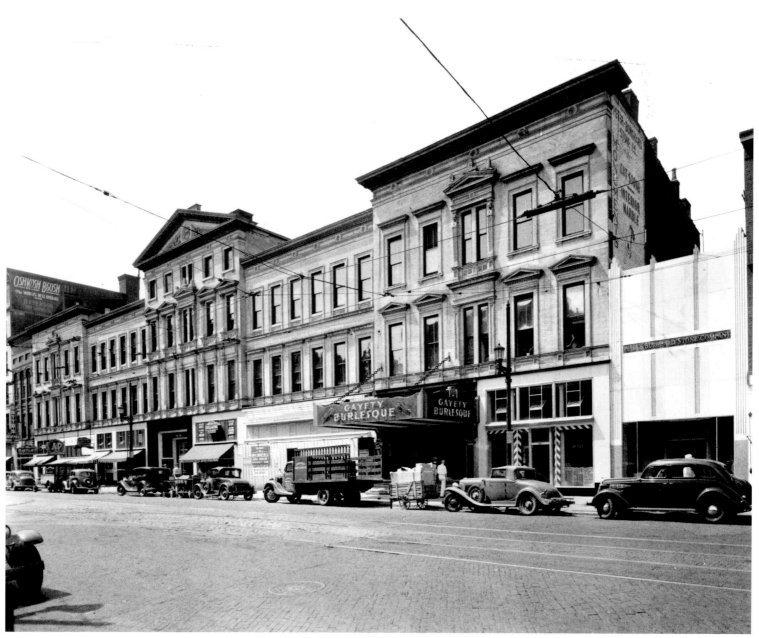

The Tyler Block, completed in 1874, was an extreme example of the nineteenth-century commercial "Palace." Located between Third and Fourth on Jefferson Street, its front was several hundred feet in length. 1933.

Jefferson Street east from Floyd, on the edge of the Haymarket area. 1932.

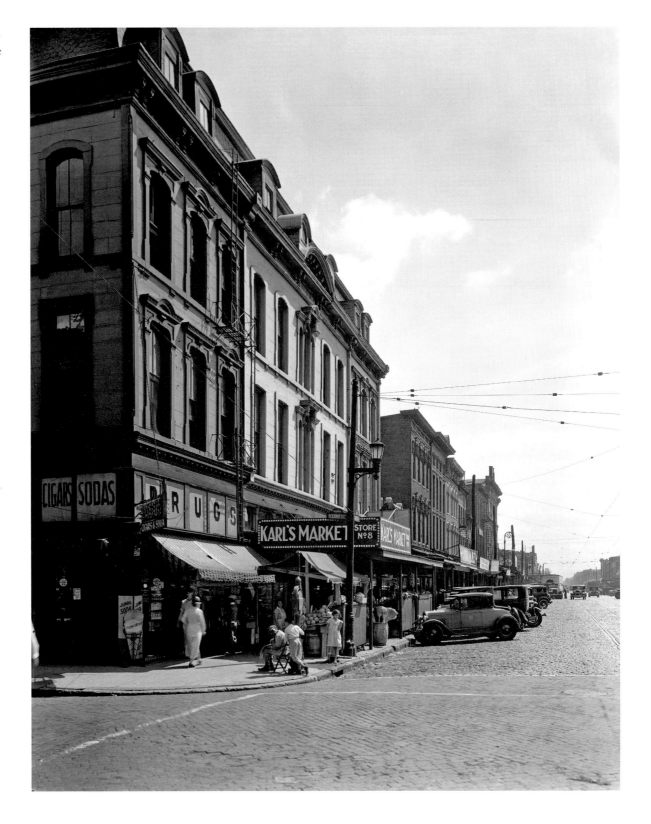

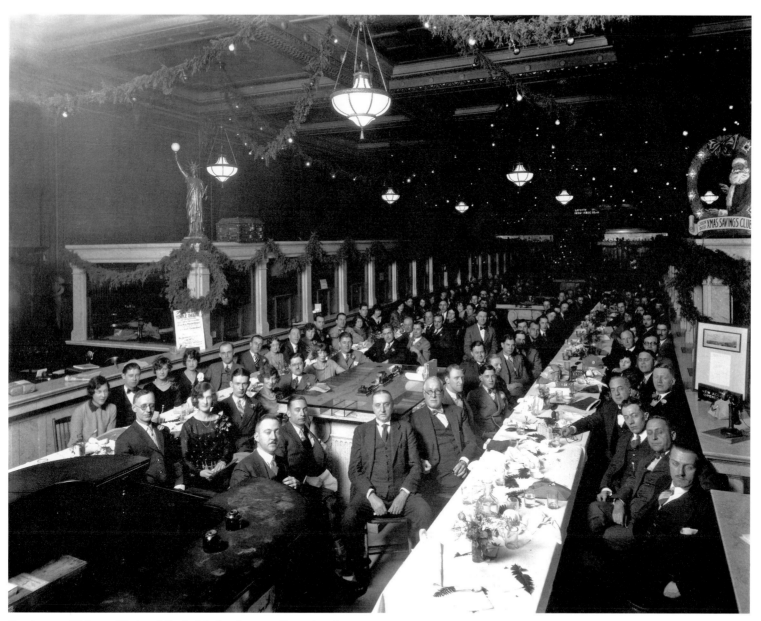

Employees of Liberty National Bank, Market Street at Second, enjoy
a company banquet in the main banking room. Circa 1930s.

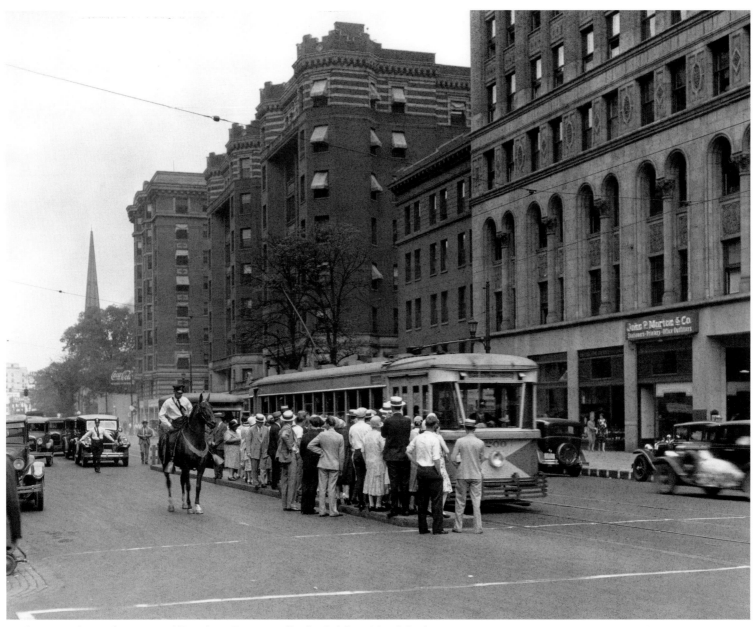

In the 1930s the Bardstown Road/Broadway Express trolley loaded from islands in the middle of Broadway. It is shown here at Fourth Street, with the Weissinger Gaulbert Apartments in the background.

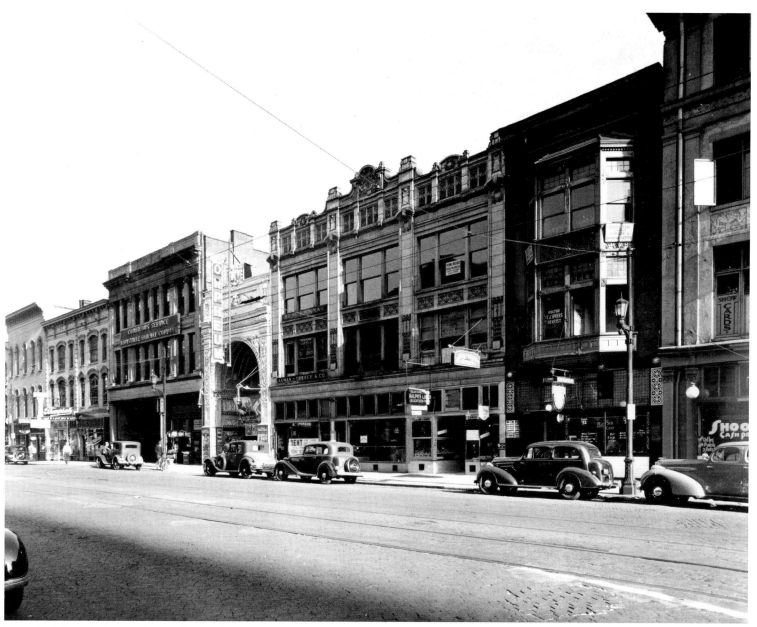

These buildings, including the Orpheum Theater, were on the south
side of Jefferson Street, between Third and Fourth. Circa 1933.

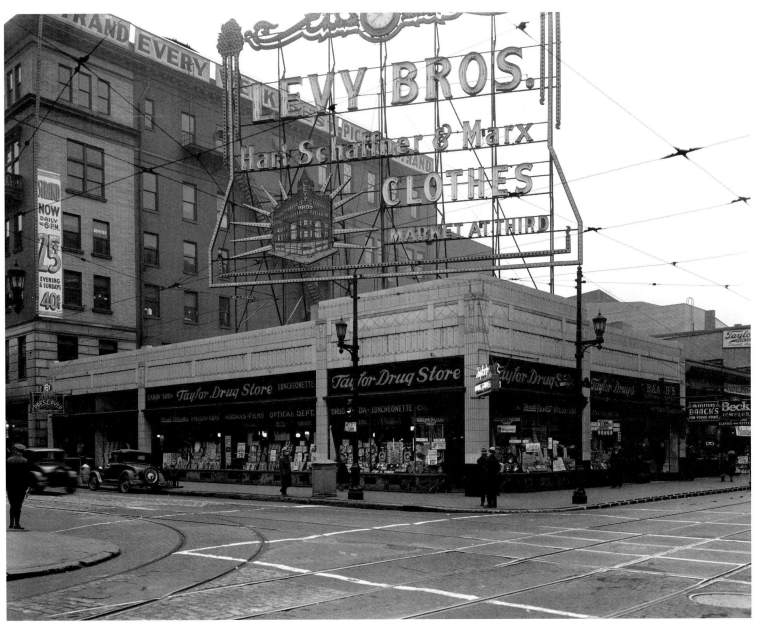

Illuminated sign advertising Levy Brothers clothiers sits atop a T. P. Taylor
drug store on the southeast corner of Fourth and 1934.

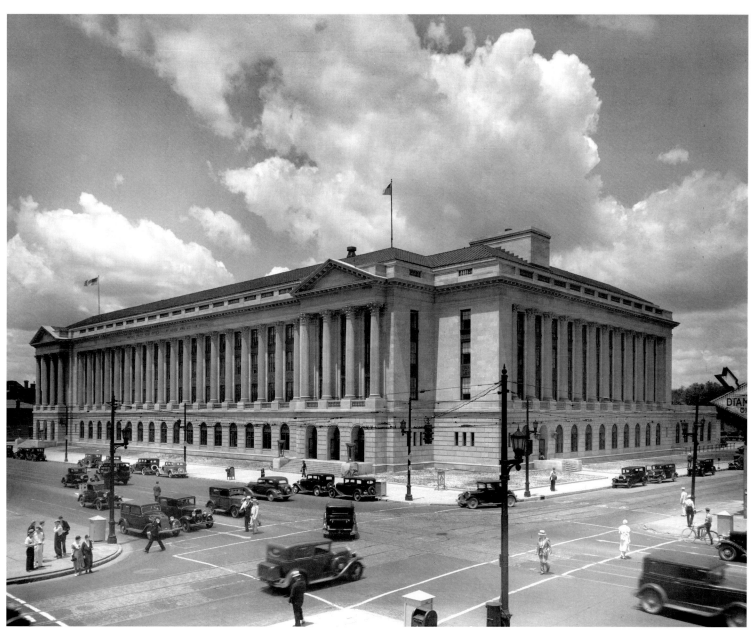

Louisville Post Office and Federal Building, built between Sixth and Seventh on Broadway was completed in 1932. It is now called the Gene Snyder U.S. Courthouse & Custom House in honor of the former United States Representative. 1934.

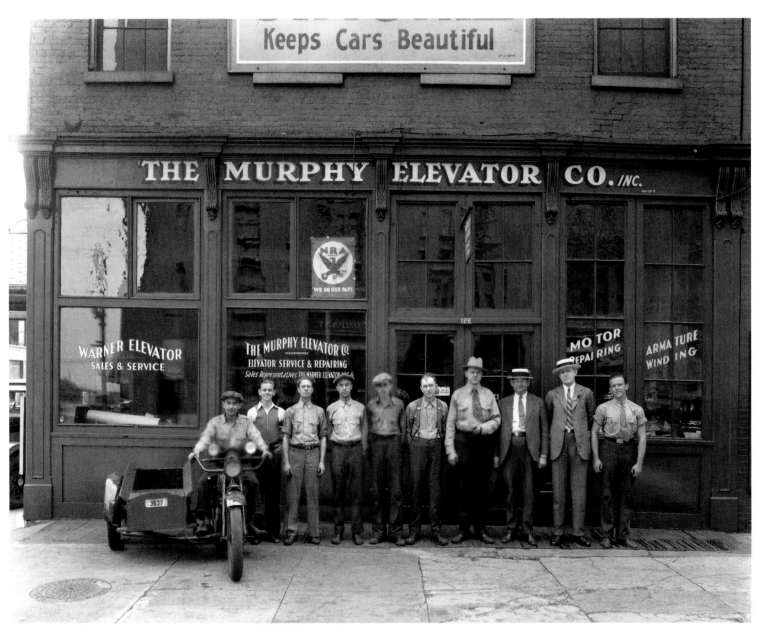

Workers at the Murphy Elevator Company, 128 East Main Street, pose in front
of the building in 1934. Note that the "Blue Eagle" symbol of the New Deal's
National Recovery Act is displayed in the window.

In 1935, Gold Medal Flour gave away Graham automobiles to seven lucky winners.

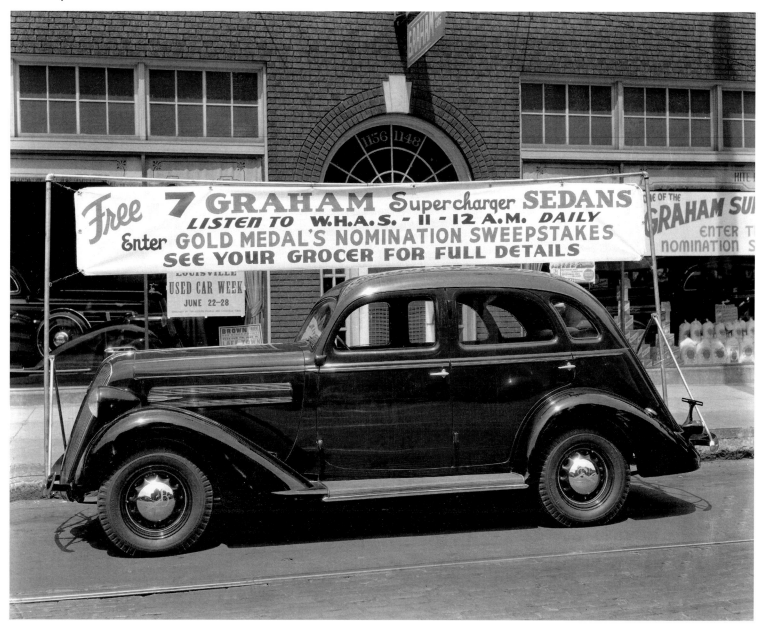

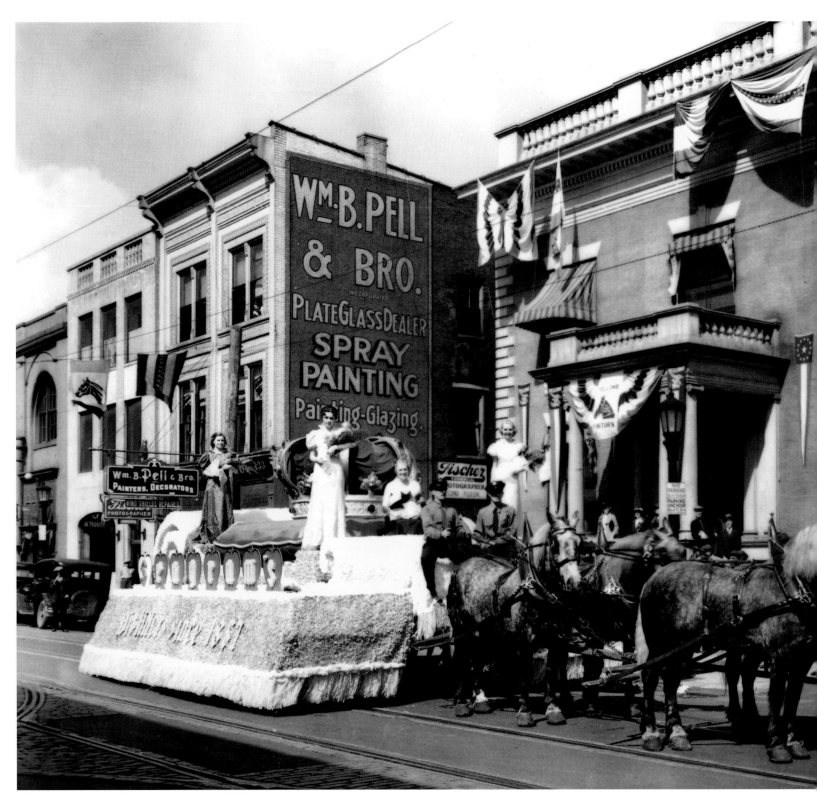

A parade float advertising Seagrams Distillery is shown here in front of the Louisville Water Company building on Third Street. 1936.

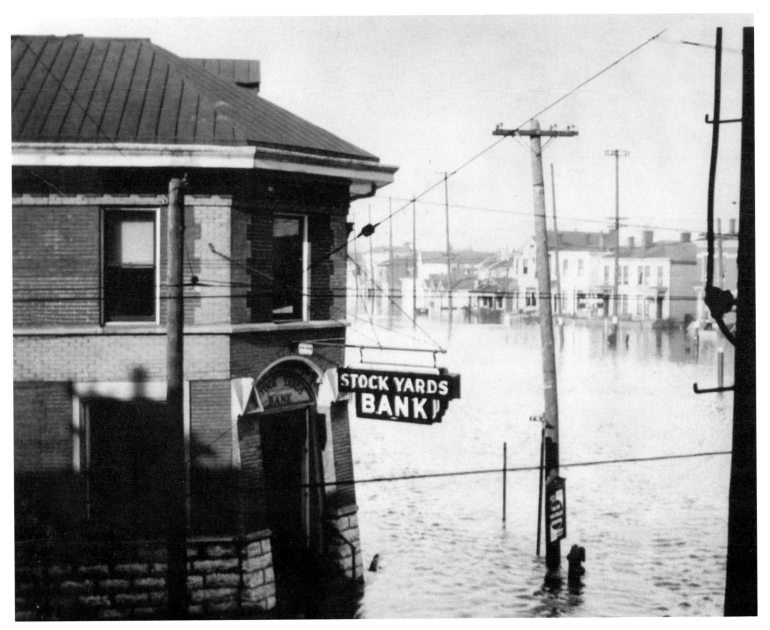

A view of the Stock Yards Bank during the 1937 flood.

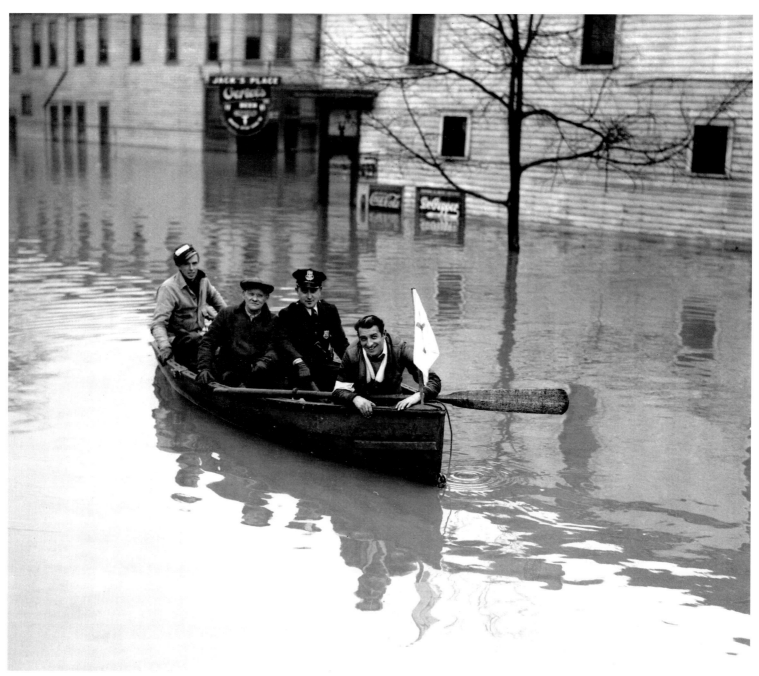

A group of rescuers patrol the city of Louisville during the 1937
flood looking for stranded victims still in their homes.

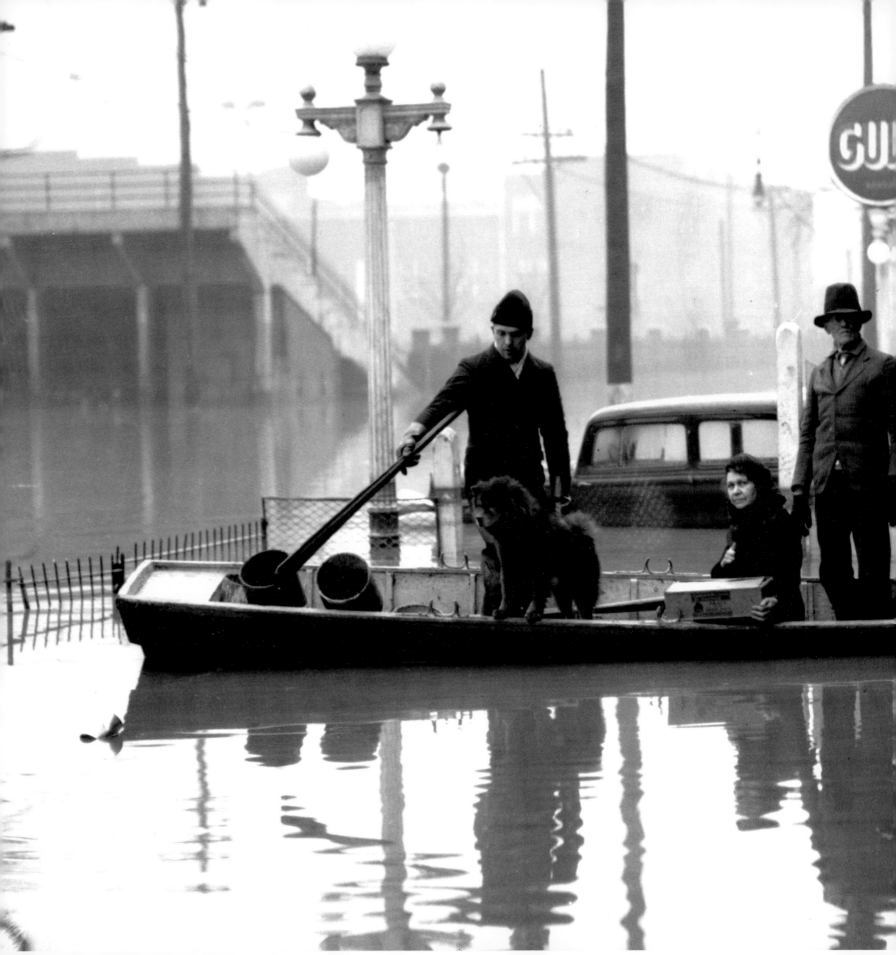

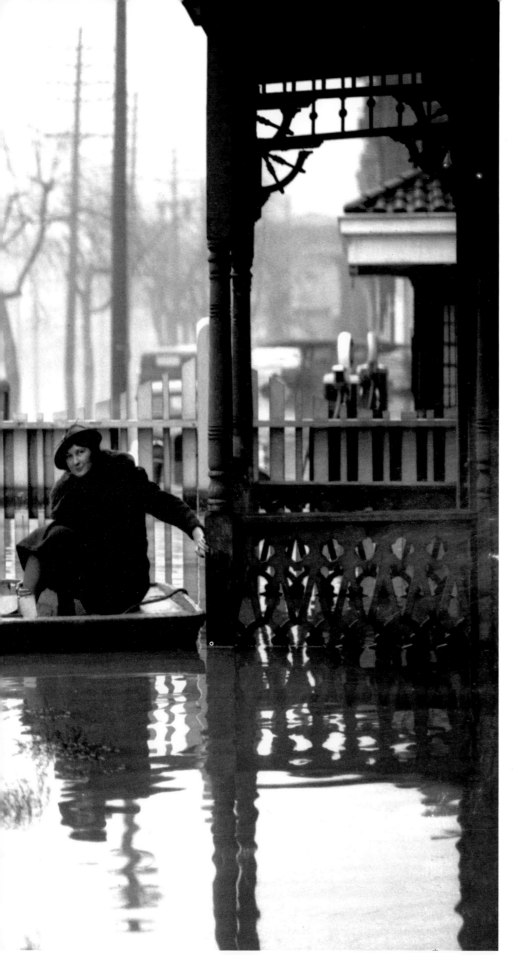

A family is rescued from flood waters at the corner of Floyd and Breckinridge streets during the 1937 flood. Male High School's football stadium is visible at right.

129

A view of northbound traffic and southbound pedestrians
on the George Rogers Clark Bridge in 1937.

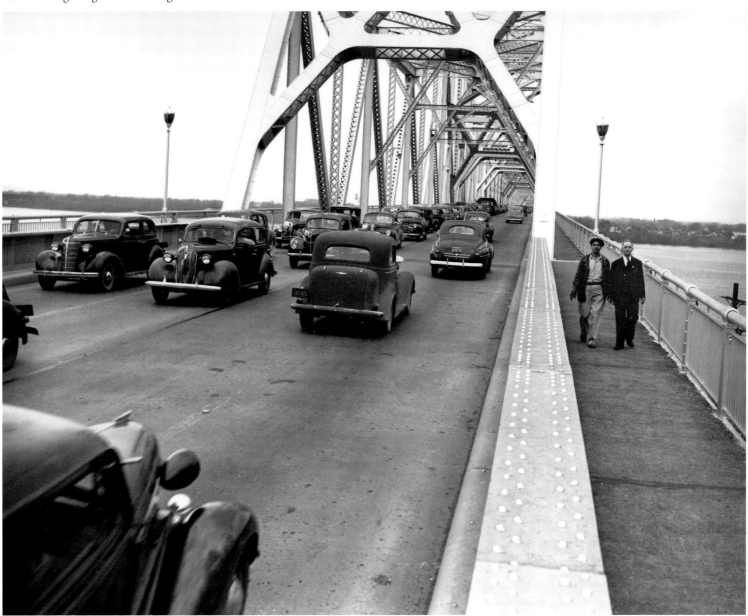

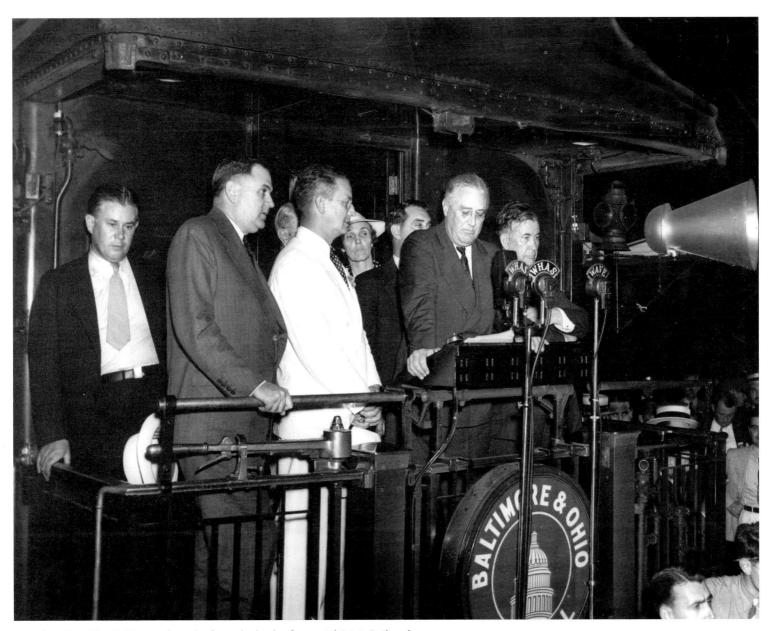

President Franklin D. Roosevelt spoke from the back of a special B&0 Railroad car in 1938. He is accompanied by Senator Alben W. Barkley of Kentucky.

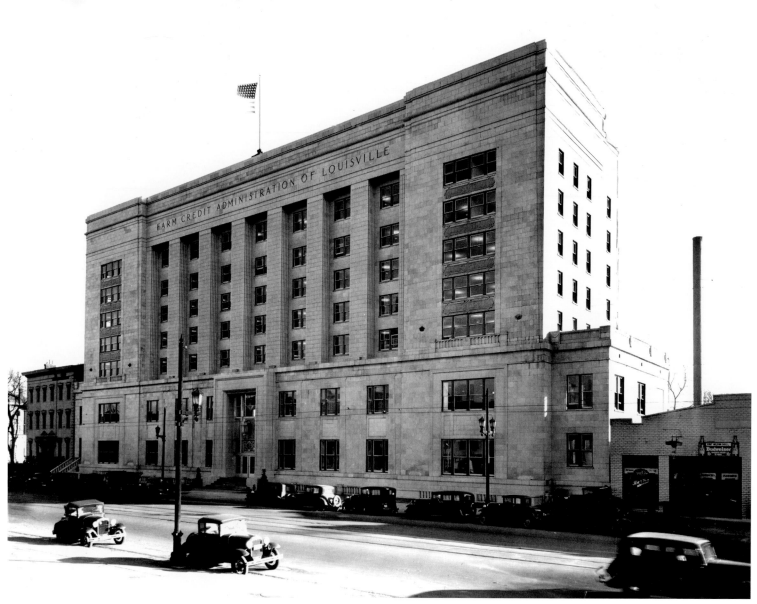

The Farm Credit Bank, 218 East Broadway. This building was built in the 1920s as the headquarters of the Kosair Shrine Temple and later operated as the Fort Nelson Hotel. Brass plates bearing the inscription "Slave of Allah" in Arabic, remnants of the Temple decoration, can still be seen between the windows on either end.

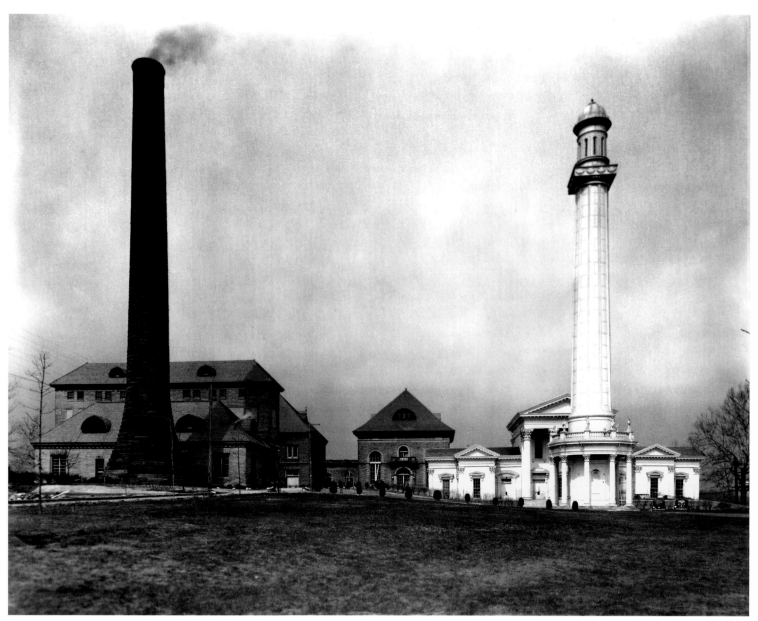

Louisville Water Company standpipe tower and pumping station, located on
River Road opposite Zorn Avenue. The original water company buildings
were completed in 1860. 1938.

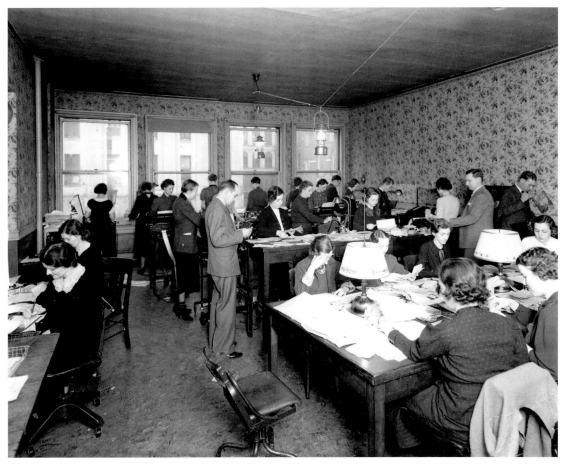

Employees at Citizen's Union National Bank
work during the 1937 flood. Note the oil lamps
on some of the desks.

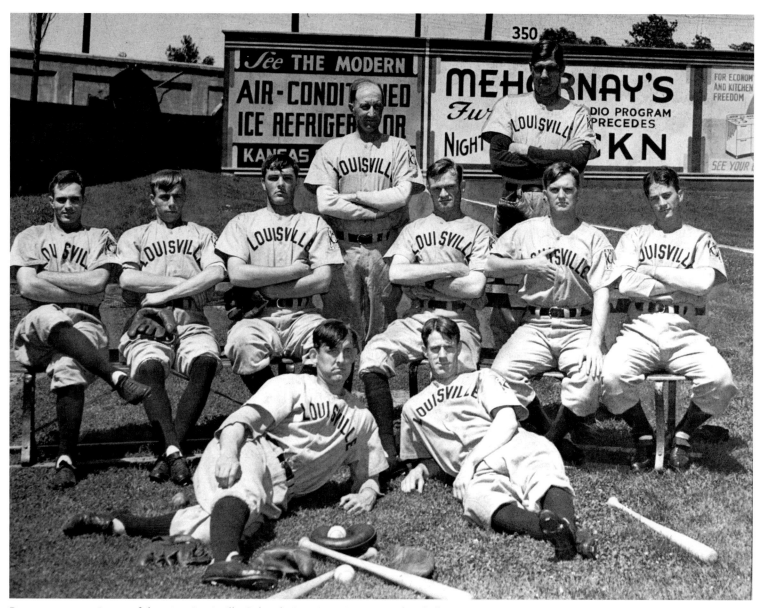

Pre-season team picture of the 1939 Louisville Colonels American Association baseball club, photographed at Parkway Field. The team won one of its five "Little World Series" titles in 1939.

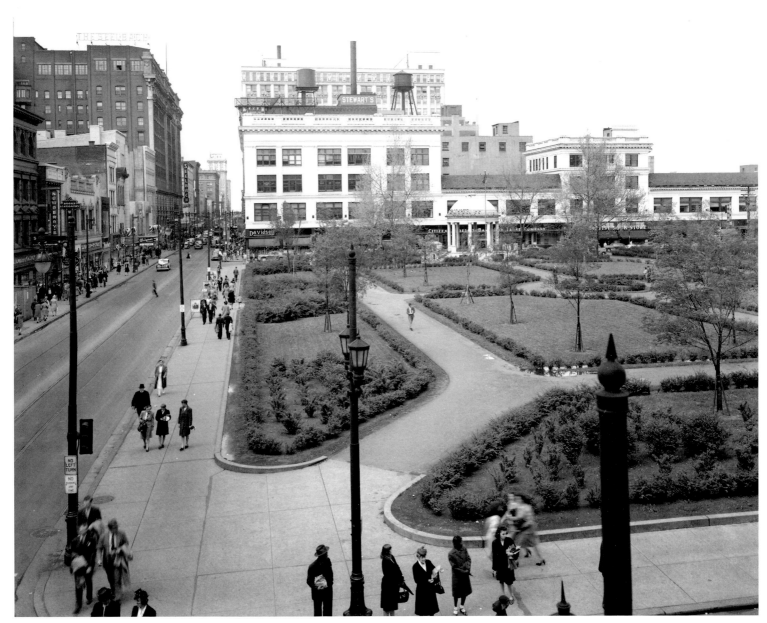

Lincoln Park, from Chestnut to Guthrie along Fourth Street,
replaced the old Post Office and Custom House, torn down
in 1942. 1947.

FROM BOOM TO FEAR OF BUST

1940–1970

Louisville's flagging industrial economy received a boost during the war years, with effects lasting well beyond 1970. In Clark County, Indiana, just a few miles the other side of the Ohio, E. I. DuPont de Nemours & Company announced the construction of a powder plant which would "dwarf any similar plant in existence," eventually employing 4,000 workers. In Louisville's West End, National Carbide built a large acetylene plant, while Du Pont, B. F. Goodrich, and the National Synthetic Rubber Company all constructed plants in an area along the Ohio that would later be known as "Rubbertown." Louisville had long been home to major producers of wood products and these turned to the production of aircraft assemblies, collapsible pontoons, and other essential military items. Louisville's Curtiss-Wright Company produced C-46 cargo planes. Even the Hillerich & Bradsby Company, manufacturers of the famous Louisville Slugger Bat, made rifle stocks.

With the addition of a large naval ordnance plant, Louisville's economy boomed and many industries employed women for the first time in their histories. The early 1950s saw the addition of General Electric's massive Appliance Park, and the Ford Motor Company opened a new assembly plant on Grade Lane in 1955.

Louisville also extended its connections to the nation and to the world during this period. With the aid of the WPA and the Army Corps of Engineers, Standiford Field (now Louisville International), Louisville's second airport, was built in 1941. Standiford opened for passenger service in 1947 and would become an important economic engine in the coming decades. The first segment of the Henry Watterson Expressway, completed in 1948, was the city's first link to the expanding system of interstate superhighways. Two new bridges, the Sherman Minton on the west side and the John F. Kennedy on the east, extended these links across the Ohio in the 1960s.

By 1970, Louisville's postwar boom was losing some of its steam and there were darker clouds on the horizon. Louisville's downtown had been its central shopping hub since the turn of the century. The newer suburban residential areas, however, had begun to be served by shopping malls, with miles of free parking and endless air conditioning. Downtown did not withstand the competition and by 1970 was slumping badly. Urban renewal projects, some overzealous and ill-advised, along with the location of an expressway along downtown's eastern edge, displaced many downtown residents, further eroding the customer base for downtown stores.

Factories built during the forties were showing their age and some industries left town for areas where land and wages were cheaper. It would take years of planning, hard work, and the eventual merger of City and Jefferson County governments to begin to overcome these bleaker trends.

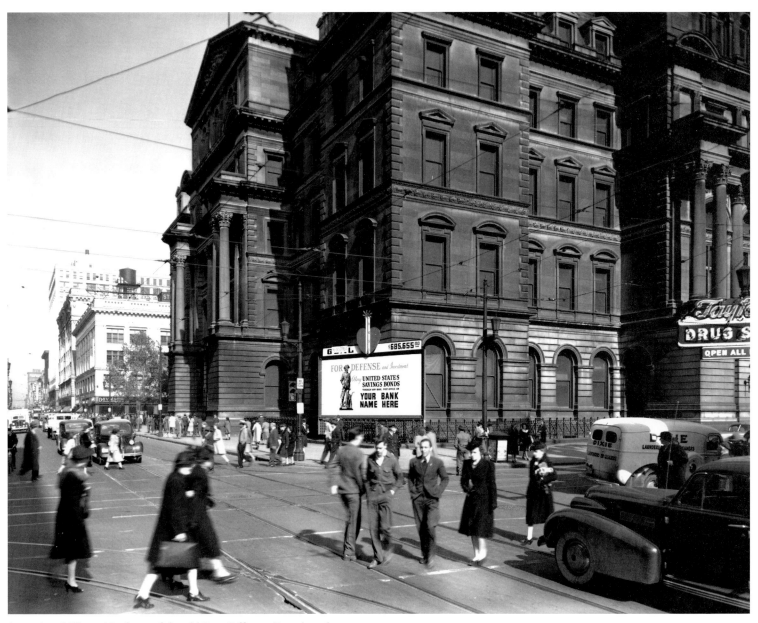

A wartime billboard in front of the old Post Office at Fourth and
Chestnut urges pedestrians to purchase savings bonds. 1942.

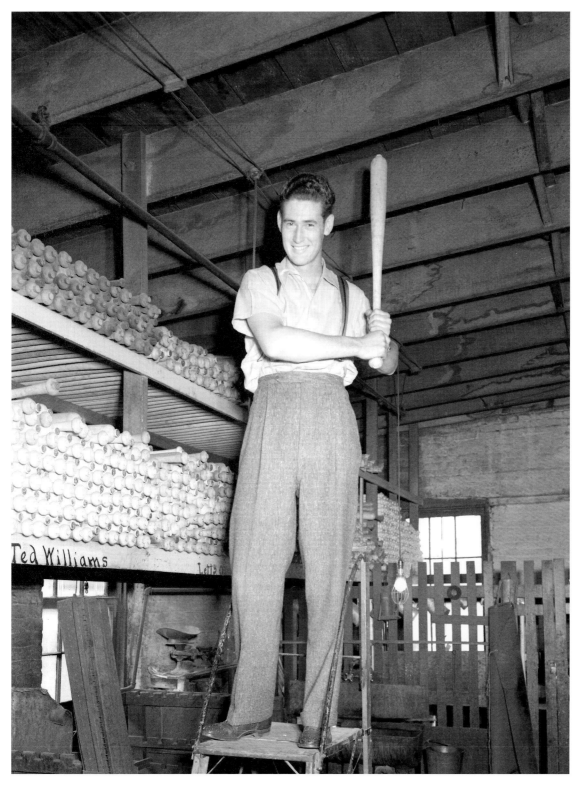

Ted Williams at the Hillerich & Bradsby Company, makers of Louisville Slugger bats, in 1942. It is said that Williams liked to personally select the wood that went into his bats, claiming that the presence of very small knots made them harder.

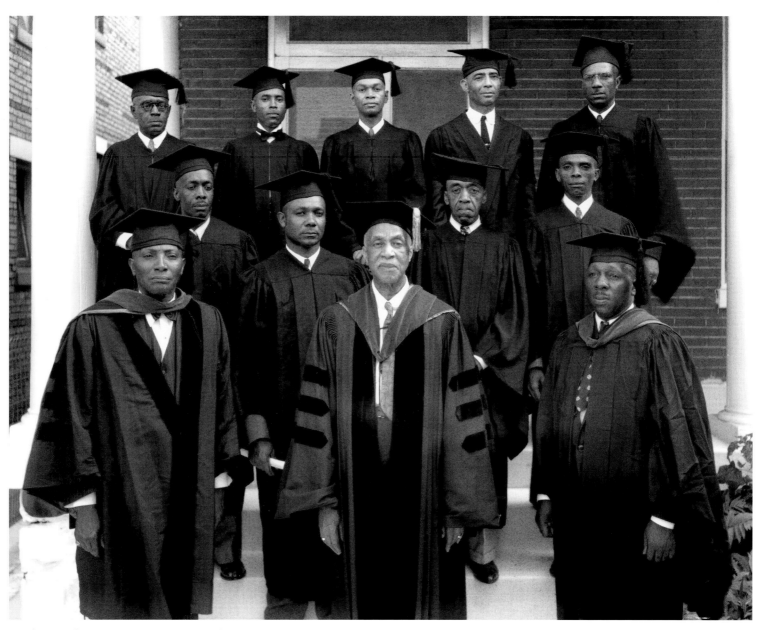

Graduating class, Simmons University, 1943.
This African American college, located at
Seventh and Kentucky, was founded by an
August 1865 act of the state legislature.

Children play on the merry-go-round at Fontaine Ferry Park in 1944. Fontaine Ferry was an amusement park located on Louisville's west end.

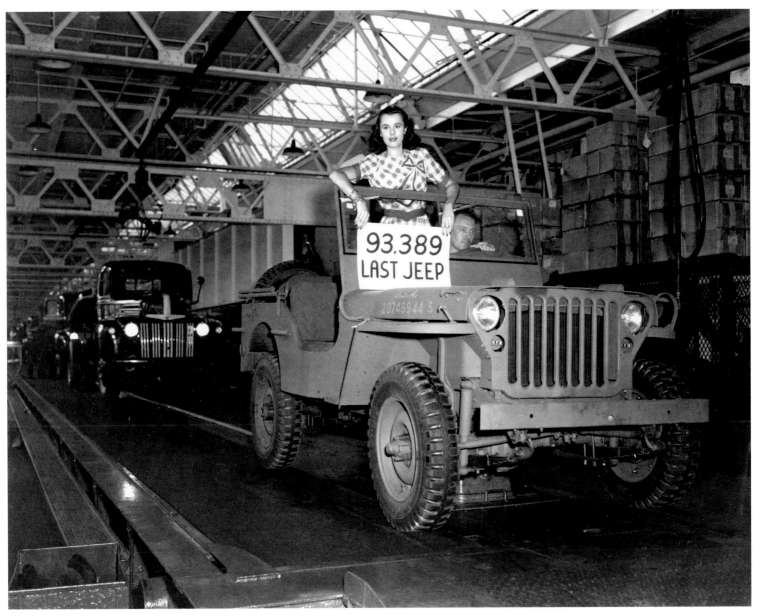

Army Jeeps had been produced at Louisville's Ford Motors plant during the war. The last one came off the line on August 2, 1945.

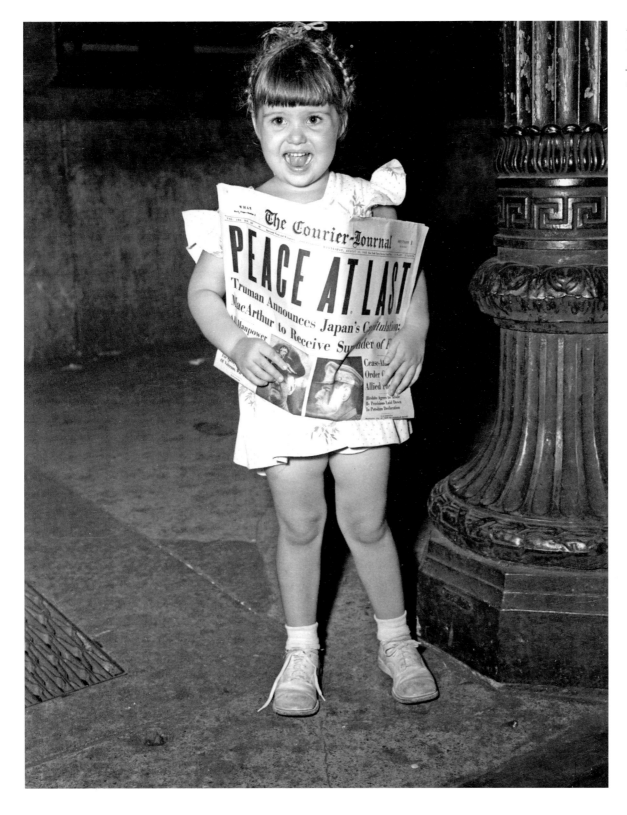

A little girl holds the V-J Day edition of the *Courier Journal*, August 14, 1945 declaring victory of Japan.

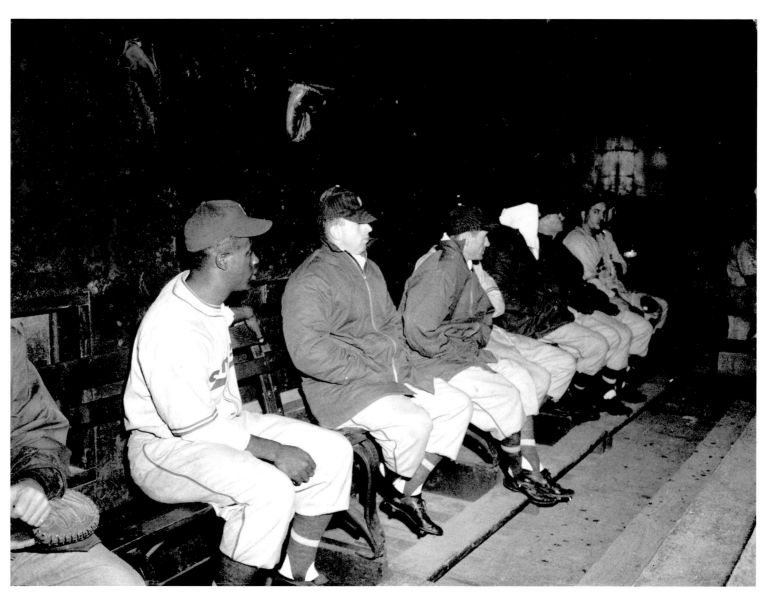

Jackie Robinson in the Montreal Royals dugout at Parkway
field during the 1946 Junior World Series against the Louisville
Colonels. Louisville won the series 4 games to 2.

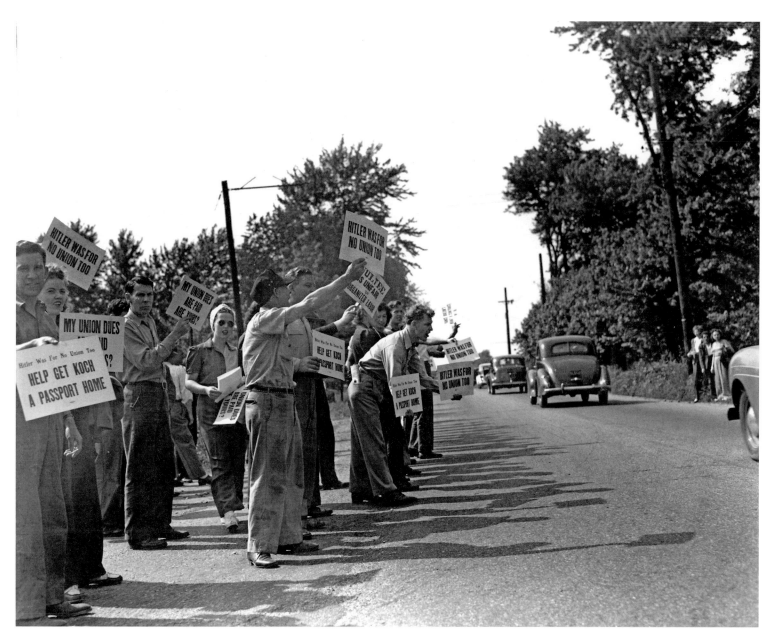

Striking workers man a picket line at Voltec Consolidated
Aircraft in May, 1945.

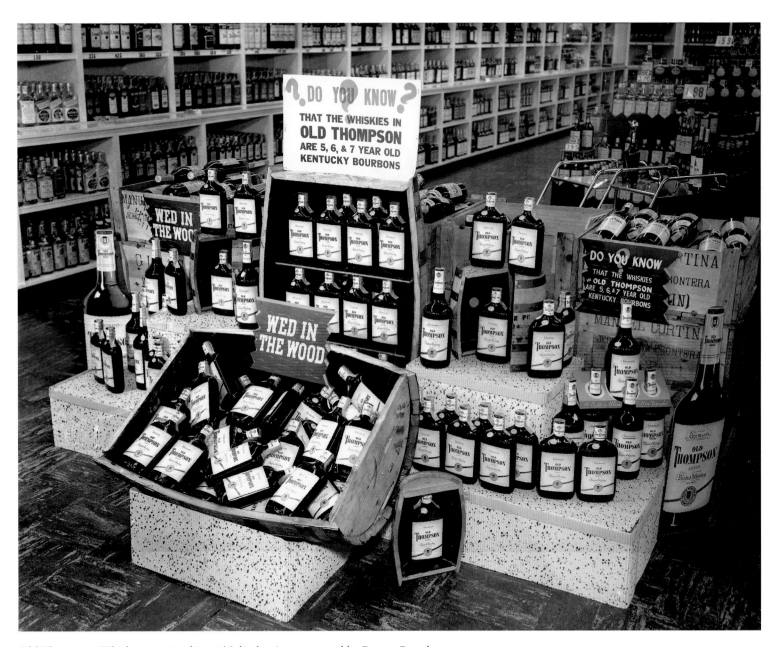

Old Thompson Whiskey, seen in this 1946 display, is now owned by Barton Brands.

A swimming party at Tucker's Lake in 1946.

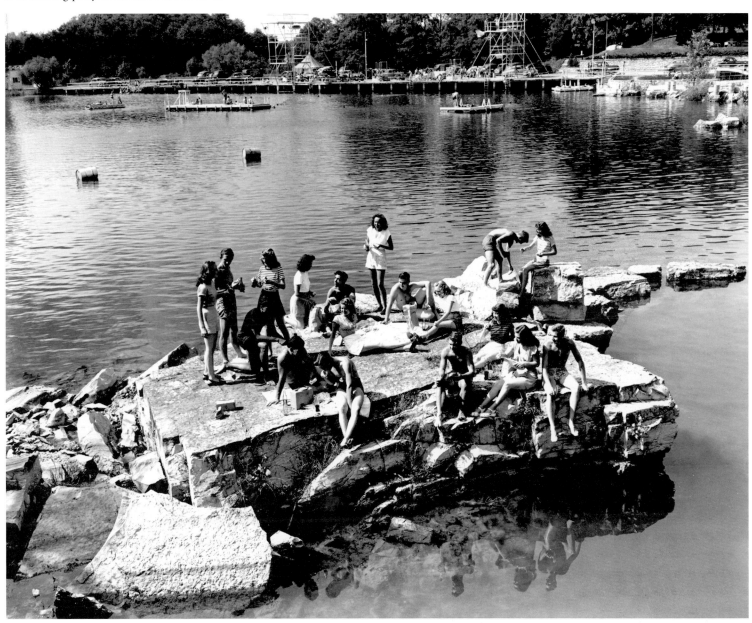

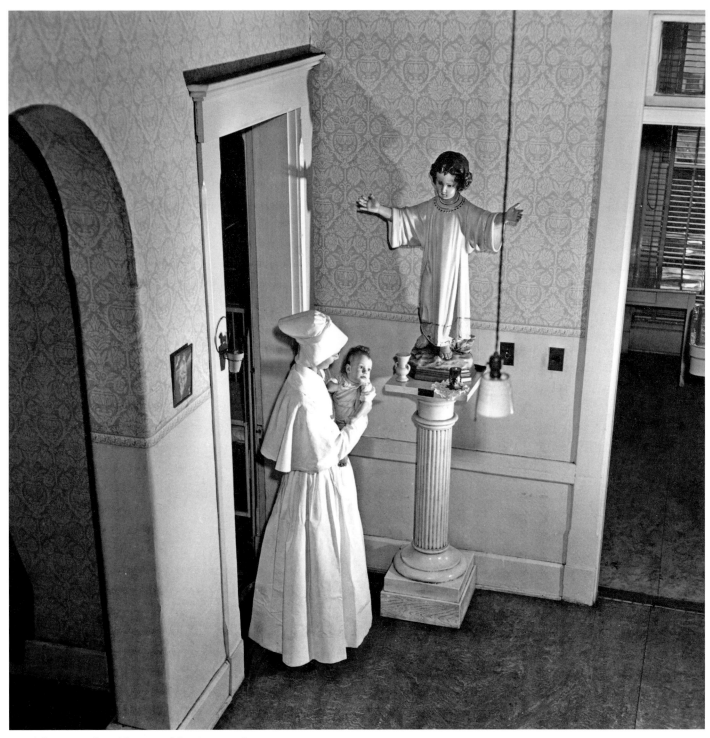

A toddler is comforted by one of the sisters at the
Home of the Innocents, 202 E. Chestnut Street.

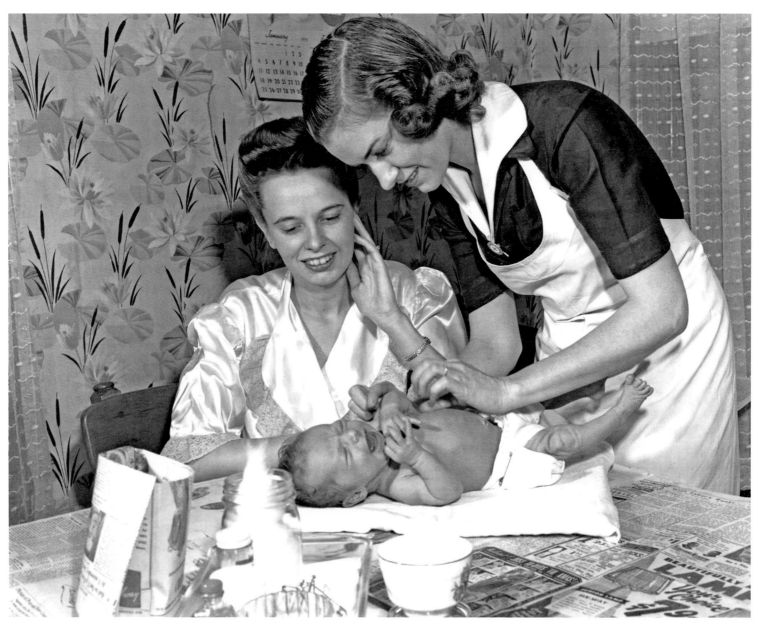

A Visiting Nurse's Association nurse instructs a new mother in 1947.

An unidentified jockey weighs in following a race a Churchill Downs in 1947.

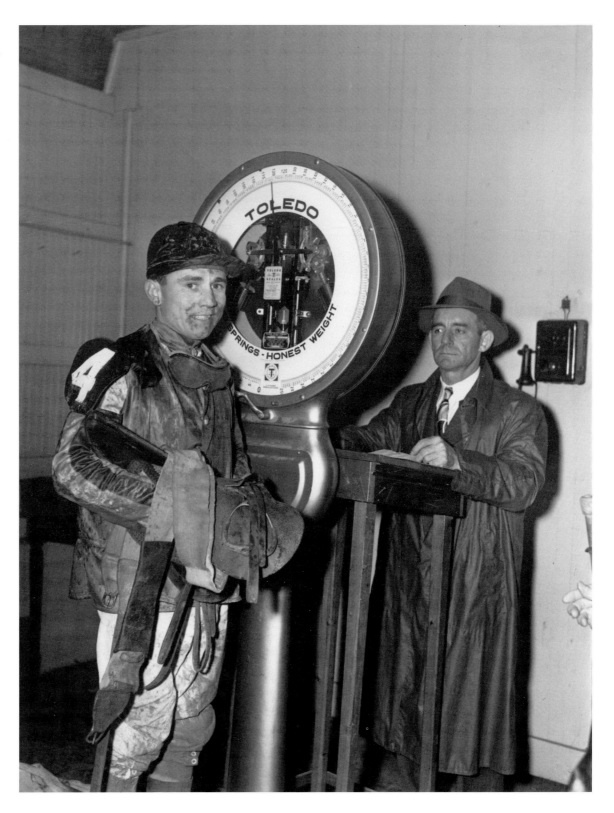

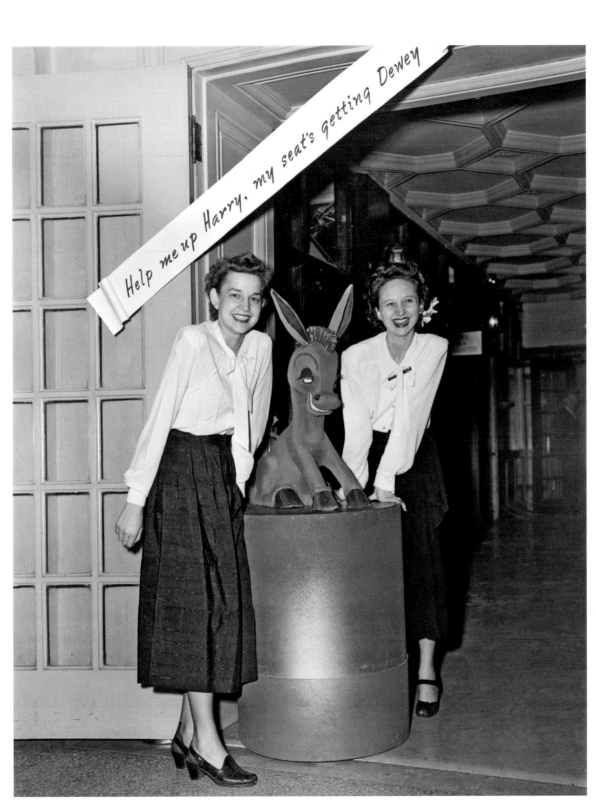

Help me up Harry, my seat's getting Dewey

Supporters of Harry S. Truman await his arrival at the Seelbach Hotel in September, 1948.

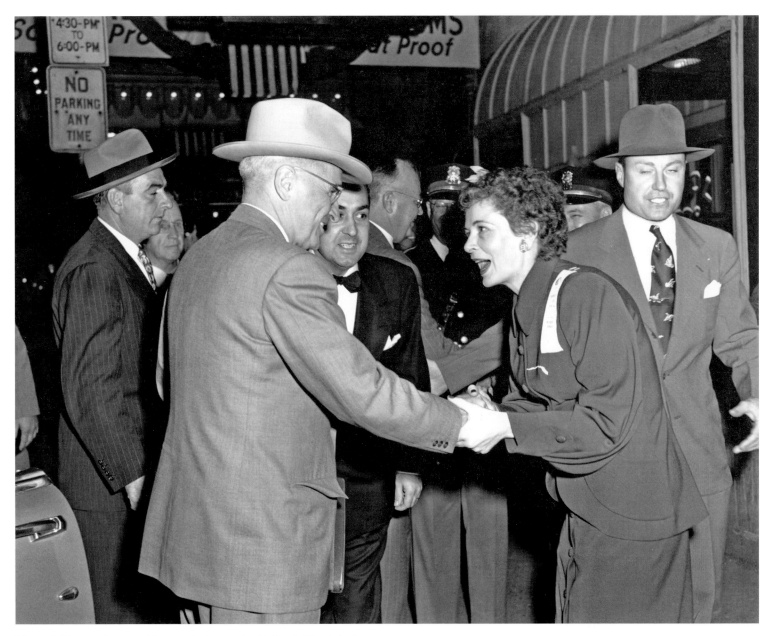

Harry S. Truman is greeted by an admirer at the Seelbach Hotel during a
campaign stop. The Seelbach has hosted more presidents than any other
Louisville Hotel. 1948.

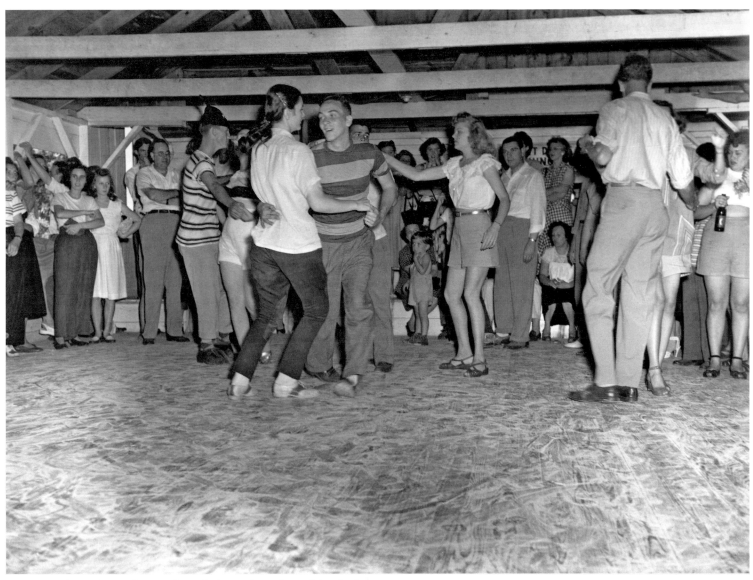

Picnic and dance for employees of Gordon's Foods, makers of Gordon's Potato Chips. The picnic was probably in conjunction with the annual Potato Festival in St. Matthews. 1948.

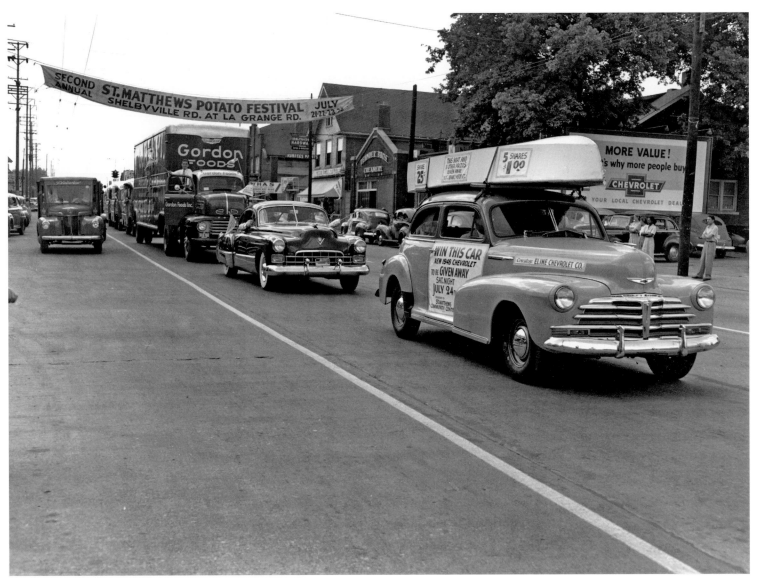

The annual Potato Festival parade in St. Matthews. Until shortly after the
war, the sixth class city of St. Matthews, on Louisville's east side, was one of
the largest producers of potatoes in the country. 1948.

A high school sorority party at Bain's Camp in 1948.

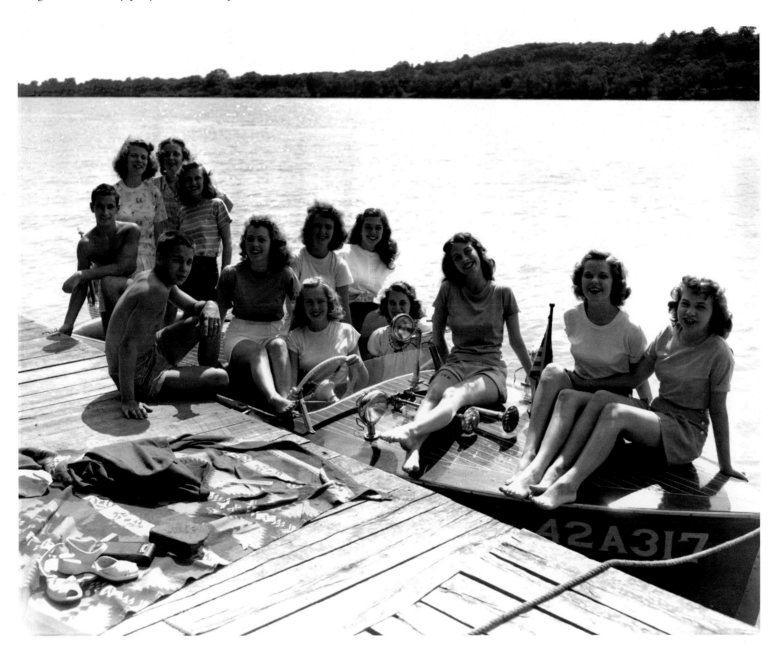

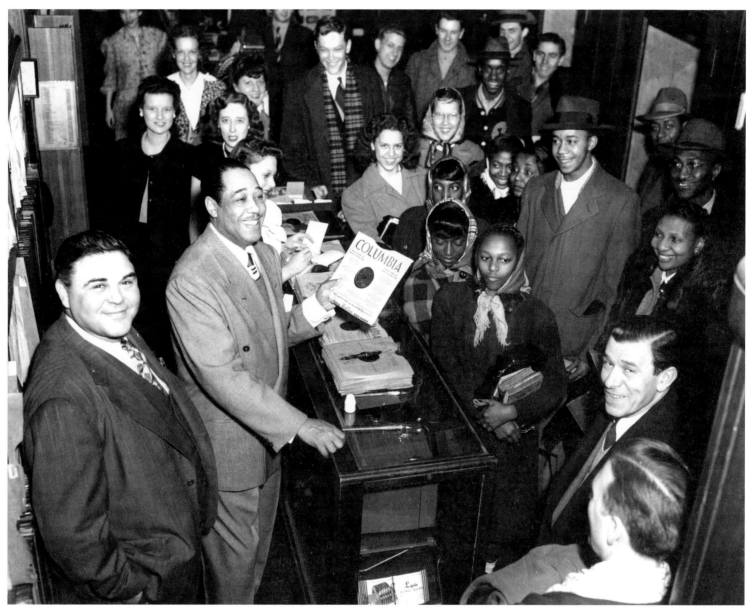

Duke Ellington thrills his fans during a visit to Variety Records on Fourth
Street in downtown Louisville in 1948.

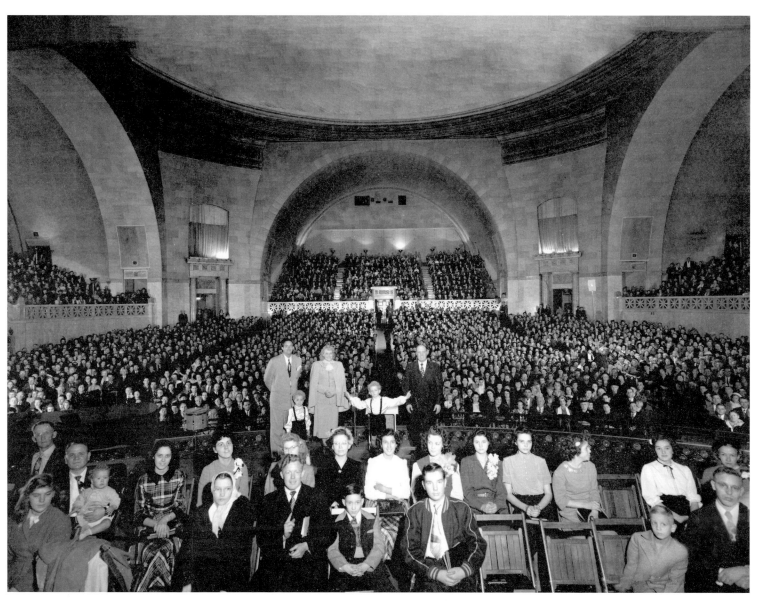

Memorial Auditorium is packed for a November 27, 1949
appearance by boy-evangelist "Marjoe" Gortner, center.

View west along Jefferson Street showing the Jefferson County Jail in 1950. The jail was completed in 1905, replacing the First Presbyterian Church on the site.

An unidentified African American baseball team in 1950.

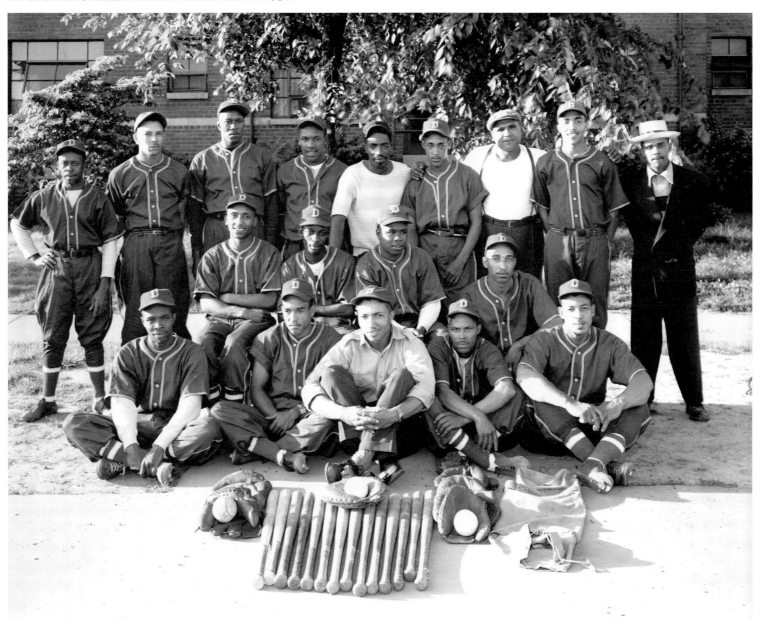

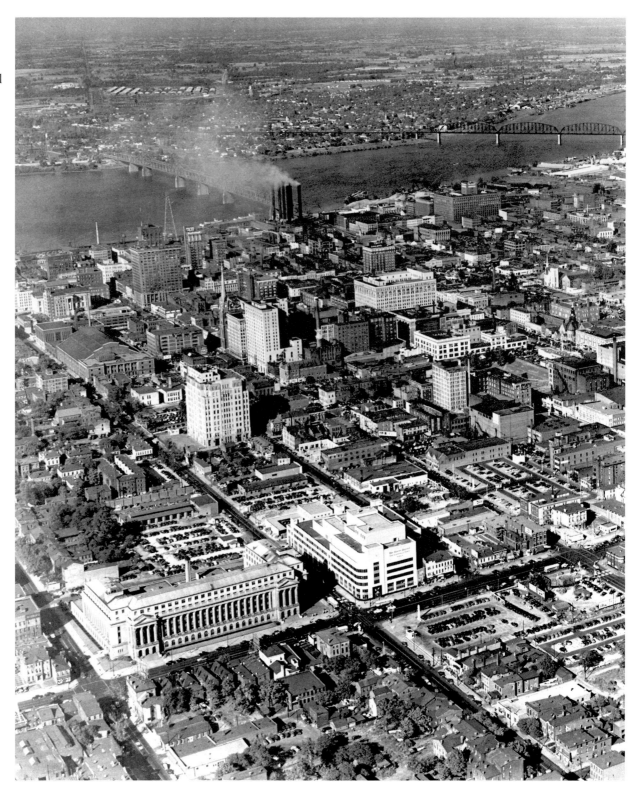

1950 aerial view of downtown Louisville, with the Post Office and the Courier-Journal building at lower right.

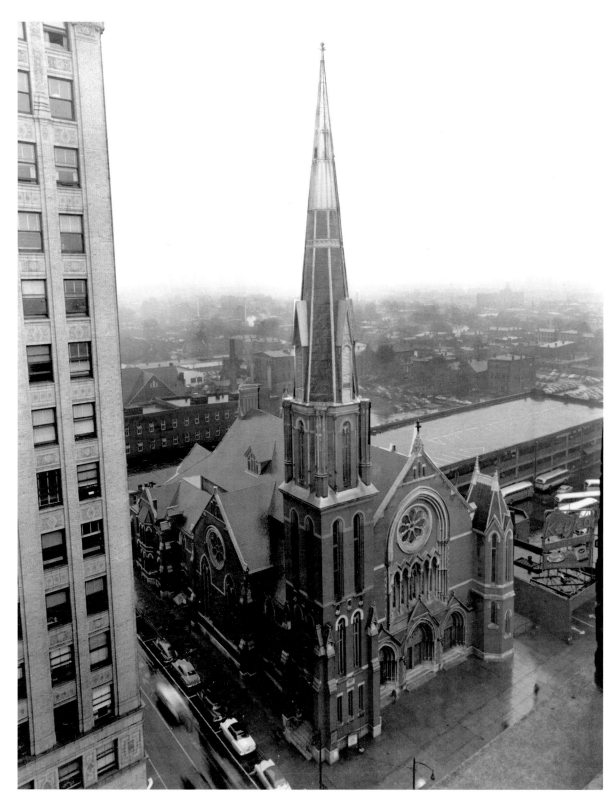

A 1951 view of the Warren Memorial Presbyterian Church from atop the Brown Hotel. The church was destroyed by fire later in the decade.

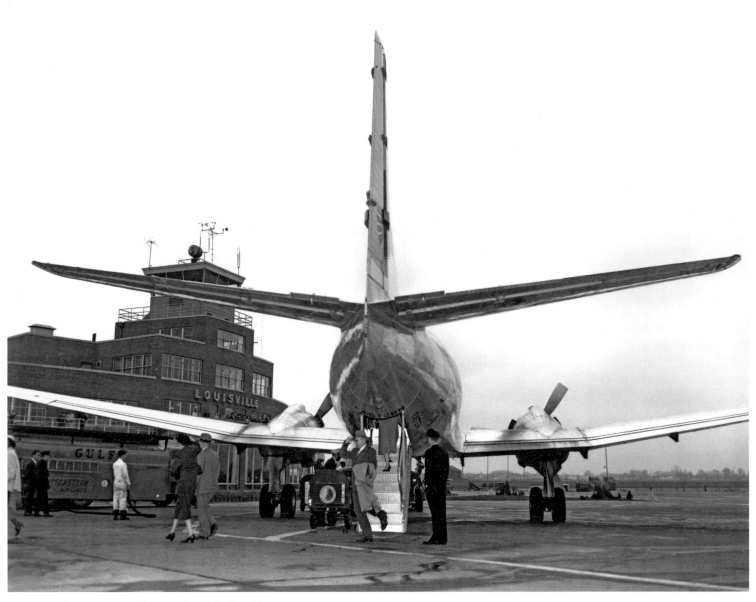

Passengers departing an air liner at Standiford Field's
Lee Terminal in 1951.

Kentucky State Police operate a traffic safety display at the 1953
Kentucky State Fair.

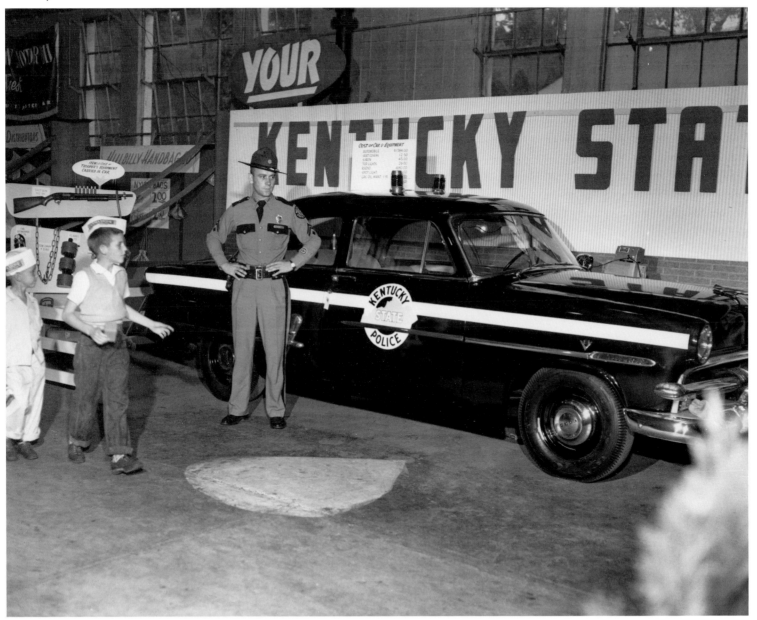

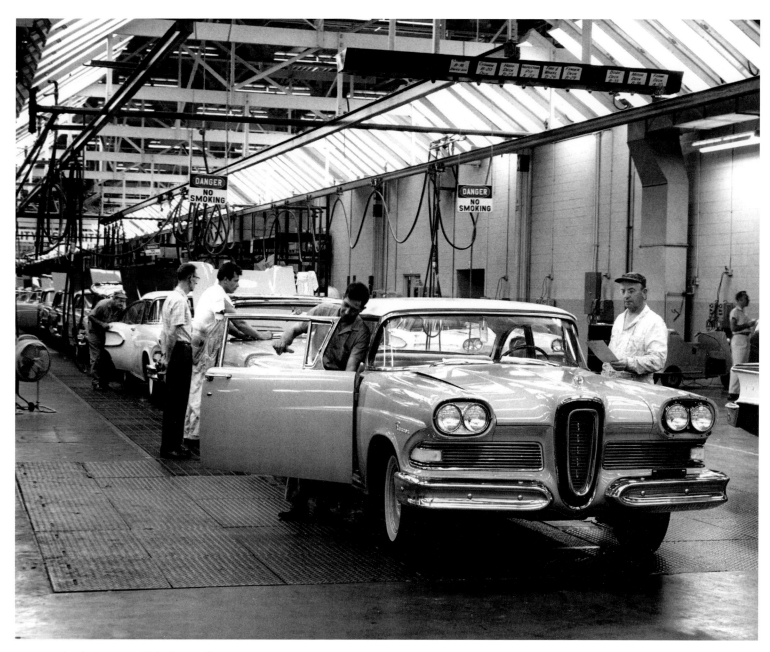

1958 Ford Edsels come off the line at the Louisville Assembly Plant on Grade Lane. The
plant had been designated as a major site for the production of the ill-fated Edsel cars.

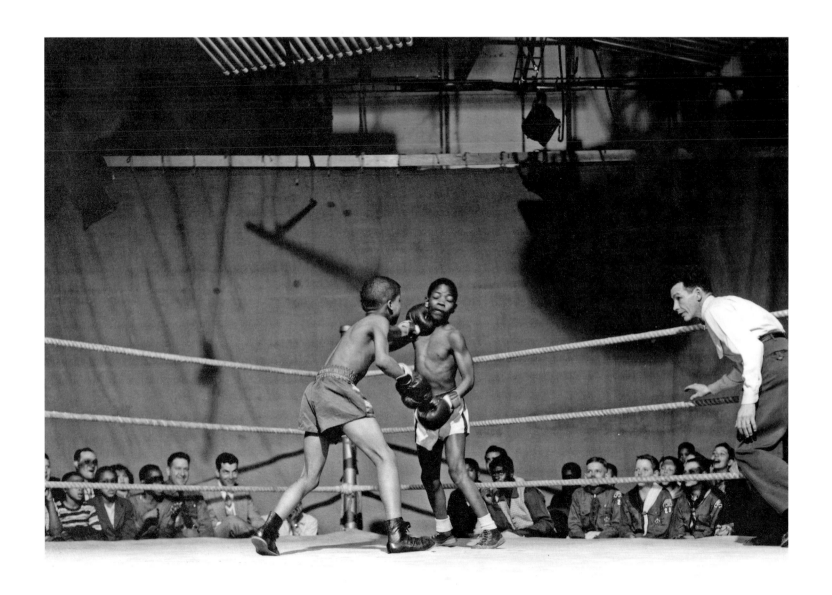

Young boxers participate in the popular
"Tomorrow's Champions" television
show in 1955.

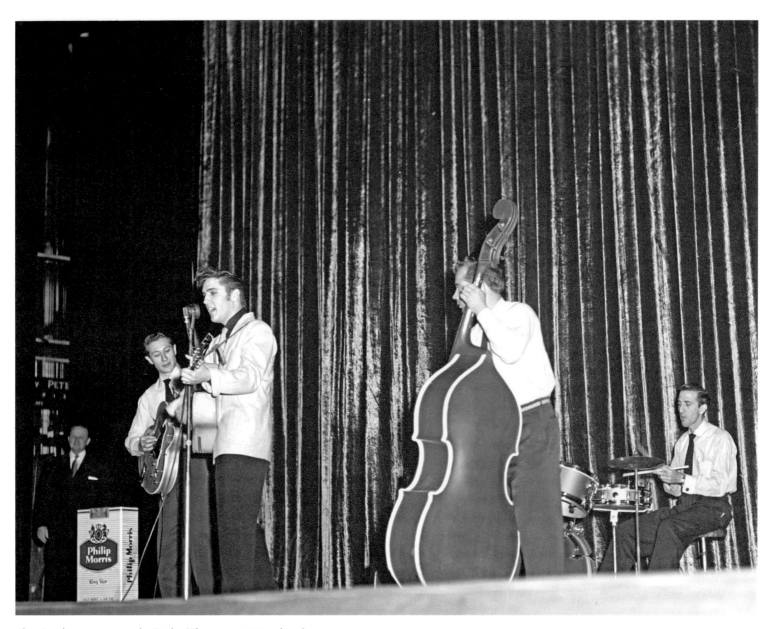

Elvis Presley on stage at the Rialto Theater in 1955 when he was
the opening act of the annual country music show produced by the
Philip Morris Tobacco Company for its employees.

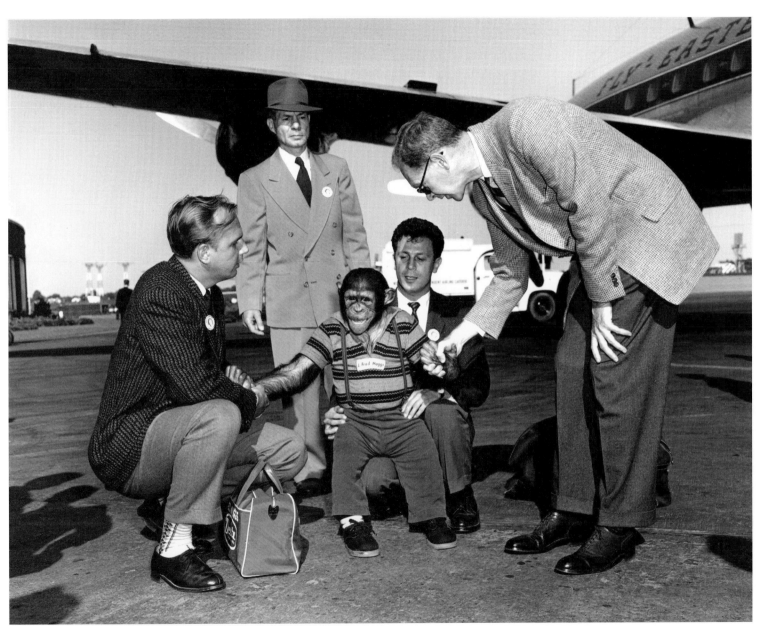

Fred J. Muggs, animal companion of Dave Garroway on the NBC-TV "Today" show, is greeted at Standiford Field in 1956.

The Seelbach Hotel, Fourth and Walnut Streets, with a campaign sign for Kentucky Senator Earl C. Clements. 1956.

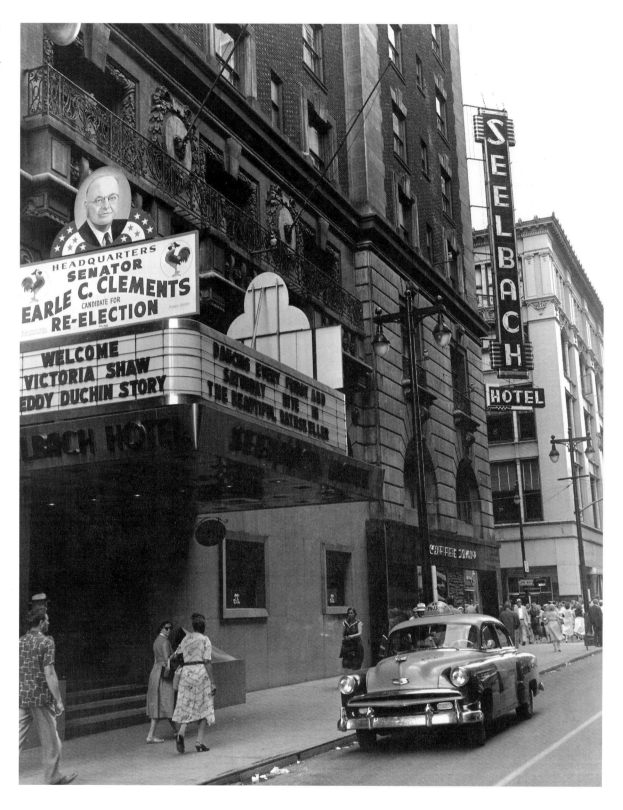

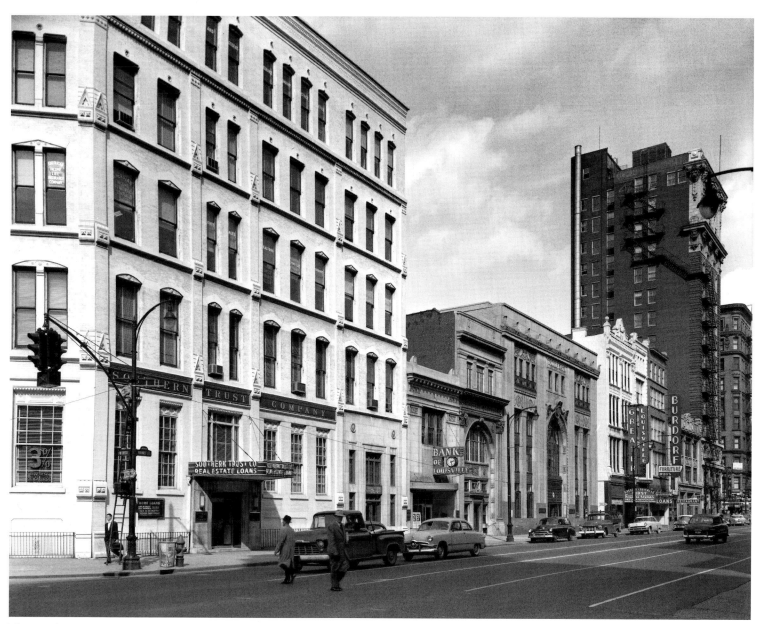

The Southern Trust Building, at the north east corner of
Fifth and Main, photographed here in 1947.

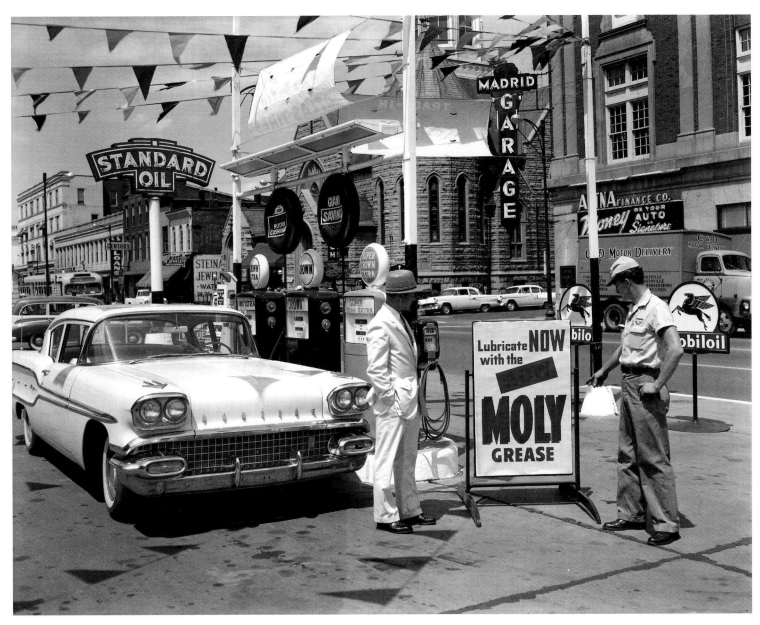

Standard Oil Station at Third and Guthrie in 1958. Trinity Methodist
Church and the Madrid Building can be seen in the background.

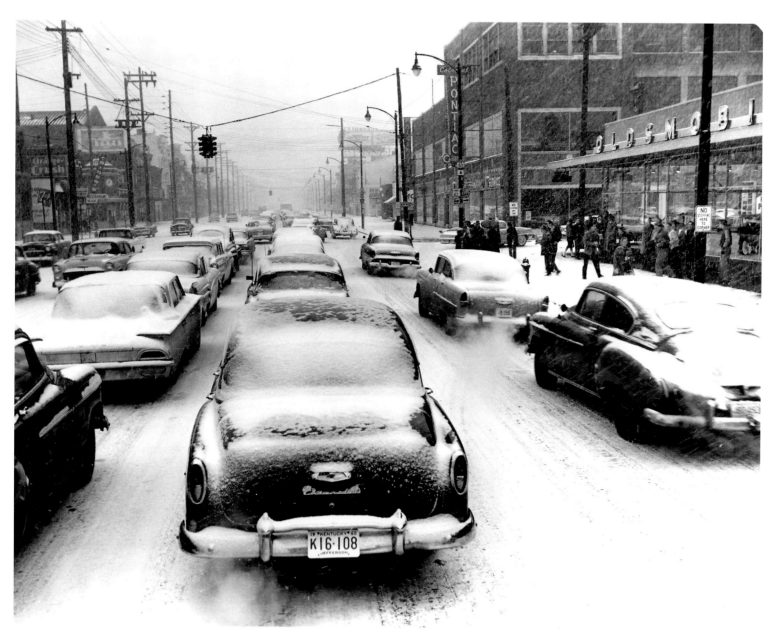

Traffic is stalled by a snow storm in this 1960
view of east Broadway.

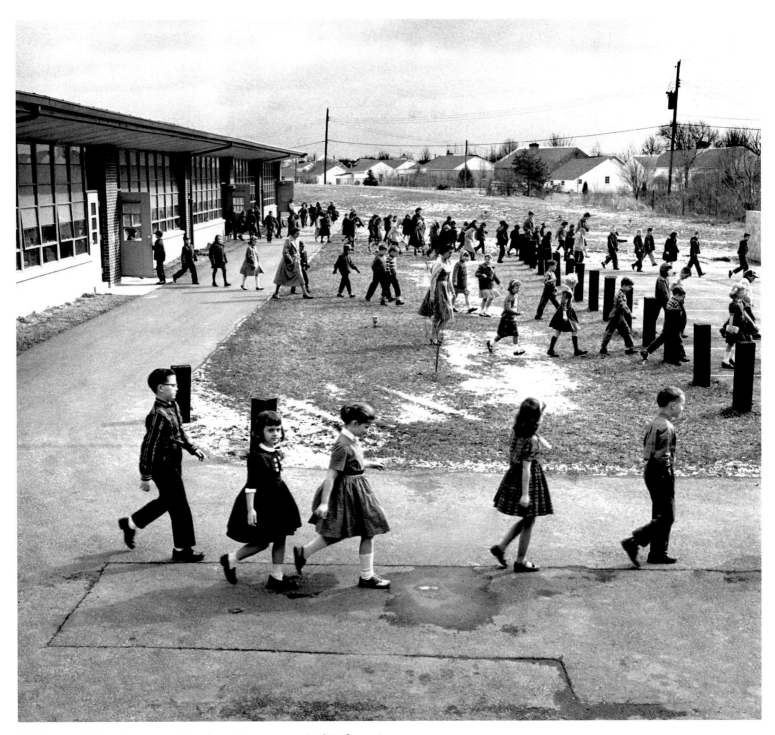

Children at Wilder Elementary School participating in a Civil Defense air
raid drill in which they must seek shelter in the basements of neighboring
houses. 1960.

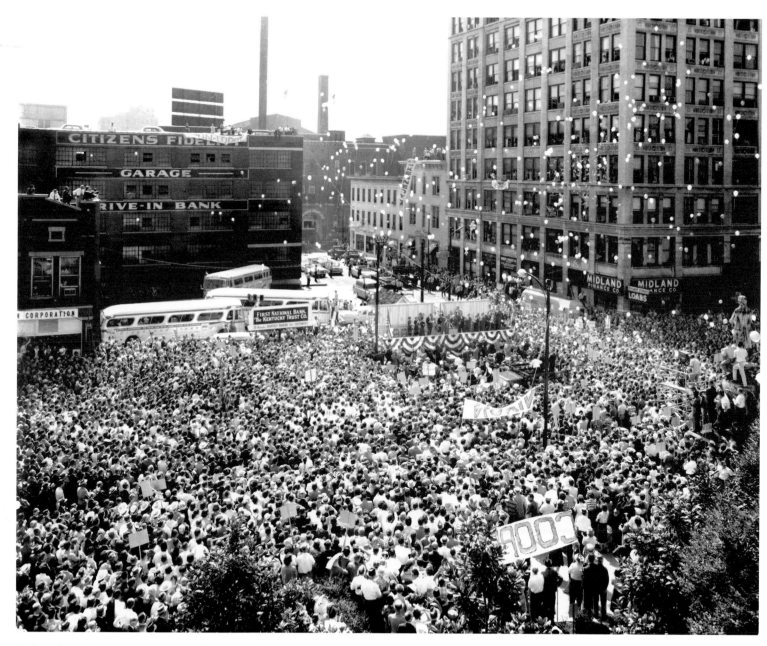

A Republican Party rally on Armory Place in 1960 supports, among others, Senator John Sherman Cooper.

This Holiday Inn opened on Bardstown Road near the Watterson Expressway in 1960.

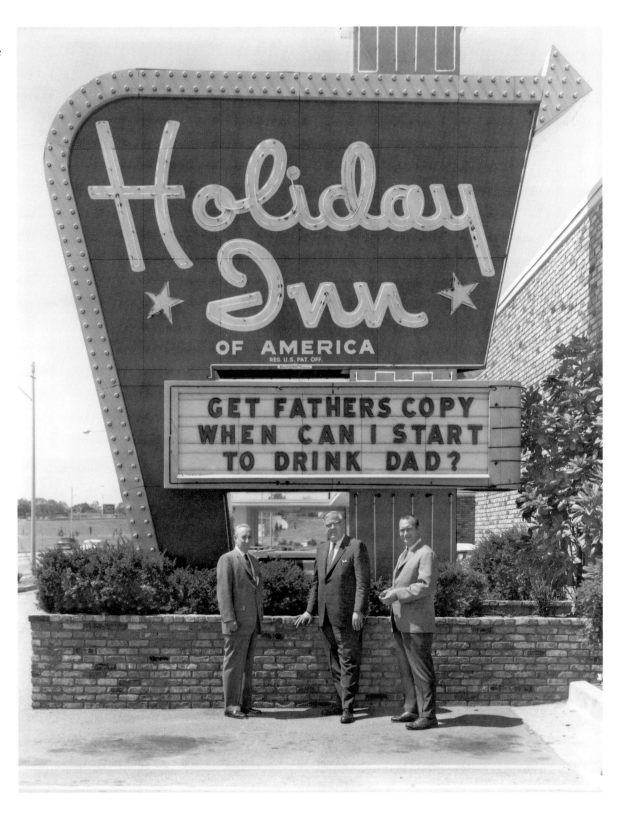

Stewarts Dry Goods, Louisville's major department store, opened at
Fourth and Walnut in 1907. 1961.

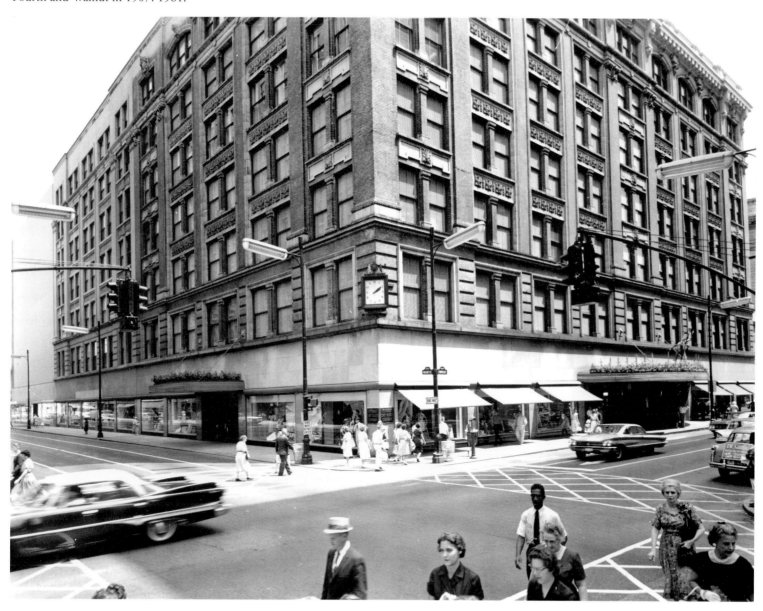

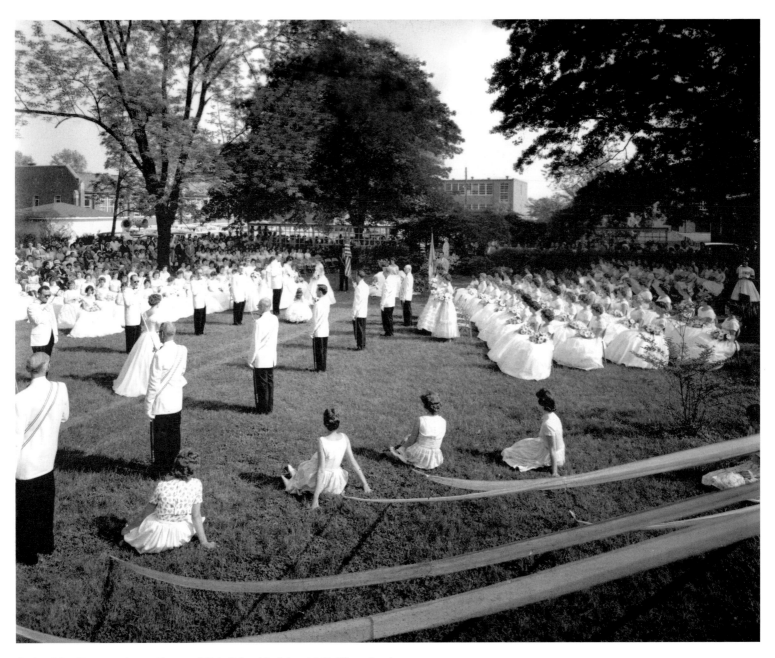

Senior May Day exercises at Loretto High School in May, 1960. The school, operated by the Sisters of Loretto, was at 723 S. Forty-Fifth Street.

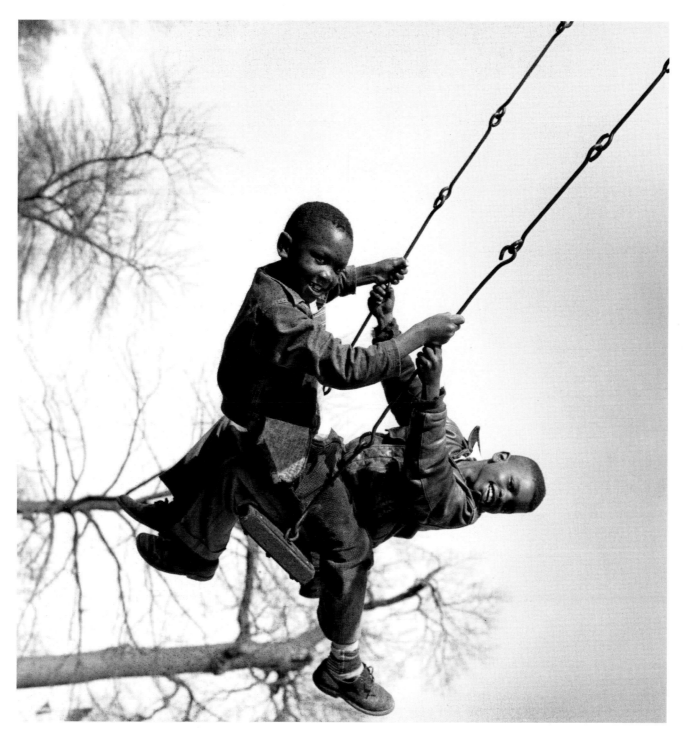

Boys playing on swings in Louisville's Central Park in the 1960s.
Central Park is one of the series of parks designed by the firm of
Frederick Law Olmsted.

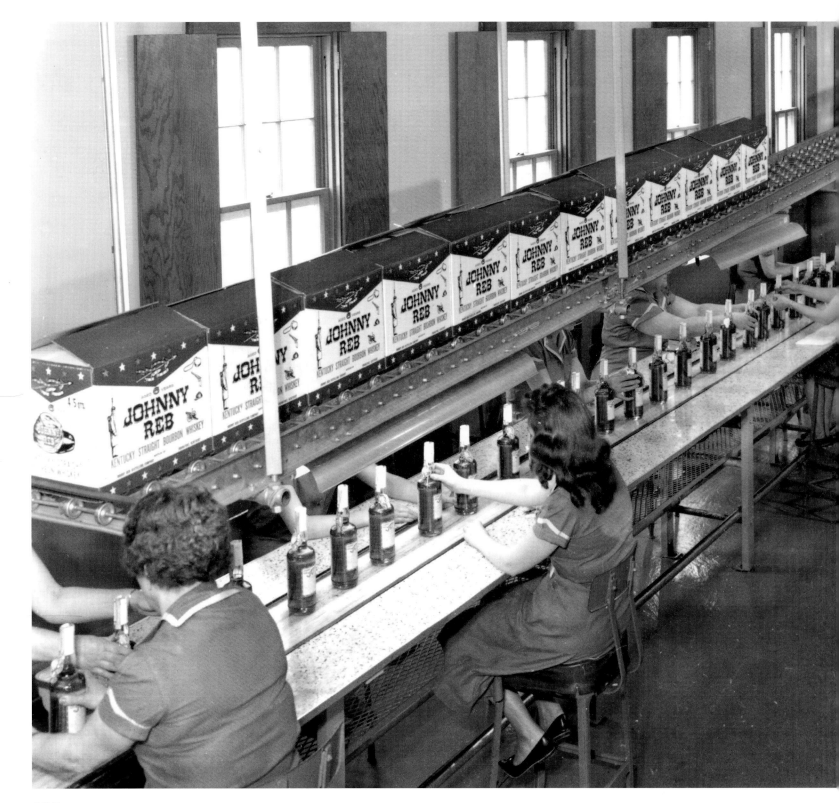

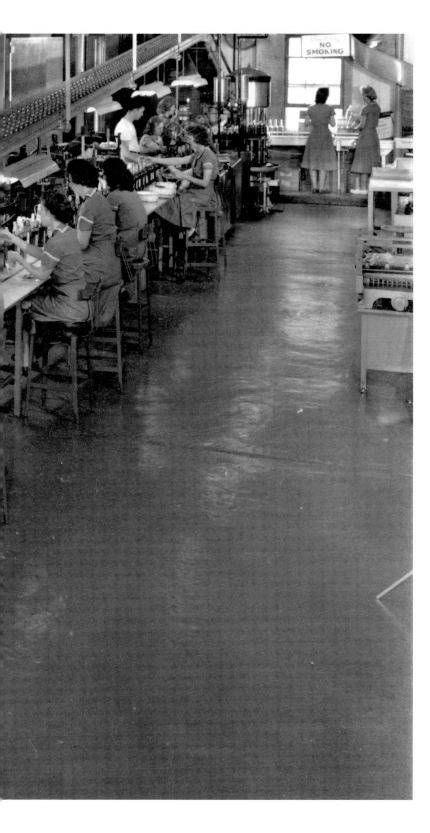

These workers at 21 Brands Distillery are shown on the bottling and inspection line in May, 1960.

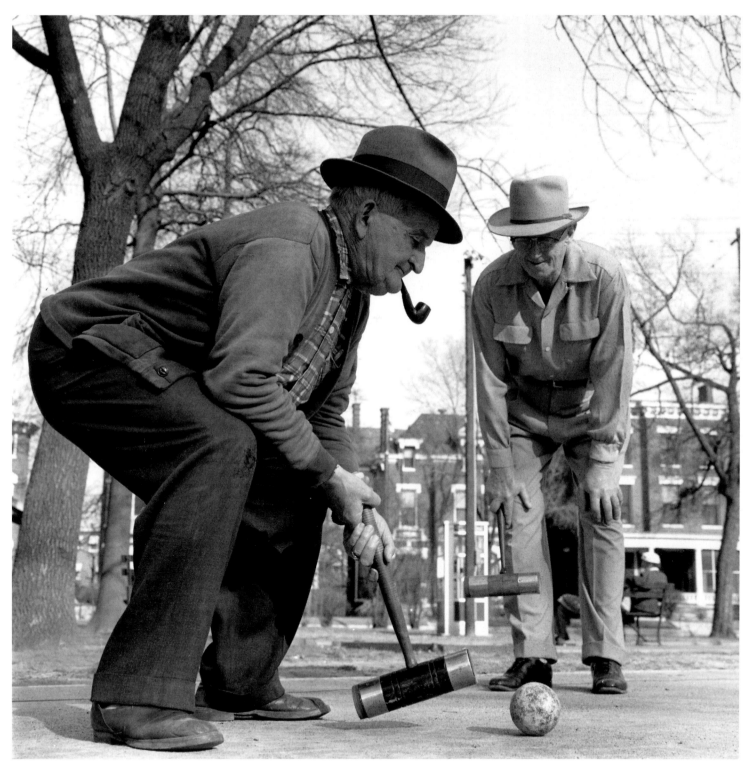

Retirees play croquet on courts at Louisville's Central Park in the 1960s.

The "Stadium" seating section at Churchill Downs, erected in 1918 and demolished in 1962.

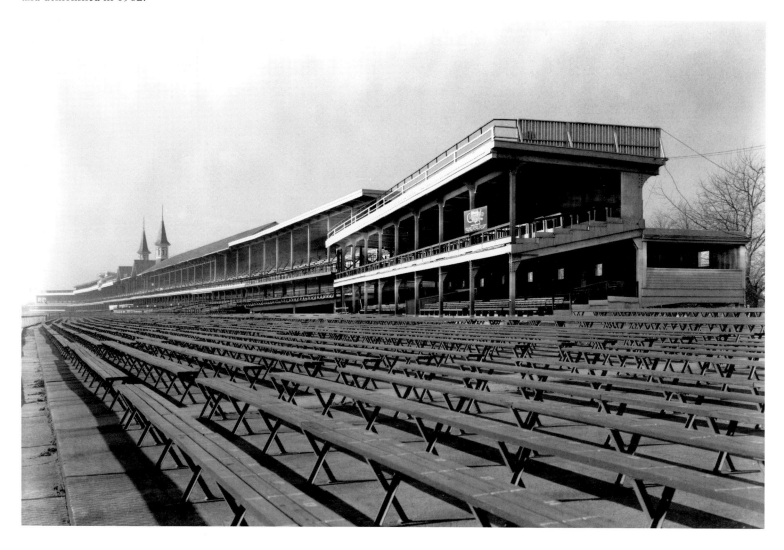

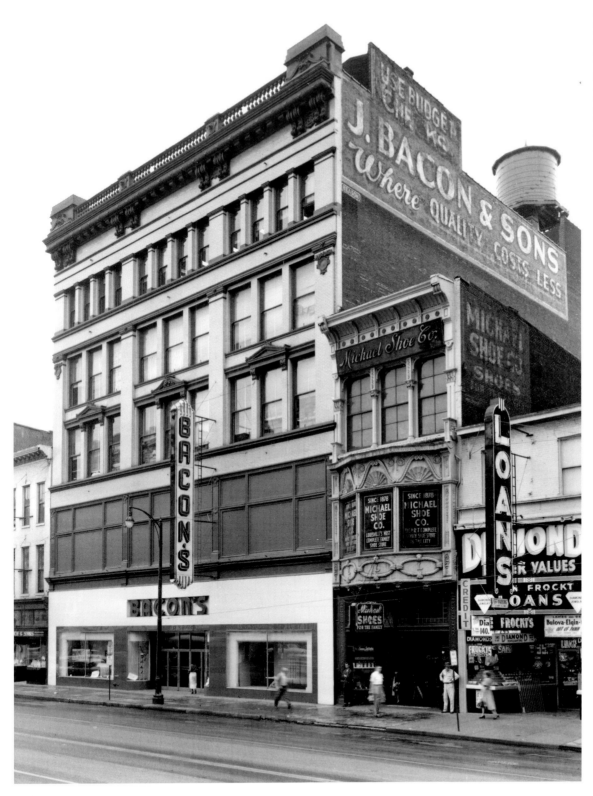

Bacon's, on the south side of Market between Third and Fourth, was one of Louisville's most popular department stores. It is seen here in a 1964 view, just before suburban malls began to take business away from the downtown shopping district.

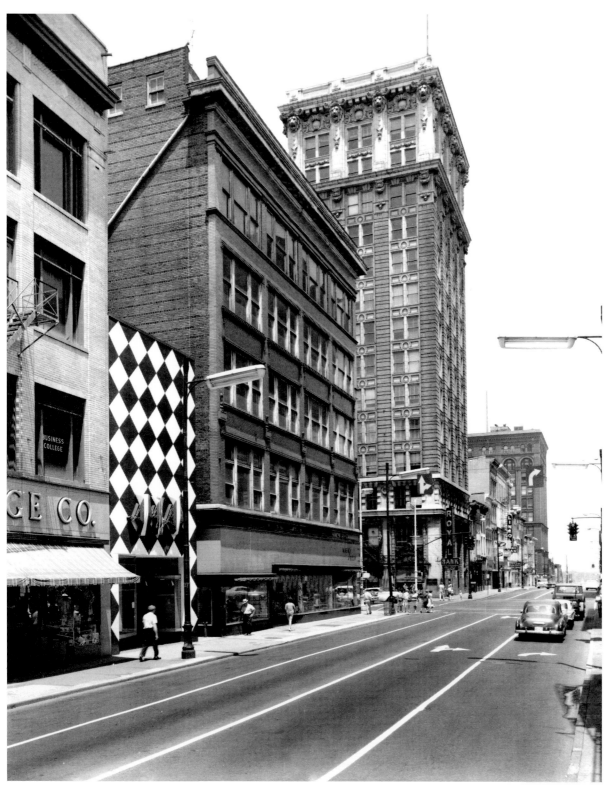

The west side of the intersection of Fourth and Market is seen in this July, 1964 photograph. The tall building in the background was built as the Lincoln Savings Bank Building in 1908.

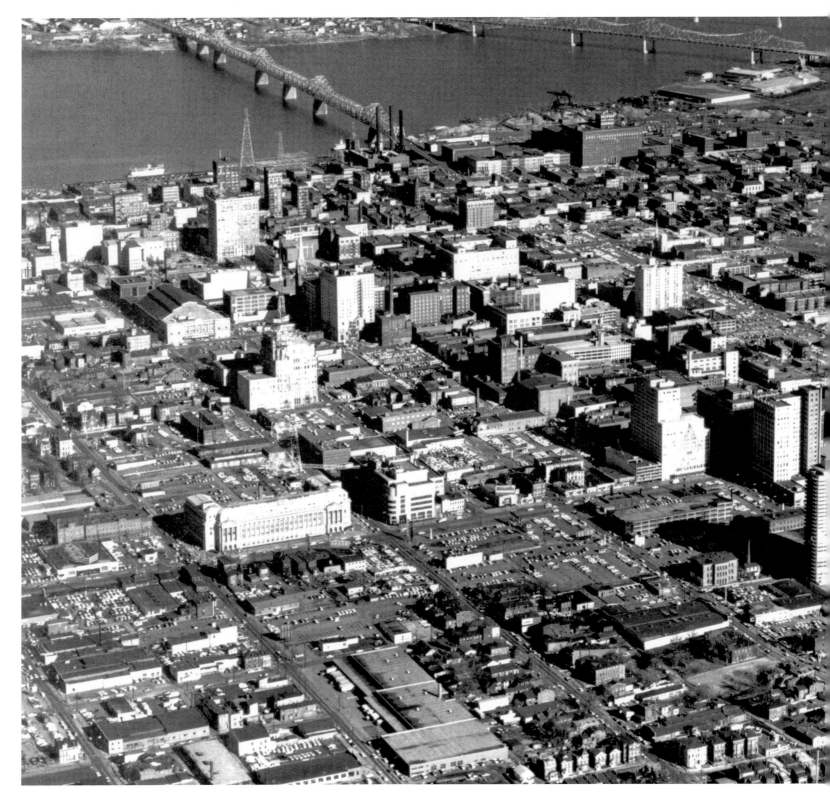

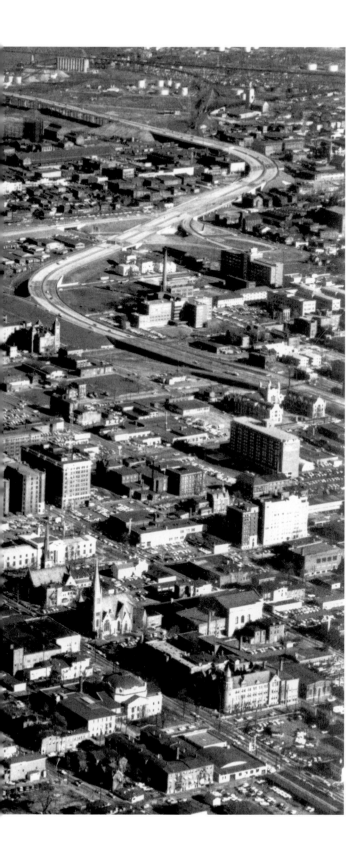

In this 1963 aerial view, the just-completed 800 Apartments building can be seen in the foreground as can the partially-completed "Hospital Curve" of I-65.

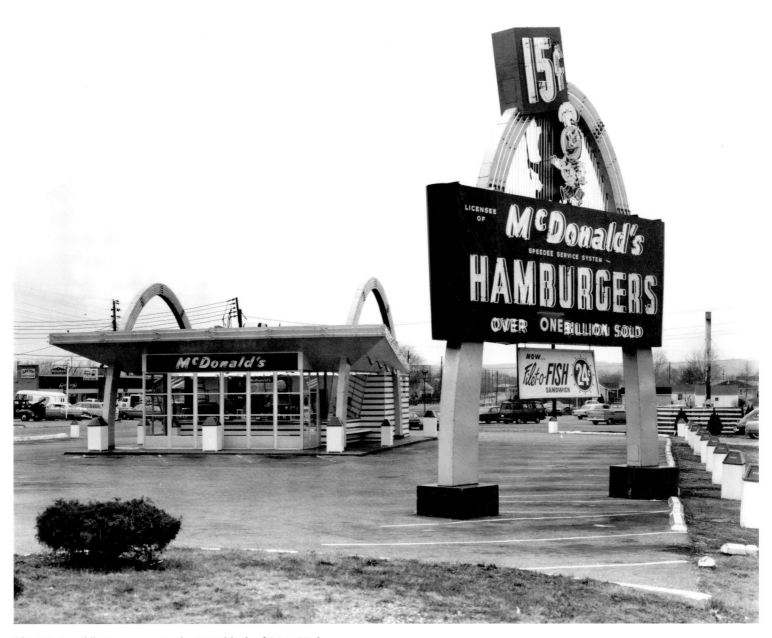

This McDonald's Restaurant, in the 8500 block of Dixie Highway in Valley Station, was one of the first in Louisville. It is seen here in December, 1964.

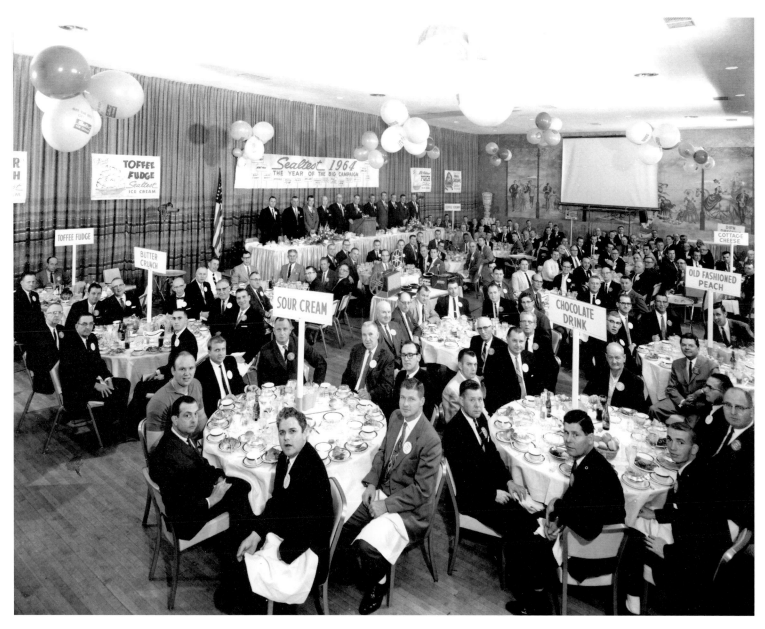

Employee dinner of the Sealtest Dairies, held January 22, 1954.
Signs on tables indicate each of the company's products.

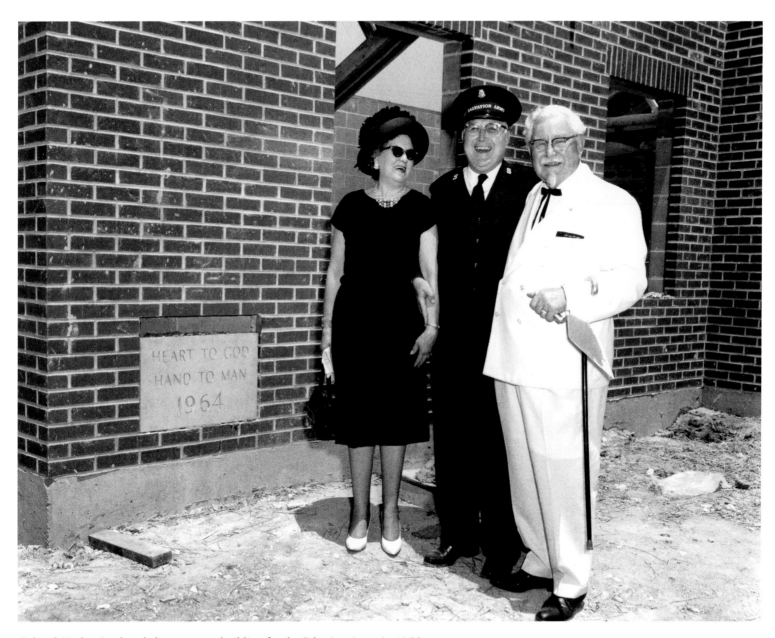

Colonel Harlan Sanders dedicates a new building for the Salvation Army in 1964.
With him is Brigadier Sawyers and an unidentified woman who is possibly the
Colonel's wife, Claudia.

Former auto dealer and photographer R.G. Potter with movie star Joe E. Brown and Potter's cairn terriers. Brown was a frequent Kentucky Derby guest of the Potters. 1964.

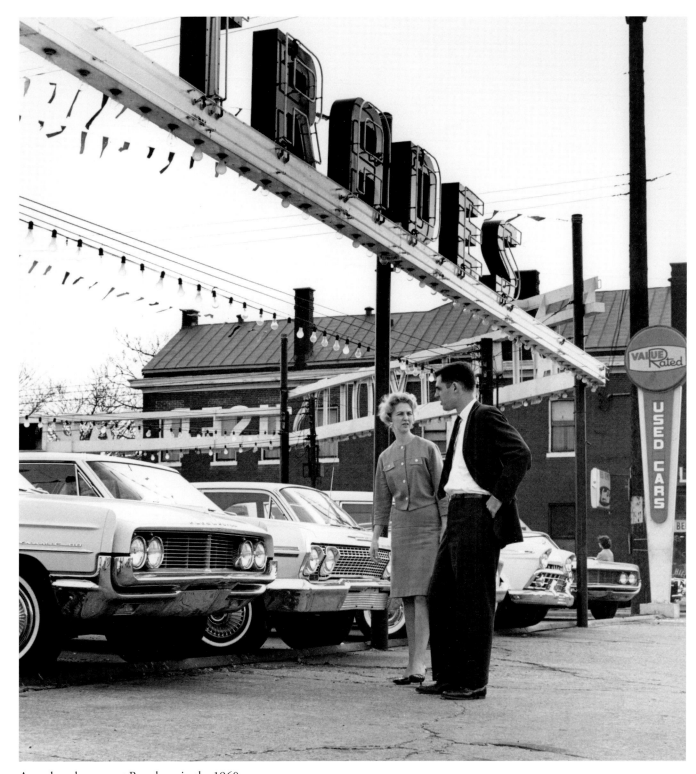

A used car lot on east Broadway in the 1960s.

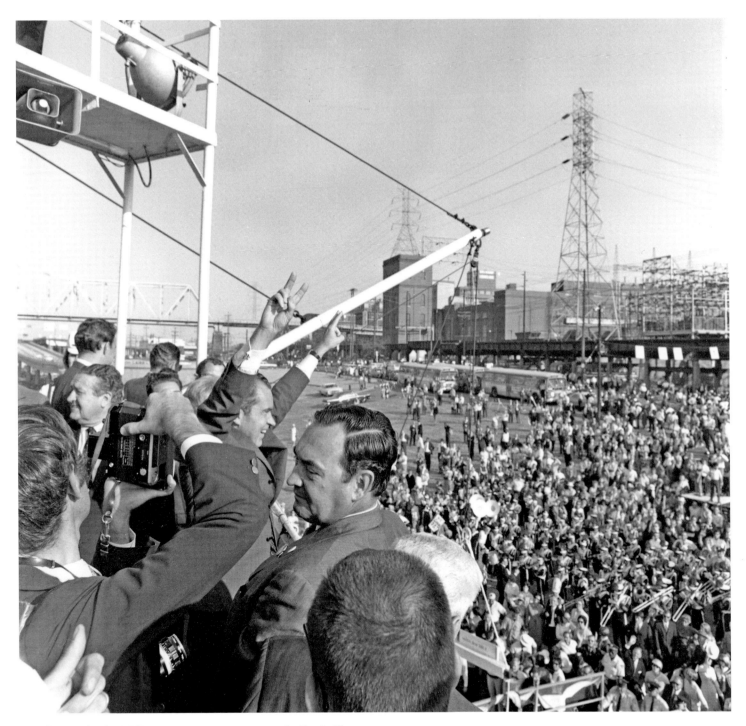

President Richard M. Nixon waves to supporters on the Louisville
Wharf from the deck of the Belle of Louisville in 1968. He is
accompanied by Republican Governor Louie B. Nunn.

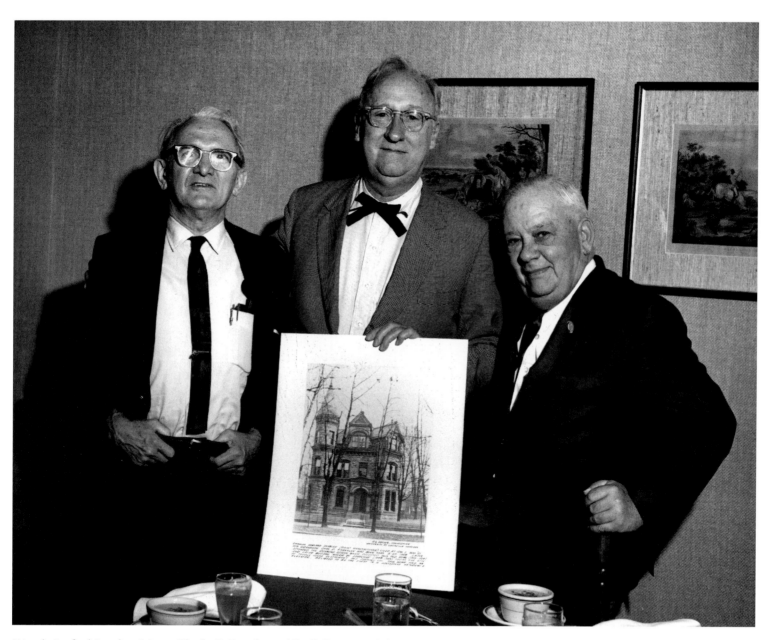

Friends Sanford Strother, Mayor Charles P. Farnsley and R. G. Potter reminisce
about historic photographs collected by Mr. Potter. Circa 1969.

194

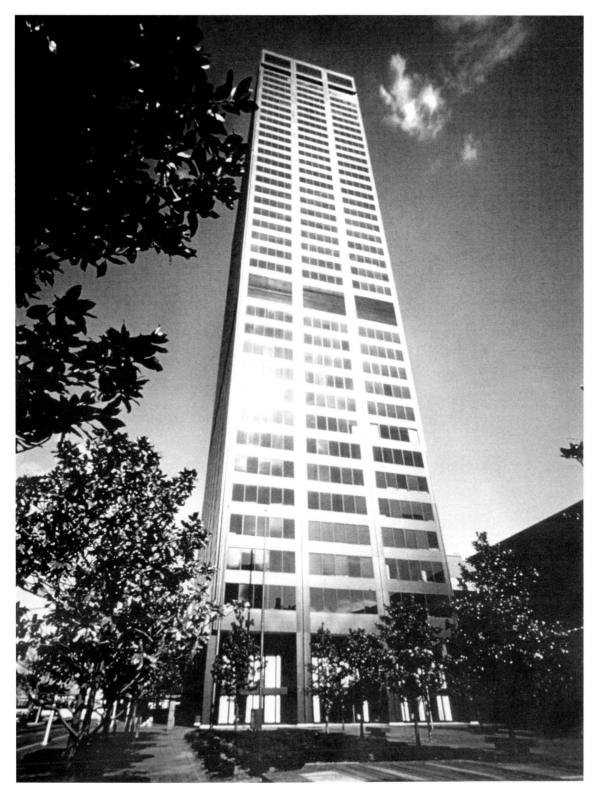

The forty-story First National Tower, built at Fifth and Main, was one of several high-rise office buildings which altered Louisville's skyline in the 1970s and 1980s. 1971.

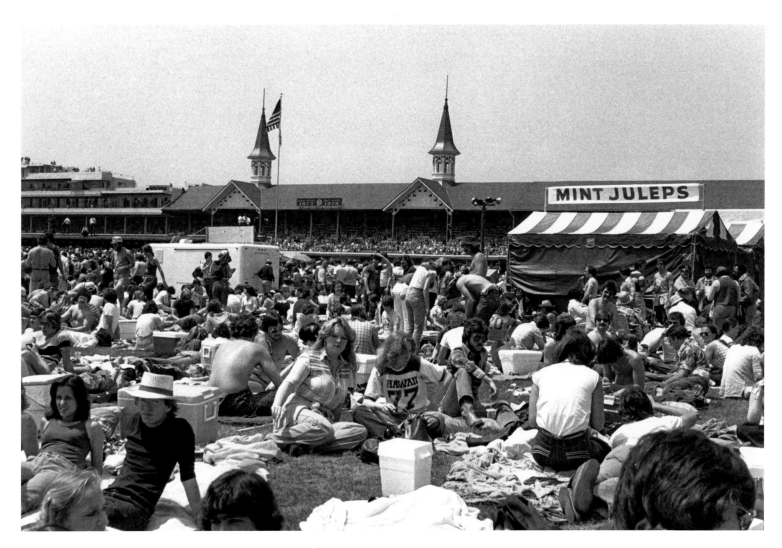

The infield crowd enjoys the sun at the 1978 Kentucky Derby.

Notes on the Photographs

These notes, listed by page number, attempt to include all aspects known of the photographs. Each of the photographs is identified by the page number, photograph's title or description, photographer and collection, archive, and call or box number when applicable. Although every attempt was made to collect all available data, in some cases complete data was unavailable due to the age and condition of some of the photographs and records.

113 N. M. Saunders Poultry
Photographic Archives
Ekstrom Library, University of Louisville
R. G. Potter Collection
P 01510

114 FDR Campaigning
Photographic Archives
Ekstrom Library, University of Louisville
Caufield & Shook Studio Collection
CS 125401

115 Tyler Block
Photographic Archives
Ekstrom Library, University of Louisville
R. G. Potter Collection
P 06591

116 Jefferson Street East from Floyd
Photographic Archives
Ekstrom Library, University of Louisville
Caufield & Shook Studio Collection
CS 128777

117 Liberty National Bank
Photographic Archives
Ekstrom Library, University of Louisville
R. G. Potter Collection
P 04179

118 Broadway Express Trolley
Photographic Archives
Ekstrom Library, University of Louisville
Caufield & Shook Studio Collection
CS 112659

119 South Side of Jefferson
Photographic Archives
Ekstrom Library, University of Louisville
R. G. Potter Collection
P 06590

120 Levy Brothers
Photographic Archives
Ekstrom Library, University of Louisville
Caufield & Shook Studio Collection
CS 131122

121 Louisville Post Office and Federal Building
Photographic Archives
Ekstrom Library, University of Louisville
Caufield & Shook Studio Collection
CS 132869

122 Murphy Elevator Company
Photographic Archives
Ekstrom Library, University of Louisville
R. G. Potter Collection
P 03746.1

123 Gold Medal Giveaway
Photographic Archives
Ekstrom Library, University of Louisville
R. G. Potter Collection
P 02991

124 Seagrams Distillery
Photographic Archives
Ekstrom Library, University of Louisville
Caufield & Shook Studio Collection
CS 144404

126 Stock Yards Bank 1937 Flood
Stock Yards Bank and Trust
Private Collection

127 1937 Flood
Photographic Archives
Ekstrom Library, University of Louisville
R. G. Potter Collection
P 00537

128 Flood Waters
Photographic Archives
Ekstrom Library, University of Louisville
R. G. Potter Collection
P 00513

130 George Rogers Clark Bridge
Photographic Archives
Ekstrom Library, University of Louisville
Lin Caufield Collection
12

131 Roosevelt Speech
Photographic Archives
Ekstrom Library, University of Louisville
Caufield & Shook Studio Collection
CS 160544

132 Fort Nelson Hotel
Photographic Archives
Ekstrom Library, University of Louisville
Herald Post Collection
94.18.0143

133 Standpipe tower & Pumping Station
Photographic Archives
Ekstrom Library, University of Louisville
Caufield & Shook Studio Collection
CS 150162

134 Citizen's Union Bank
Photographic Archives
Ekstrom Library, University of Louisville
R. G. Potter Collection
P 3472.1

135 Louisville Colonels
Photographic Archives
Ekstrom Library, University of Louisville
R. G. Potter Collection
P 01010

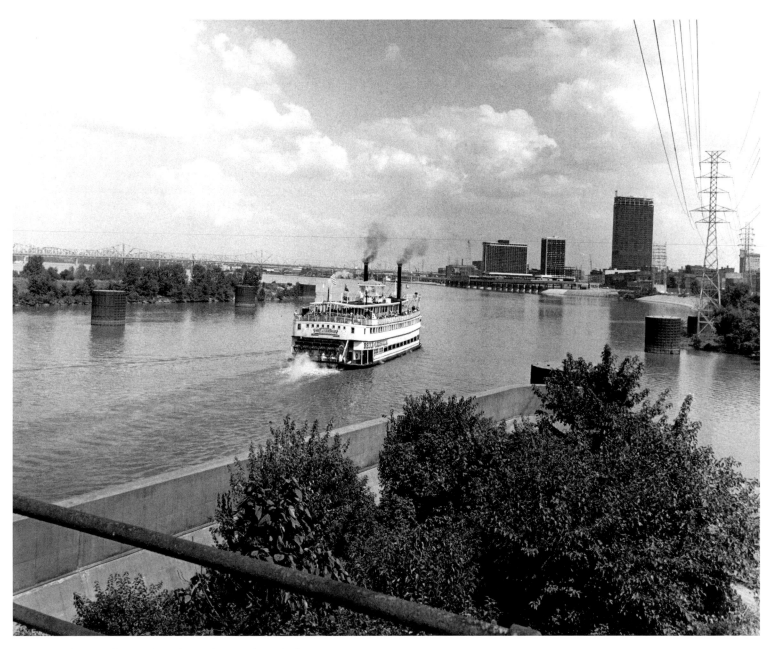

The *Belle of Louisville* steamboat leaves the McAlpine locks in
1973, headed upriver toward downtown Louisville.